AFRICAN

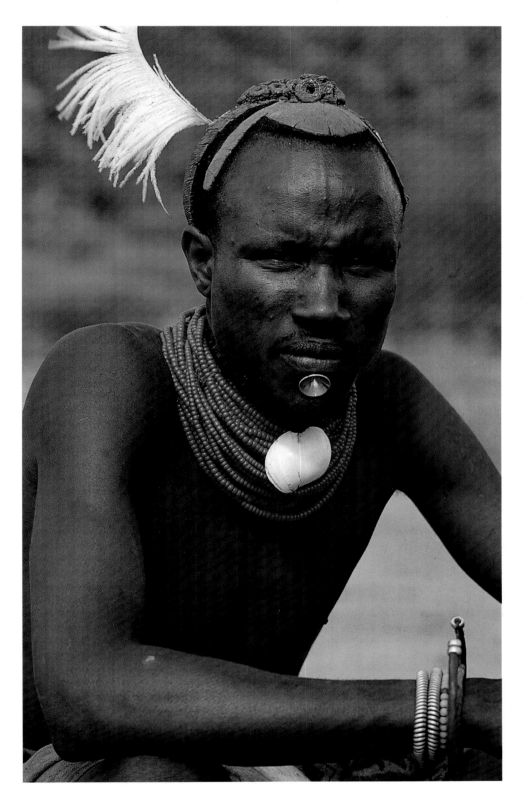

ELEGANCE

AFRICAN

ELEGANCE

ETTAGALE BLAUER

First published in the United States of America in 1999 by
RIZZOLI INTERNATIONAL PUBLICATIONS, INC.
300 Park Avenue South, New York, NY 10010

First published in Great Britain in 1999 by
New Holland Publishers (UK) Ltd
London · Cape Town · Sydney · Auckland

ISBN 0-8478-2224-9
LC 99-70301

Managing editor: Annlerie van Rooyen
Editors: Alfred LeMaitre and Lesley Hay-Whitton
Designer: Janice Evans
Design assistant: Lellyn Creamer
Picture researcher: Carmen Watts
Consultant: Alan Donovan
Map illustrator: Annette Busse
Proofreader: Lesley Hay-Whitton
Indexer: Claudia Dos Santos

Reproduction by Hirt & Carter Cape (Pty) Ltd
Printed and bound in Singapore by Tien Wah Press (Pte) Ltd

FRONT COVER: *Karo painted body decoration, Ethiopia;*
BACK COVER: *Hamar man, Ethiopia;* SPINE: *Turkana vessel, Kenya;*
FRONT FLAP: *Kuba cloth, Democratic Republic of Congo;*
ENDPAPERS: *Mud cloth pattern, Mali;* HALF-TITLE PAGE: *Turkana*
warrior, Kenya; TITLE PAGE: *Maasai women, Kenya;*
THIS PAGE (CLOCKWISE FROM ABOVE): *Woven fabrics, Ghana; detail*
of Xhosa beadwork, South Africa; detail of Ndebele wall painting,
South Africa; OPPOSITE PAGE: *Beaded cow hide, Kenya.*

CONTENTS

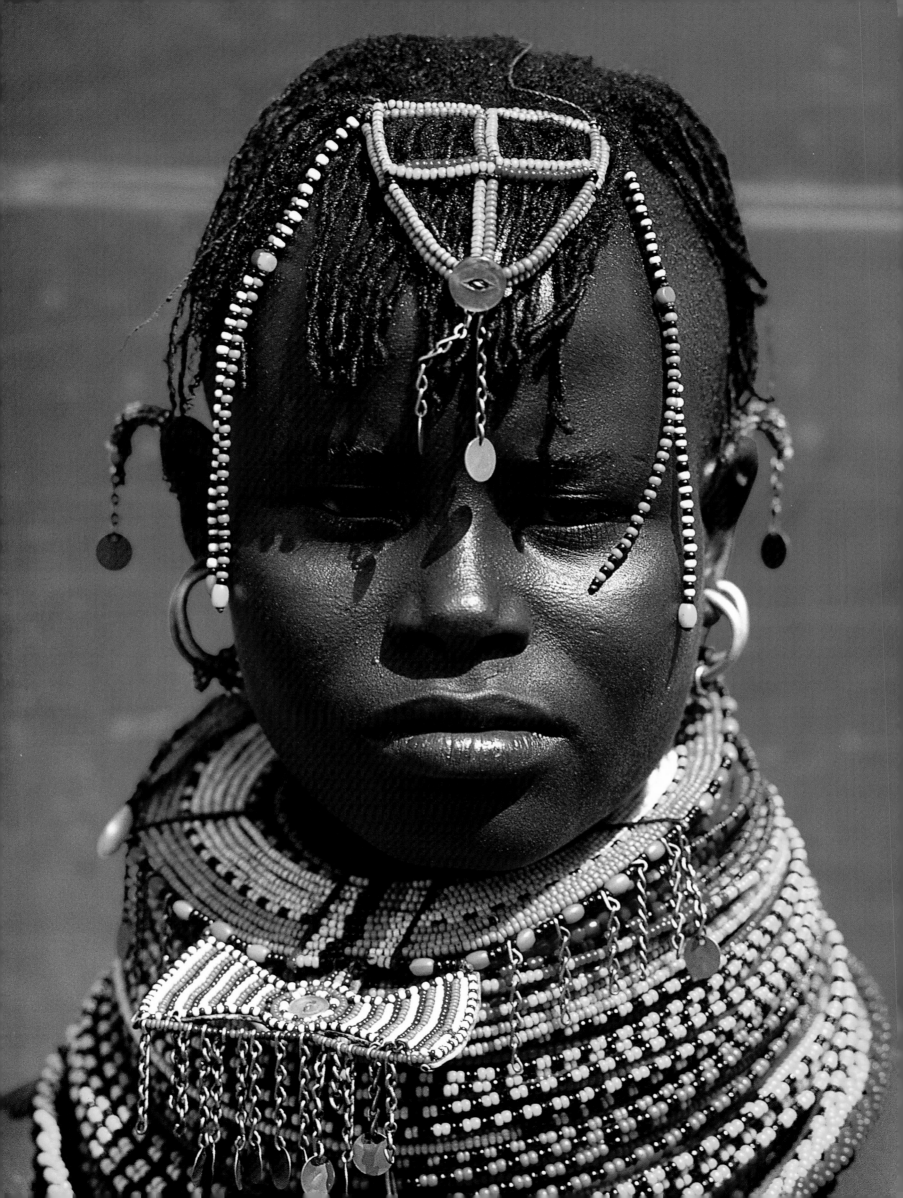

INTRODUCTION

We live in an increasingly homogeneous world, where brand names are as familiar to people living in the bush as they are in European cities, where T-shirts bearing the crests of Harvard and Oxford are worn in the interior of Africa by barefoot boys who have never been to school. In this era of computers, e-mail and technological marvels, is it possible for people to maintain traditional cultures that celebrate their uniqueness? Is there still a place for ritual ceremonies and initiation rites? Is there still an authentic reason to turn beads into jewellery or carve wood into headrests that maintain their symbolic meanings? For all those who make and use these objects, and for those who admire and treasure them, the answer is still 'yes'. However, African traditional practices are eroding and changing through contact with other peoples, other materials, other ideas.

A young Turkana girl from Kenya's dry northern region wears numerous single strands of large red and yellow beads.

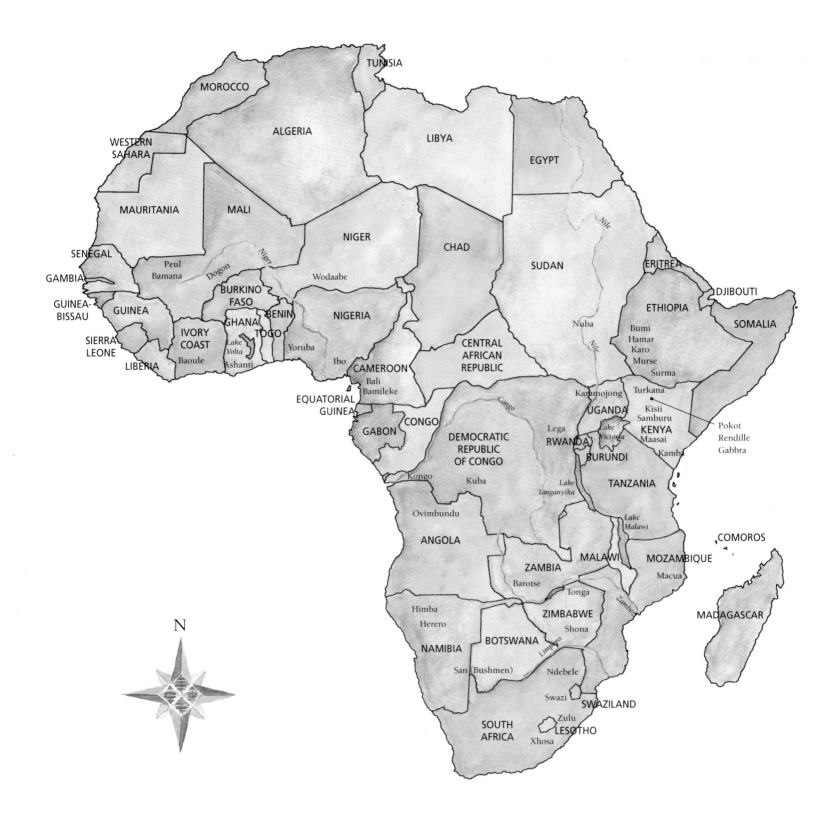

A future in which traditional art will be seen primarily in museums or private collections is certainly on the horizon. In some instances, African people themselves have virtually become museum exhibits, performing at cultural villages that simulate the authentic life of a rural community. For those who take part, working and sometimes living in such attractions, the villages make it possible to earn a living and at the same time perpetuate traditional crafts and practices. For those who want a glimpse of the 'traditional' way of life, the villages provide that opportunity. In many ways,

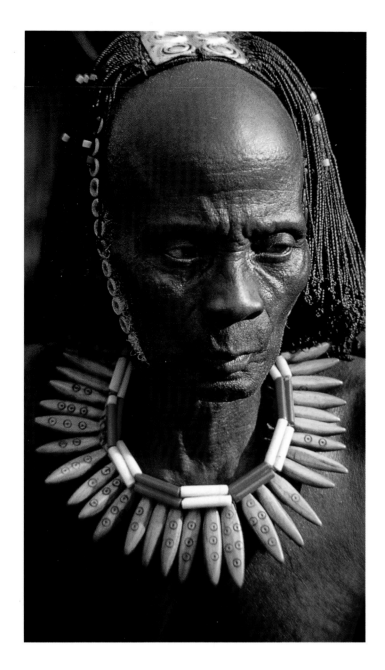

A high-ranking Lega man, near Kalima in what is now the Democratic Republic of Congo (formerly Zaïre).

people are disappointed when they see a Maasai warrior, resplendent in his beads and ochre, wearing a wristwatch, or wish that the Ndebele woman, decked out in beads and brass rings, were not wearing sneakers.

Where do these ideas of 'cultural purity' originate? People around the world are victims of an illusion perpetuated by Hollywood. Small wonder that so many believe that Africa is covered with vines creeping up bamboo trees, or that lions roam through villages. Westerners may see Africans dancing in movies and then fail to grasp any sense of ritual, ceremony or meaning. That notion, those images,

A traditional chief wears Kente cloth and a hat ornamented with gold at the funeral of President Félix Houphouet-Boigny of the Ivory Coast in 1994.

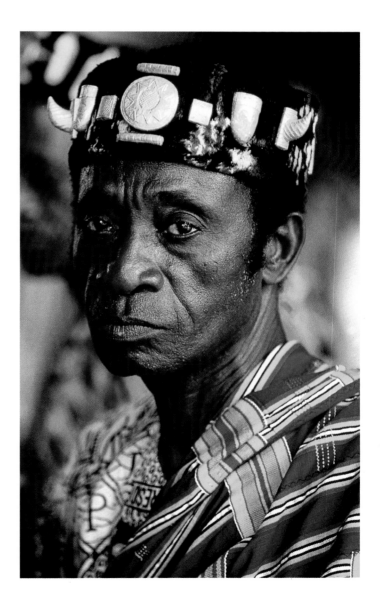

they are the Hollywood version of the real thing: too pretty, too cheerful, too organized. But few visitors have the chance to go into remote areas that are still relatively untouched by Westernization, where Africans live as their ancestors did, under chiefs, following traditional laws.

Although information zaps around the globe in nanoseconds, many people would like certain cultures to remain pure, as if they were preserved in a time warp. Tourists expect to see other cultures unchanged, so that they can wallow nostalgically in their exotic traditions. Some

could not be further from the truth. There is a powerful connection between African cultures and their dances, their ceremonies and the objects they make. Many of those rituals are in fact far more mysterious and compelling than the most fevered imaginings of Hollywood.

Each culture of Africa has been shaped by two major forces: the materials available and traditions of the people themselves, and the role played by the cultures of outsiders. It is not in the nature of cultures to remain pure and intact, unchanged and unaffected by outside influences. There are precious few such cultures, tiny islands of people who have little contact outside their own communities. Africa was also shaped by trade, by raiding and by exploration, and most of

its cultures reflect that history. Africa has been within the grasp of peoples from Europe and Asia for many centuries. Trade routes across the Sahara are thought to be five thousand years old, while the advent of traders from the Indian Ocean rim, though more recent, created its own impact. Whether the contact was benign or brutal, it brought new ideas, new materials, new technology. These were absorbed to varying degrees by indigenous cultures.

The ingenuity of people in making use of new ideas, materials and techniques keeps cultures vital. Although much of the contact between Africans and outsiders has resulted in the loss of traditional ways, Africa has withstood much more than a few centuries of European colonization.

Long before the missionaries and the explorers, the colonialists and the conquerors, the people of Africa were on the move. Cultures were constantly changing as people moved from the north and west into the centre, east and

Dominated by a large figure of a snake, a rock painting from the Dogon area of Mali shows a Songo circumcision ceremony.

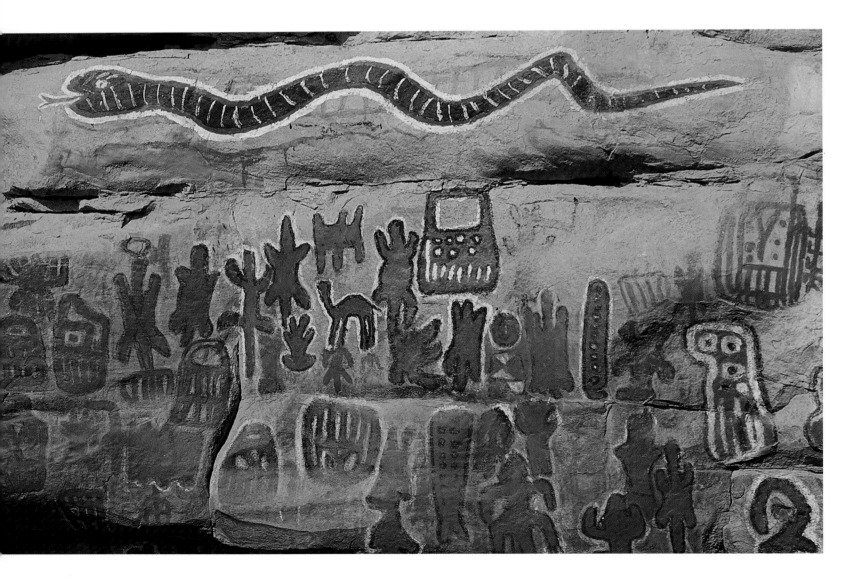

south of the continent. They moved to escape droughts and hostile peoples; they migrated in search of better farm and grazing land. As they moved, they discovered new materials from which to build houses and make household goods. Through trade, they learned how to make use of other kinds of livestock and how to grow new foods. When they were prosperous, their populations grew. Often they became too numerous to be sustained in the one area, and family groups broke away, migrating to new lands.

Change can be the catalyst for a new tradition, and to try to hold back change is to stand in the path of human nature. Some change is natural, a result of climate and geography. Equally often in Africa, it has been the result of force: the wrenching of people from their villages to feed the slave trade, the subjugation of communities in colonial states or the imposition of religions and laws. This process continues in the form of wars and ethnic strife. Yet the African spirit lives on, standing its ground where possible, adapting when necessary.

Cave paintings in Africa throw light on an ancient life that has now vanished. In the Sahara, early people depicted animals that are now found only in climates far to the south. Those people had to adapt, to move, to learn new ways of living in order to survive.

We have the opportunity, in these pages, to view African cultures as they flourish today and as they looked in the recent past. This is a record of vibrant, living cultures that absorb new ideas and materials, new motifs and shapes. Even the seemingly most traditional of objects – for example, beaded necklaces and ornaments – may be built on imported materials, embracing vibrant change from one generation to the next.

A tie-dyed raffia cloth worn by Dida women of the Ivory Coast for ceremonial occasions.

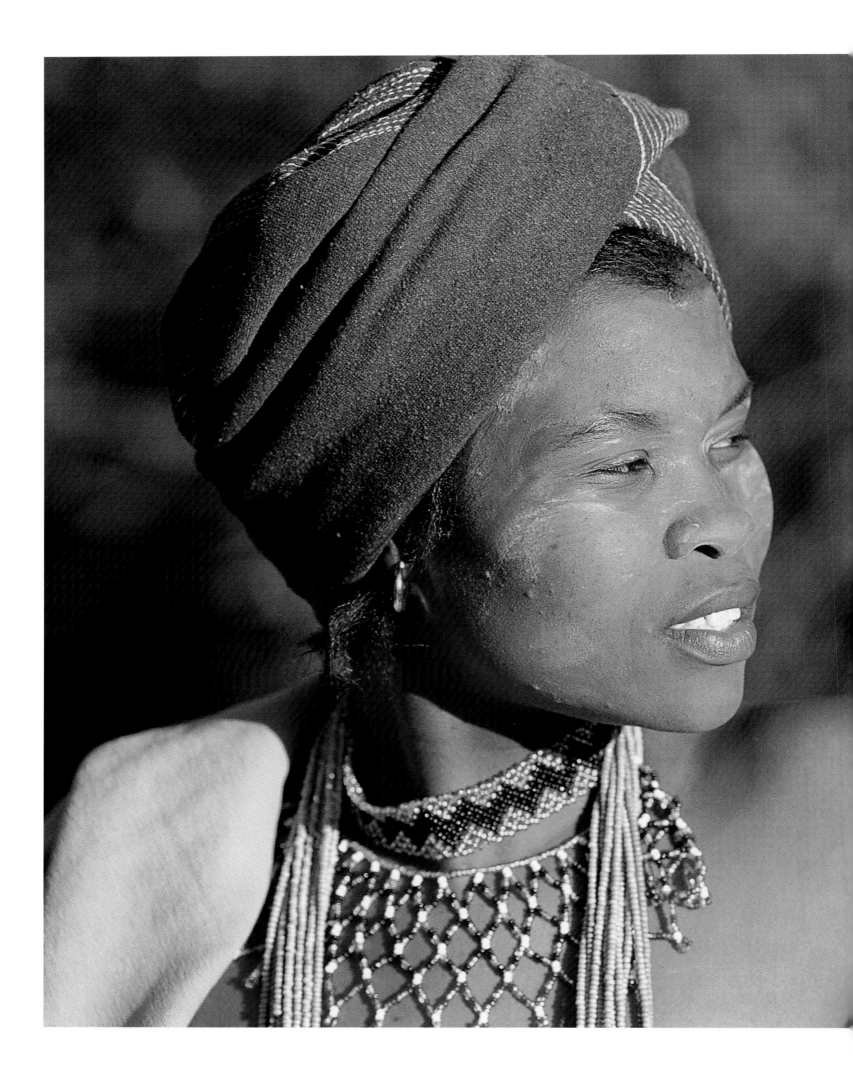

The objects made and used by a particular people are known as material culture. The distinction made in Western society between art and craft does not exist in traditional African societies. Functional objects are decorated, carved, beaded, incised and otherwise enhanced, both according to the maker's artistic ability and the accepted motifs and themes of the particular culture. But these objects are not made as art. In many African languages, there is no specific word for the concept of 'art' since this would set the object apart as something without utility. In fact, every object made in a traditional African culture has a use, whether it is to ladle soup from a pot or to honour ancestors in a dance.

That there is no division between art and craft is a significant, consistent difference between traditional and Western cultures. When old materials disappear and new ones are introduced, people are forced to find new techniques to work with the new materials. What is the 'appropriate' material for traditional objects? Trying to draw such a line means picking a date and declaring that nothing after that moment is genuine. In fact, every tradition is genuine for its time and place, as long as it is acceptable to those who make and use the objects.

Those who introduce objects into a culture are often the first to wince in dismay when the people pick up those objects and incorporate them into their jewellery and other objects of adornment; camera flashbulbs and film canisters are widely used and discarded by tourists, but among the Maasai and Samburu of East Africa, for example, such items are incorporated into jewellery. Film canisters have been used in place of an earplug in a Maasai man's extended earlobe. Flashbulbs are strung on necklaces along with traditional beads. Some people are disturbed because this is the 'wrong' use for these materials. Not only is beauty in the eye of the beholder, so too is appropriateness. The difference between the two views of the same object seems to lie in whether you are in a 'consume and discard' mode or a 'nothing goes to waste' culture. In this sense, Africans may be the ultimate recyclers.

Having said this, the fact remains that tourism has a wider impact on material culture. When Africans first began to sell their handwork to outsiders, the exchange itself was the beginning of profound change. Although outsiders, tourists or explorers, temporary or permanent, may profess to want the authentic object, often what they really want is a convenient, travel-size version of that authenticity. But authenticity often

The face of this Xhosa woman of South Africa is coated with a traditional skin lotion made from the bark of indigenous trees or local white clay.

13

comes with a price: the ochre that stains your city clothes, leather bags imbued with the distinctive smell of the animal skin that was used to make them. The makers of the objects may also be unwilling to part with truly authentic items that may be used in a ceremony or ritual. What harm is there in making something similar, a replica of the original? The buyer is happy with something 'African' and the seller is happy to earn money.

Ironically, what is lost in this transaction is the very authenticity that attracted the buyer in the first place. Is the buyer likely to feel that loss, or will he or she be just as happy with a brightly painted mask that has no particular cultural connection other than the person who made it? Price is the deciding consideration; for those who value the authenticity of the original, culturally connected piece, the price is worth paying. What role does the 'inauthentic' object play in the culture that created it? Can it be viewed as authentic merely because it has been made by the same person who makes something culturally authentic? When Zulu women and girls begin to wear the beadwork they make for sale – beadwork that does not carry connotations of status – the impact of tourism becomes profound. It makes the study of material culture ever more urgent, if only to separate the authentic from the rest.

African cultures exist on many planes. They are associated with a piece of land, a region, a specific place. They are also part of political entities, countries that were defined by Europeans. The lines drawn in the sand, or on inaccurate, vague and often fantastic maps of Africa, by colonial bureaucrats, were notorious for dividing African peoples by means of artificial barriers, many of which were to become the borders of independent states. At the time most of these borders were defined, at the Berlin Conference of 1885–1886, much of Africa was unknown to Europeans. One infamous British cartographer simply printed the letters MMBA – 'Miles and Miles of Bloody Africa'.

In Niger, a wall painting adopts imagery from other cultures, including the geometric patterns characteristic of the Kuba people of the Democratic Republic of Congo.

But of course those vast stretches of land were rich in cultures that had strict mores and rituals, ceremonies and objects that were replete with meaning. It would be arrogant for an outsider to assume that if a meaning is not readily apparent then it does not exist. Because much of Africa's material culture is an expression of a specific society, it is almost inevitable that its meanings will be hidden.

In the years following colonization, the peoples within those European political borders did indeed begin to think of themselves as members of distinct nations, but not the kinds of nations designed by the Europeans. No matter how 'European' their manners and languages became, the black peoples of Africa wanted most of all to direct their own destinies. To do this, they had to be free of their colonizers.

The move toward political independence began in 1957 when the territory known as Gold Coast achieved independence from Britain, taking the name of Ghana. Within 25 years, all but a few colonies had made their way to independence, sometimes through negotiation, sometimes through protracted war. A few colonial powers clung to power: bitter wars were fought in the former Portuguese colonies of Mozambique and Angola. In the former Rhodesia, the breakaway white minority government held on until 1980. When the colony gained its independence, it took the name of Zimbabwe, in tribute to the great culture that had flourished centuries earlier.

The peoples of South Africa walked their own long and unique path to independence, achieving their goal in 1994 when the first democratic elections were held. The vast South African landscape is home to a multitude of diverse ethnic groups. While much of the emphasis on rights has centred on the nation's language groups, some of the material cultures were battered nearly to extinction under apartheid. Today, those same cultures have become compelling attractions for visitors.

This discussion of African material culture has been organized by materials, rather than by cultures. This allows the reader to look at the variety of ways in which, using the same materials, different peoples have created diverse expressions and interpretations of their beliefs and mythologies. One of the most compelling examples described is the use of tiny glass beads, which have long been imported from Europe yet are considered absolutely essential to the rituals and lives of many African peoples.

African Elegance is a survey of material culture in Africa, and, of necessity, a selective survey. In covering such a vast field, with so many riches, choices must be made all along the way. The cultures portrayed in these pages differ in many ways but are united by one common thread: the people who make and use these objects are following traditions that have their roots in Africa. This may seem obvious in a book with the word 'African' in the title until one considers the alternative: those cultures with roots in Islam. A line drawn across Africa, roughly through the southern margins of the Sahara, separates these two very different, and often overlapping aesthetics.

Islam has had a profound impact on Africa, different in many ways from other parts of the world, but nevertheless significant. Islamic prohibitions regarding choices of decoration have changed the very face of Africa's material culture. Many of the designs that define African culture are no longer allowed under modern interpretations of Islamic law.

African and Islamic – these are two very different aesthetic sensibilities. For that reason, this book confines itself to a look at the cultures found mainly in sub-Saharan Africa. Collectors of African objects believe that, as more cultures adopt and adhere to the laws of Islam, the look of the objects they make and use will change. This seems inevitable, for change has been a constant feature in Africa's cultural life. In order to present a book with artistic coherence, the line drawn in the sand is that separating Islamic and 'black' African cultures. This is a look at African material culture at this moment in history.

OPPOSITE: *A Murse woman of the Omo River region of southern Ethiopia is ornamented with a clay lip disc.*

FOLLOWING PAGES: *Samburu girls are distinguished by masses of single strands of tiny glass beads. Their beaded head ornaments include aluminium 'birds' that flash in the sunlight.*

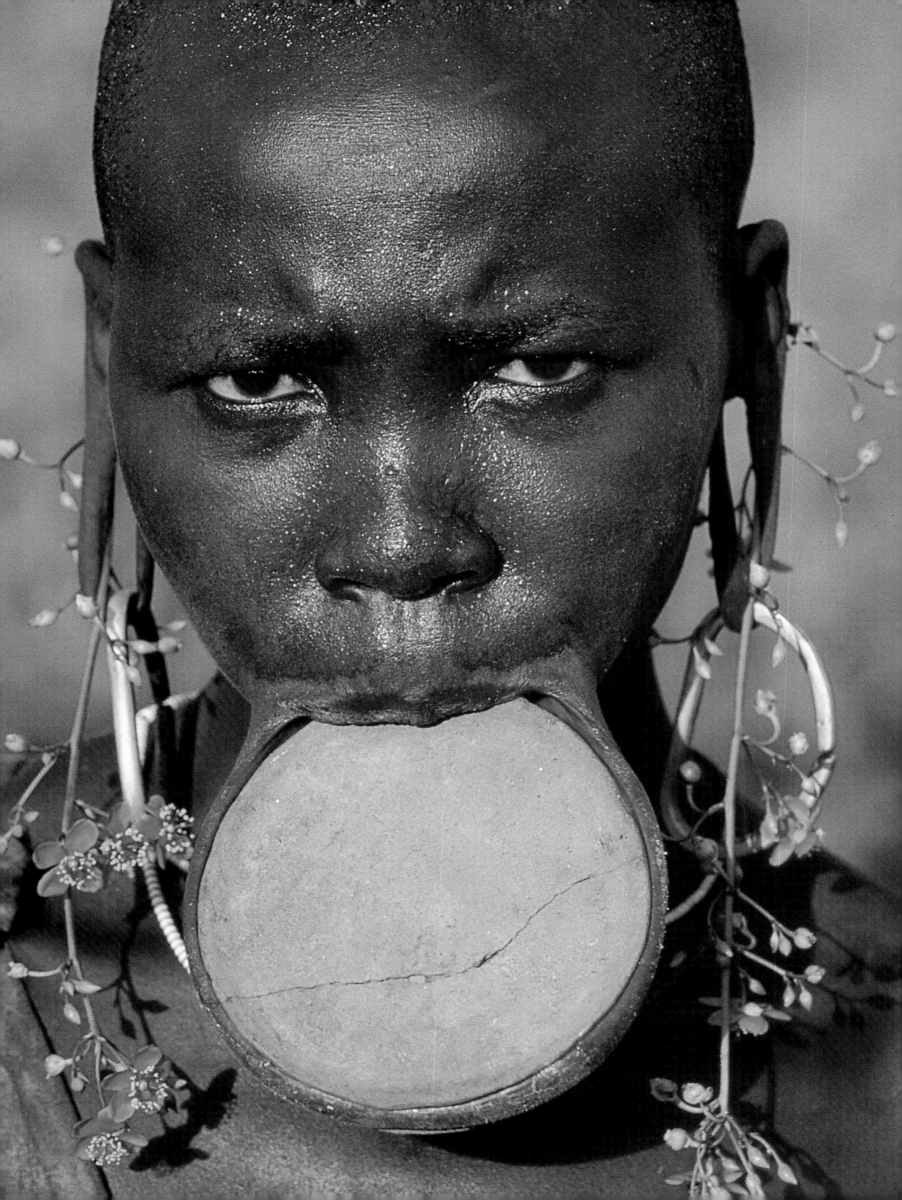

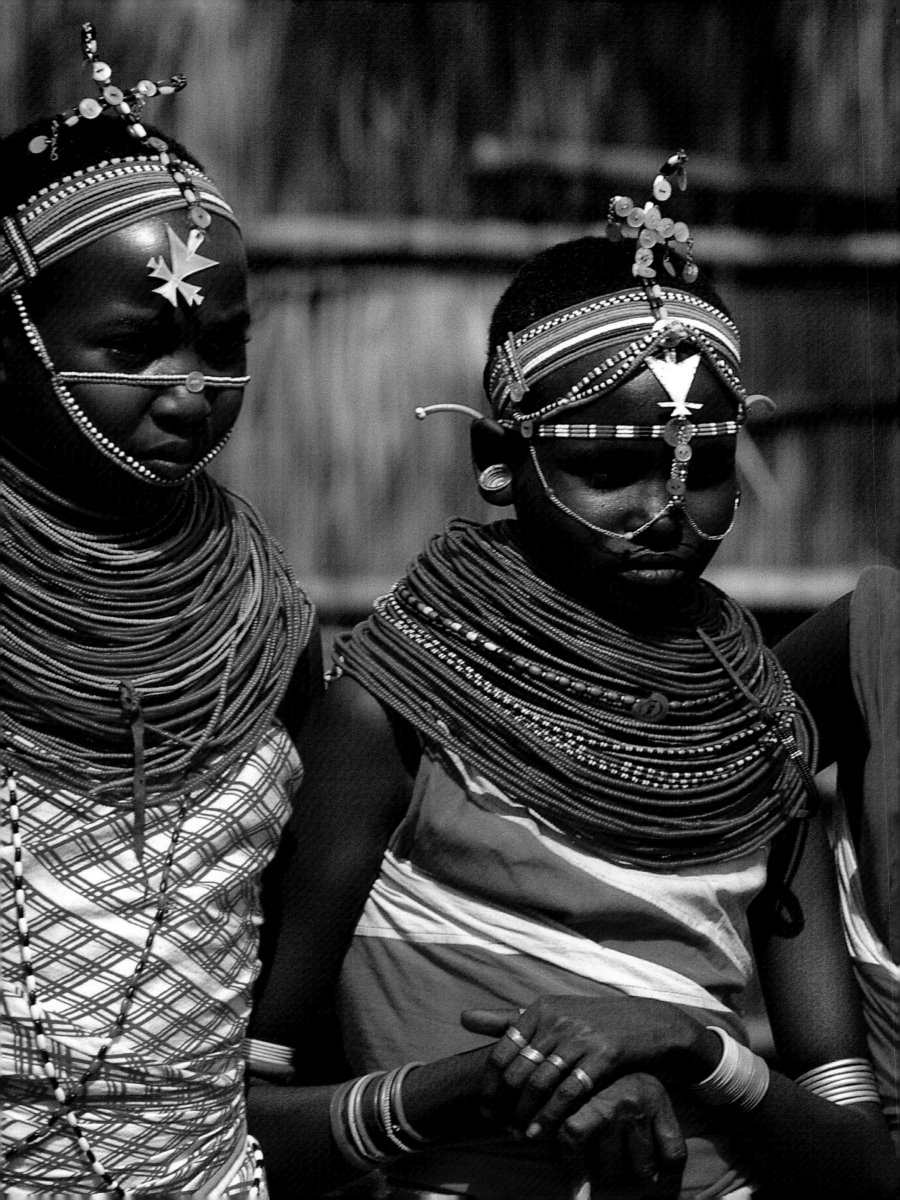

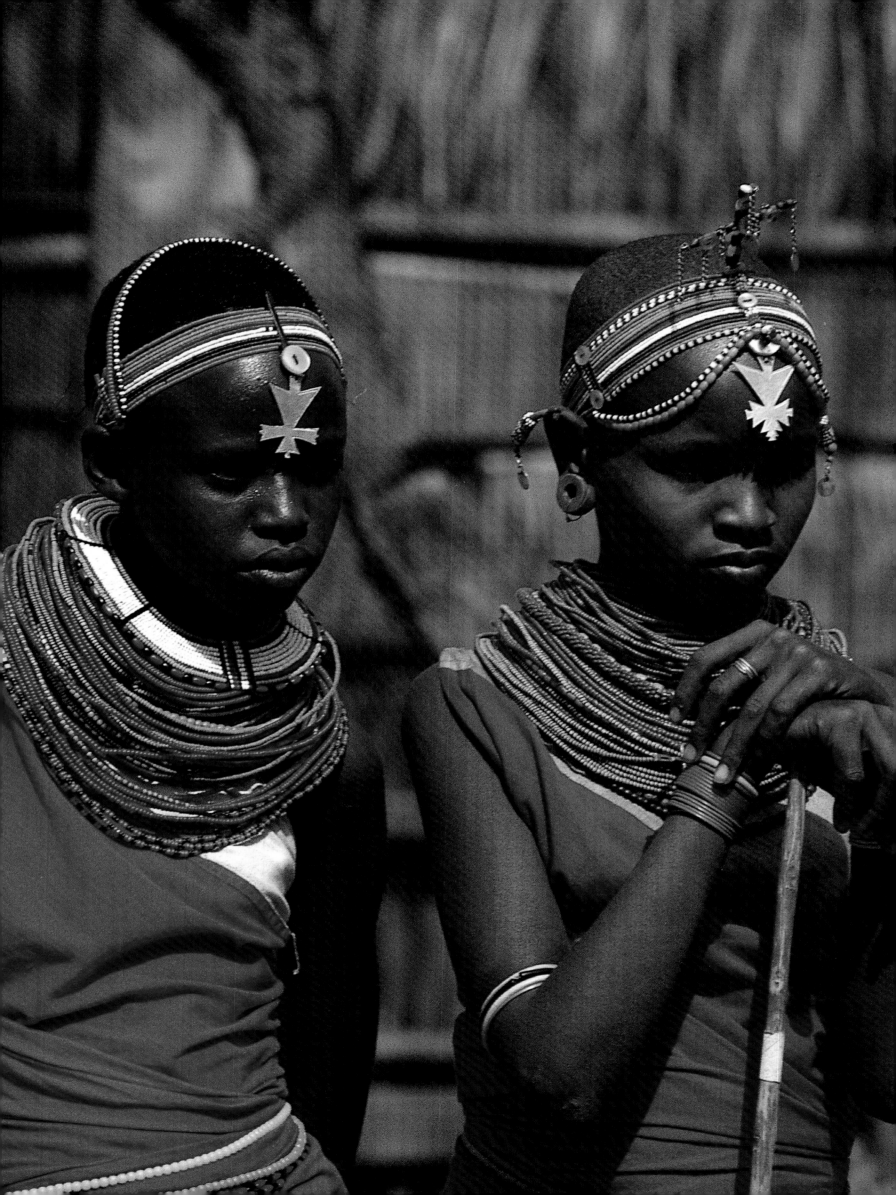

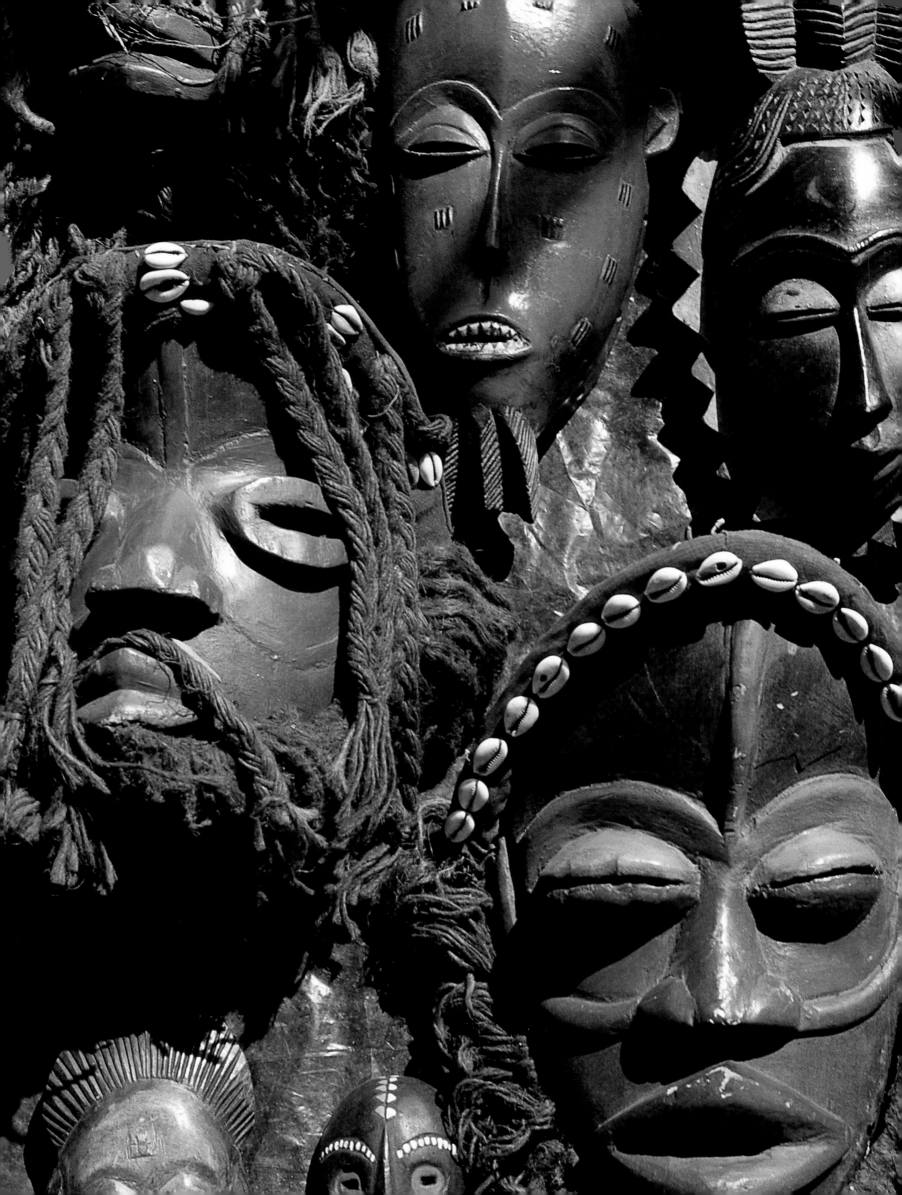

WOOD

Wooden objects, no matter how exquisitely carved, no matter how significant they are to a culture, are ephemeral and destined to decay. All wood starts to lose its natural moisture once it is cut; in humid climates, insects and mildew eat away at wooden objects. It is, however, the nature of cultures to use the materials at hand, and, in areas with significant forest reserves, wood is the material of choice both for household objects as well as for ritual and ceremonial articles. Indeed, the versatility of wood, combined with the creativity and ingenuity of African peoples, has lent itself to a range of objects that is probably greater than those formed from any other material, ranging from simple bowls and spoons to the masks and fertility figures that define and celebrate a culture.

Although intended for sale to tourists, these carved masks, made in the style of the Goro and Dan peoples of the Ivory Coast, display the originality and skill of African wood carvers.

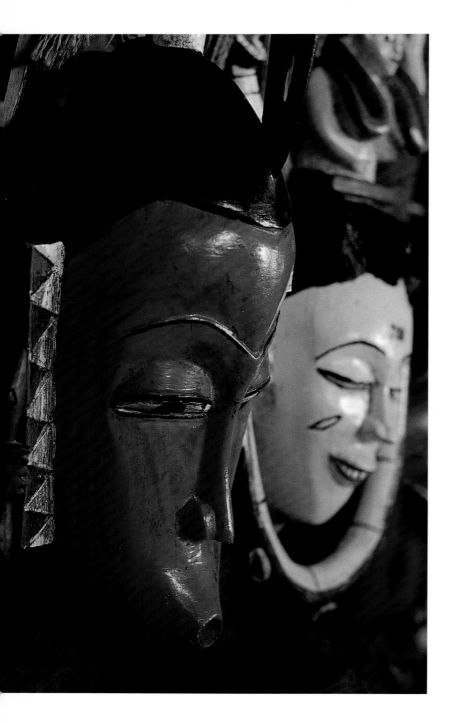

MASKS

When used to make household objects and the houses themselves, wood is simply a building block. But, when it is used to make masks, it becomes imbued with tremendous power. Elaborate and complex beliefs surround masks and their use in rituals, and the wood used for certain masks is so powerful that it may be touched only by a chosen few – those who wear the masks and the elders of the culture. Virtually everything associated with the making of masks has a corresponding ritual. One culture may forbid the use of a particular tree because its wood is thought to possess harmful qualities which would become part of anything made from it, sapping the power from the image carved. Other types of wood, on the other hand, are highly prized because they are thought to have their own inherent power, which would become part of the mask.

A sculptor of masks is not merely carving an object, he is perpetuating the beliefs of his people. During the course of his work, the unfinished piece must be kept out of sight, or some of its power could be taken. Once the carving is complete, the mask is usually treated with a vegetable oil to prevent the wood from cracking, but time takes its toll on virtually all wooden objects. The mask takes on a life of its own as it is decorated, either with paint or with such materials as hair, real teeth, shells, fibres, mirrors, beads or cloth. These objects not only add to the appearance of the mask, but they are believed to be part of its actual power.

African masks and statues are frequently dubbed 'abstract', based on a Western concept of paring away, of getting down to the essentials. The sculptor or carver, however, emphasizes those features that are important in the context in which the object is used: women's breasts and buttocks are often exaggerated to indicate fertility, the most important quality a woman possesses within her culture; heads are large because they are the seat of sense and thought. The aesthetic impact of these choices is the *result* of their symbolic importance, not the primary reason for them.

Masks are inseparable from the ceremonies for which they are created. They are often made in secret, out of the sight of women, who are particularly forbidden to see them. In many societies women are viewed with both fear and awe: women are at the very essence of a culture's continuity, and life springs from them. For this reason, women loom large in African figurative work, but it is that very quality which makes them a threat to the mask's power.

ABOVE: *These brightly painted masks draw their inspiration from traditional pieces made in the Ivory Coast.*

OPPOSITE: *Hair, feathers, raffia and paint add to the power of masks and dancing costumes, as shown by this striking dancer from the Ivory Coast.*

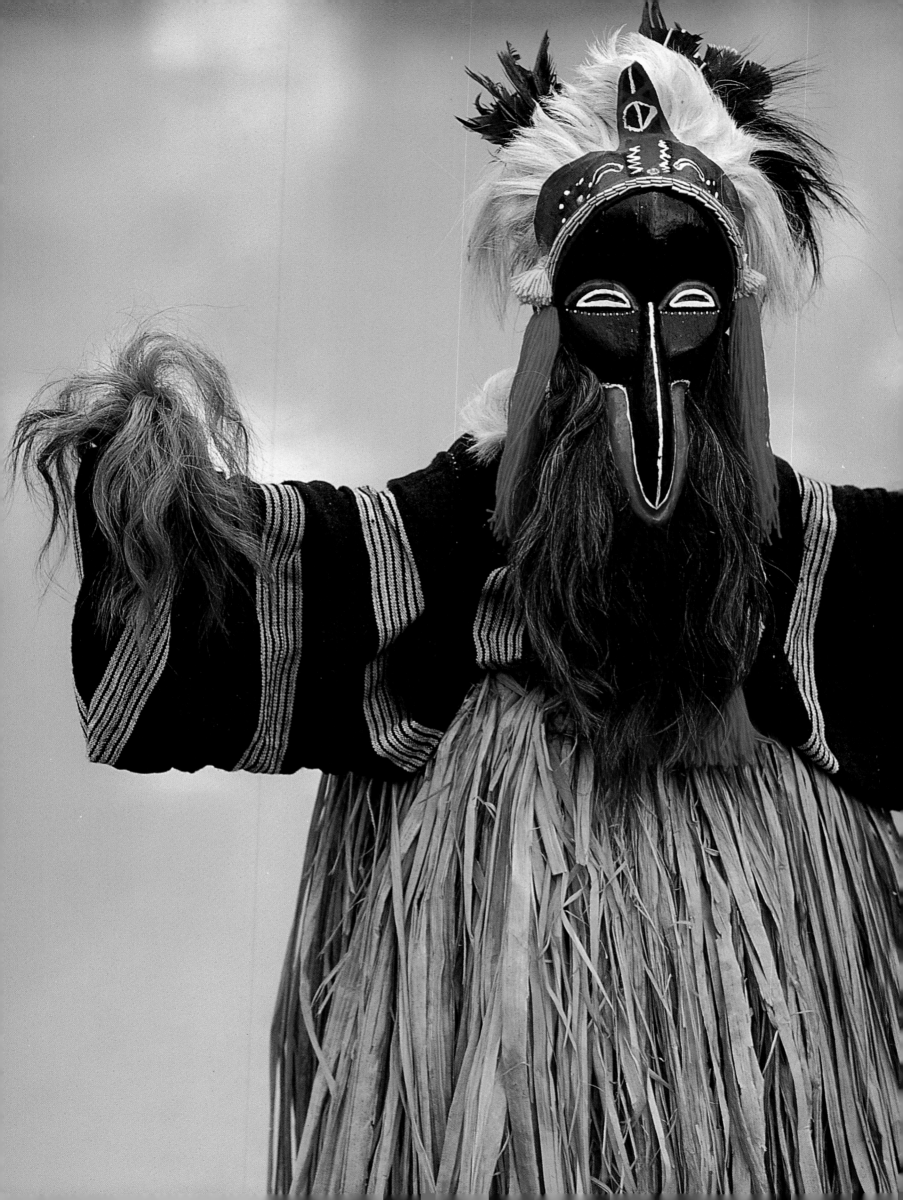

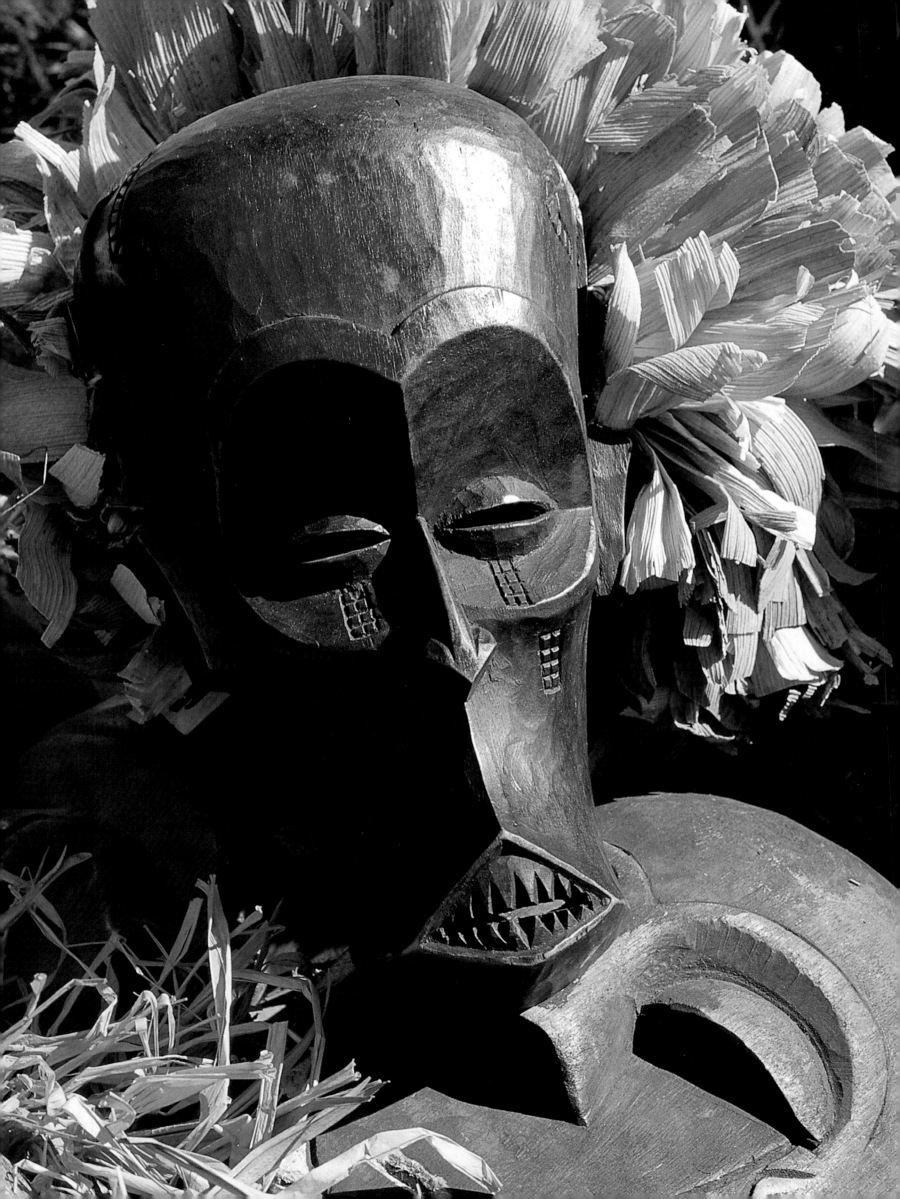

To the members of a society, the power of the mask is quite real, even though not all the people understand its specific meaning. Part of the power of masks stems from their secrecy, and that secrecy extends to limiting the number of people who understand the symbols and shapes used in their construction.

As part of a society's educational system, masks help the elders to pass on cultural beliefs to the young. Through masks, a culture can express its view of the world, its cosmology or religion. For many cultures, no distinction is made between religion and the rest of life; masks enable the people to deal with the unseen forces at work in their world.

When masks are not being used, many societies hide them from casual observation because they contain so much power. The person who wears a mask is submerged within it and assumes its power; he becomes the essence of the mask. For people outside the culture, this power and energy is largely lost. But masks, like other examples of African material culture, give aesthetic pleasure to outsiders, quite apart from their original intent and use.

The variety of facial styles on masks produced throughout Africa is a virtual history of art. Some faces are recognizably human while others are clearly based on animals. Some conform closely to the structure of a human face, others are stylized and emphasize a particular feature. The eyes may be mere slits or dominate the entire piece. In some the eyes are tiny dots while the nose is elongated to cover more than half the length of the face. Emphasis on elements considered powerful vary from one culture to another. Some of these qualities are determined by the mask's intended use: will it be used in a circumcision or other initiation ceremony, for a harvest festival or a funeral ritual?

DOGON

A handful of peoples have come to be regarded as icons of Africa. The Dogon of Mali are among this group. The wooden masks made by the Dogon represent some of the most compelling ritual objects produced by African cultures.

Several hundred years ago, the Dogon migrated into the desolate region of Mali which they now inhabit, escaping from the growing demands of the powerful kingdoms that flourished around Timbuktu, just north of the River Niger. Pressed to pay taxes and homage to other peoples, they chose instead to retreat to the area around the Bandiagara Cliffs, where the Dogon still scratch crops out of the arid soil. The cliffs are not sheer rises but are instead broken up with numerous openings, caves and crevices. The Dogon dead are interred in these caves, well away from the attentions of predators. The people's retreat is complete both in the large scale and the small: the whole group is secreted away, as are their objects. Their isolation served the Dogon well and has helped them to keep their traditions intact over the passing centuries.

OPPOSITE: *These masks do not represent one single ethnic group, but instead draw upon elements from Angolan and Congolese cultures.*

25

BELOW: *A rare mask made in female form, and worn by a woman, is used for a female initiation ceremony in Sierra Leone.*

RIGHT: *The elaborate wooden masks of the Dogon people of Mali are worn only by men, who represent male and female ancestors. The power of the masks is fiercely protected.*

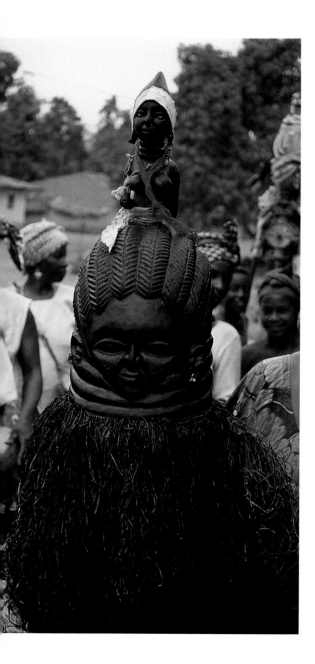

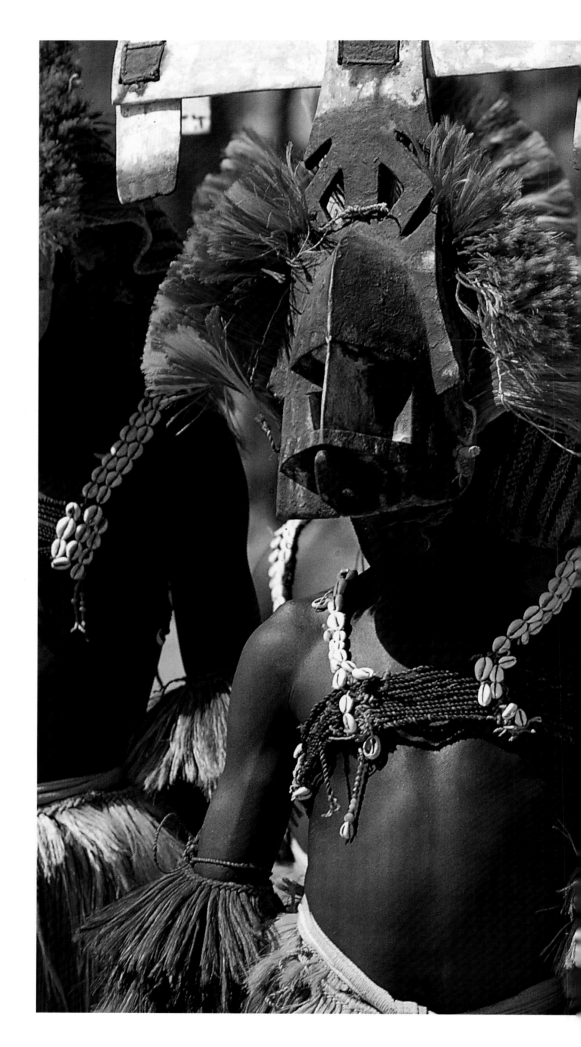

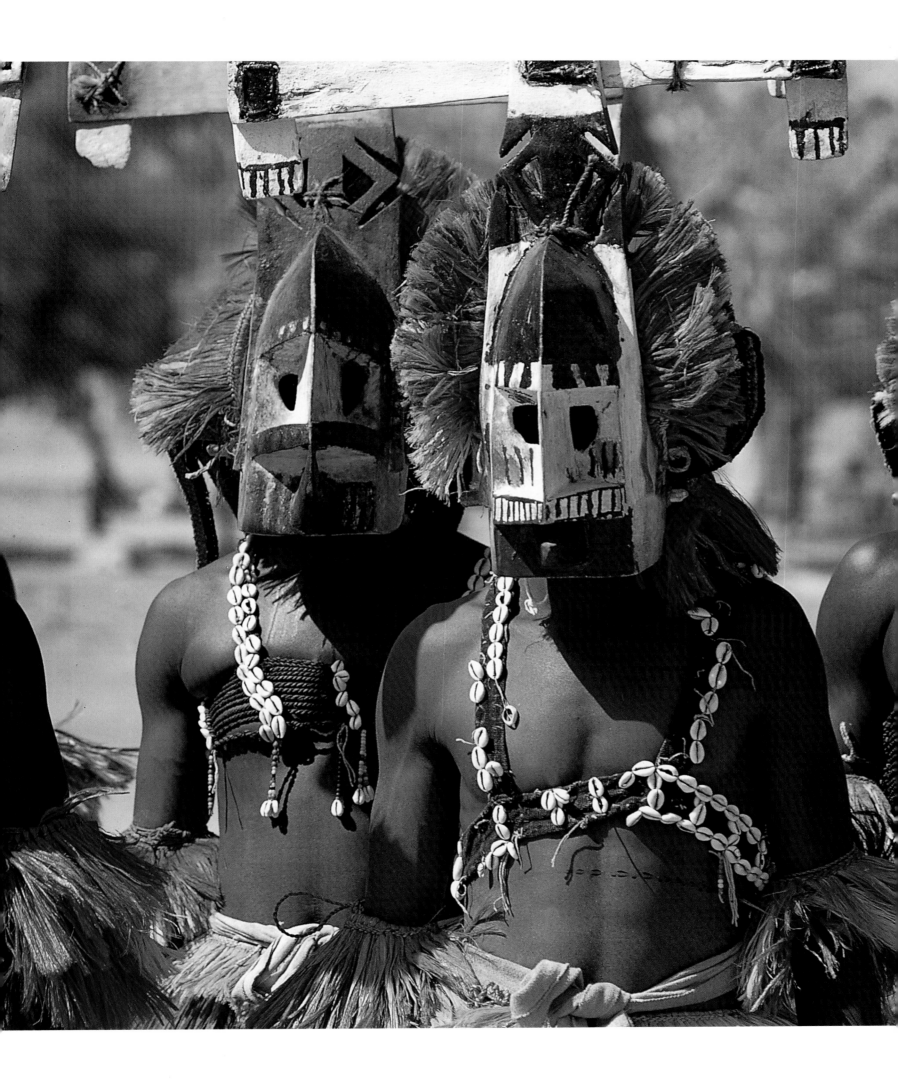

The wooden masks of the Dogon are the property of the *awa* society, which governs Dogon life. The masks have a theatrical look: worn over the face and on the head, they are a major part of the Dogon dancer's costume, transforming the wearer into an awe-inspiring figure of mystery. This is one of the aims of the costume since the dancer is expressing the entire history of his people. Yellow and red dyed raffia is used to give 'hair' to the wooden masks and to make the dancer's skirt. Dogon dances, during which these masks are used, take place at funerals, one of the principle stages of Dogon ritual life.

The masks are made out of view of the people, and are hidden in the caves until needed for the ceremony. Because they are made of soft wood, they are vulnerable to the climate and to termites. When they can no longer be used, they are hidden away in caves and left to decay.

Dogon masks represent animals, figures from mythology or people from Dogon society, such as the blacksmith and the hunter. The masks are quite fantastically shaped structures, and the word 'sculptures' better describes them than 'masks'. Worn on the head, they rise high above the dancer, appearing to connect the heaven and earth. The face of the dancer is well hidden behind a stylized wooden face, pointed at the front, or with cut-out features where the nose, mouth and eyes would be. The tallest mask, the Sirige ('multi-storey house'), rises straight up, and features pierced-out shapes, which are then painted. The dramatic Kanaga mask has a superstructure topped by a specific motif often compared to the cross of Lorraine, two of its elements pointing up while the other two point downward. When the masks are 'danced' at a funeral, each mask has a special dance step relating to it. The faces of the masks are severe, with sunken cheeks, and combine human and animal elements, including antelopes, hyenas, buffaloes and serpents.

HEADRESTS AND STOOLS

The intimate relationship between utility and artistry is well exemplified by the and headrests and stools made in many regions of Africa. Headrests in particular reflect the lifestyle of the people who make and use them. Among nomadic peoples, such as the Karamojong of Uganda and the Turkana of Kenya, headrests are smaller, lighter in weight, and easily transported. Headrests are used to protect the elaborate coiffures created from the wearer's hair, which is coated with clay. The headrest allows the wearer to keep his hairdo intact and not touch the ground. Headrests may be carried, but equally often they are worn dangling from a leather wrist strap. Sometimes they double as stools. Among settled people, such as the Zulu of South Africa, headrests are heavier, wider and longer, since they can be stored away until needed. Although headrests are for personal use, they carry considerable importance in cultures in which the head is revered. A spiritual leader's head, in particular, must not be seen to touch the ground.

Headrests are carved from a single piece of wood, and each one is curved to fit the neck of the user. Shown here are headrests made by the Karamojong of Uganda (below) and the Turkana of northern Kenya (bottom).

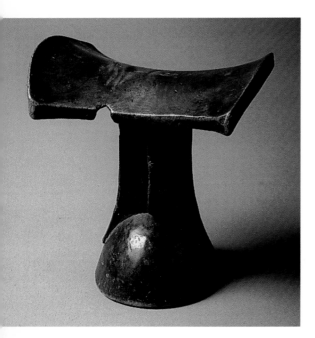

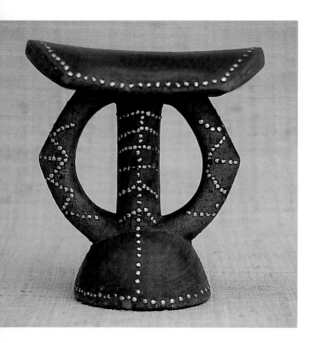

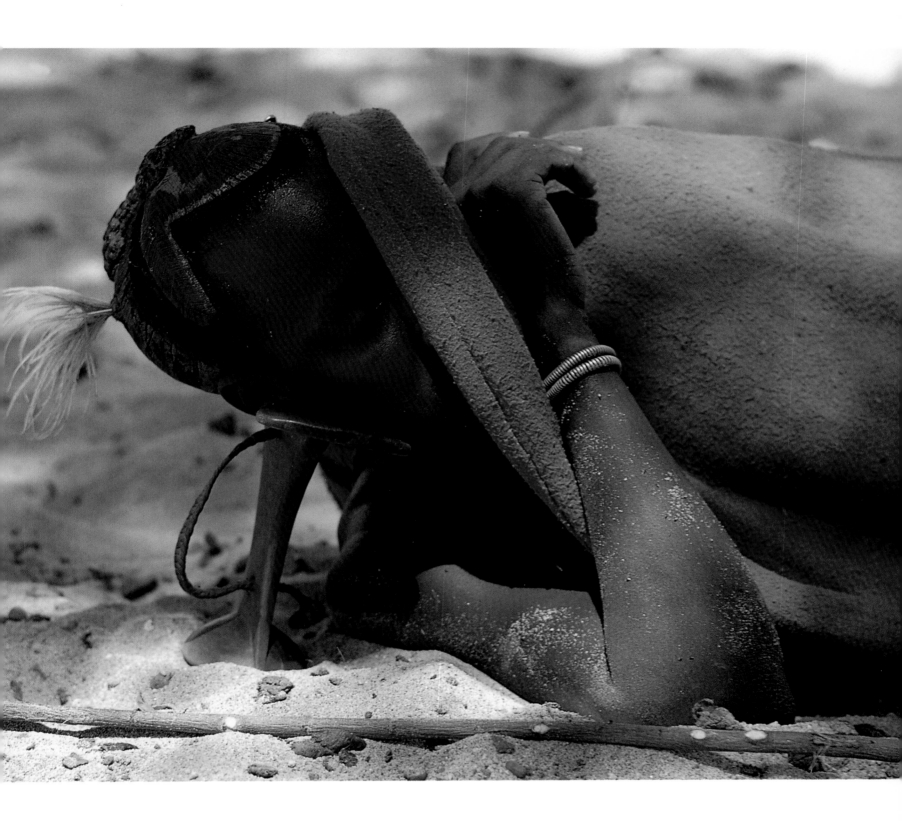

Stools, which are also personal items, are made for individuals and used only by them. It is not done simply to enter a home, pull up a stool and sit down, and an outsider with little knowledge of the high regard in which stools are held could easily give offence. Stools also reflect personal status and wealth. They may be intricately carved, often featuring animals that figure importantly in the culture's system of beliefs. Such symbolism is enormously important, whether or not the pieces have ritual functions. Intricate carving requires a highly skilled craftsperson and is restricted to the wealthier members of a society.

A Turkana man takes a nap using a wooden headrest to protect his elaborate hairdo from coming into contact with the sand.

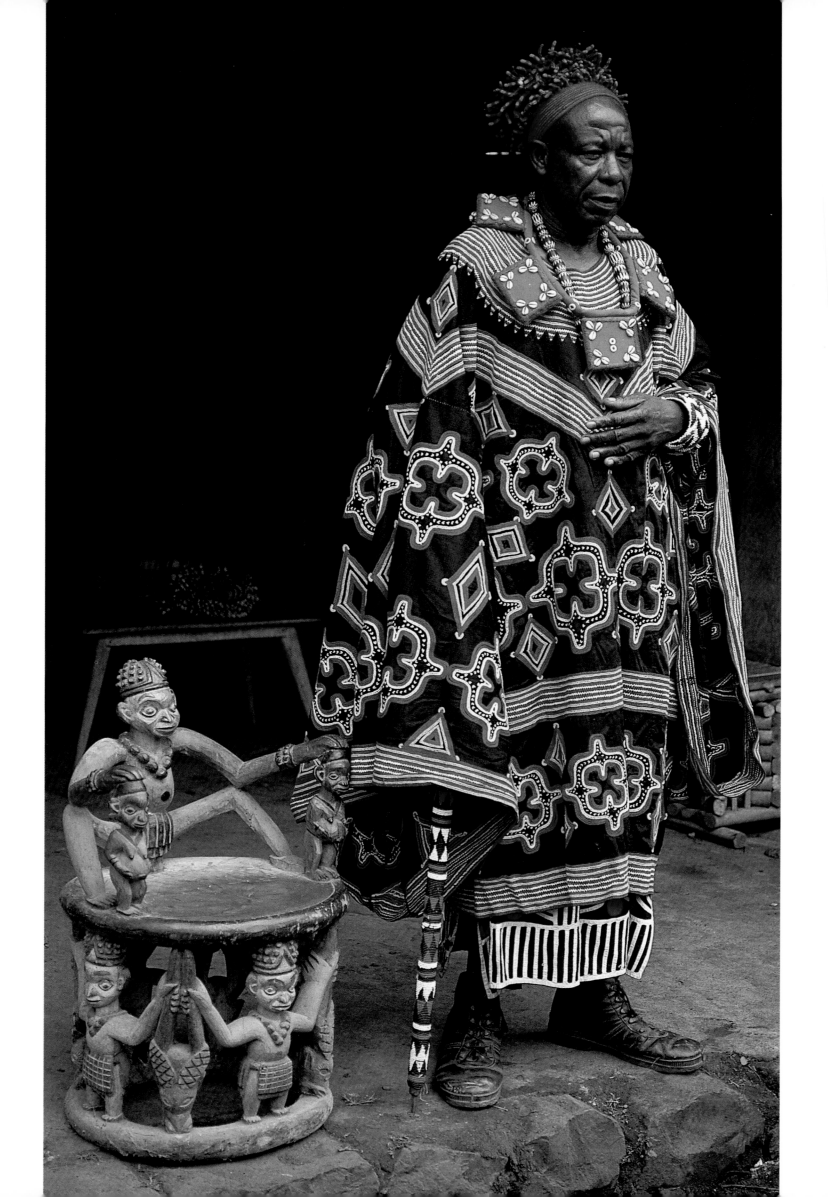

ASHANTI

Among many African peoples stools have prestige, but only among the Akan people, who include the Ashanti of West Africa, do they have ritual functions. The Ashanti live in Ghana, which takes its name from the ancient kingdom that flourished eight hundred kilometres (five hundred miles) to the north-west during the 10th and 11th centuries. This kingdom was at the centre of two major trade routes that brought an influx of traders, ideas and wealth to the region.

The Ashanti kingdom played a major role in the material culture of West Africa. Its fabrics, gold objects and entire ceremonial life were built on a tradition of well-educated leaders and a thriving business class. They were the descendants of an educated class that evolved to complement the vigorous trade along the Ghana coast, a process that started in the late 15th century when the Portuguese began to conduct their trade in gold and slaves. The Europeans turned to the local people to help them carry out this trade. These interactions and transactions strongly influenced the indigenous culture, and European styles, customs and attitudes became incorporated into the African ethos.

To the Ashanti people, a particular gold-covered wooden stool is at the core of their society. It was believed to have been given to their first king, Osei Tutu, when the Ashanti people gained recognition as a distinct ethnic group early in the 18th century. The stool was the repository of the people's power, a power held by the king during his reign. It was not a functional stool – not even the king was allowed to sit on it – but an object to treat with reverence. It was brought out only on rare occasions, assuring the people that the power was still there.

When the British became active in the region they called the Gold Coast (around 1850), they saw the strength of the African society as a threat. To assert their authority over the Ashanti, the British decided to seize the stool. In 1900, British governor Sir Frederick Hodgson demanded that the stool be brought to him so that he could sit on it. As a result, the Ashanti rose up in their final war against the British. Although the British were victorious, they destroyed any hope of a cordial relationship with the Ashanti.

The Ashanti belief in the power of the Golden Stool never diminished. In 1920, when thieves took the stool from its hiding place and stripped it of its gold, the Ashanti mourned as if for a person. This time the British understood the importance of the stool. Acting on behalf of the Ashanti, they imprisoned the thieves.

A stool conveys important information about its owner, even when it is not a ritual object. When a chief travelled, for example,

OPPOSITE: *Prince Titu Tacu of the Bali people of Cameroon stands beside an elaborate, carved stool. The figures that support the seat, as well as the unusual figure carved on it, are all made from a single piece of wood.*

BELOW: *A headman of the Njemps people, who live near Lake Nakuru in Kenya, uses his headrest as a stool.*

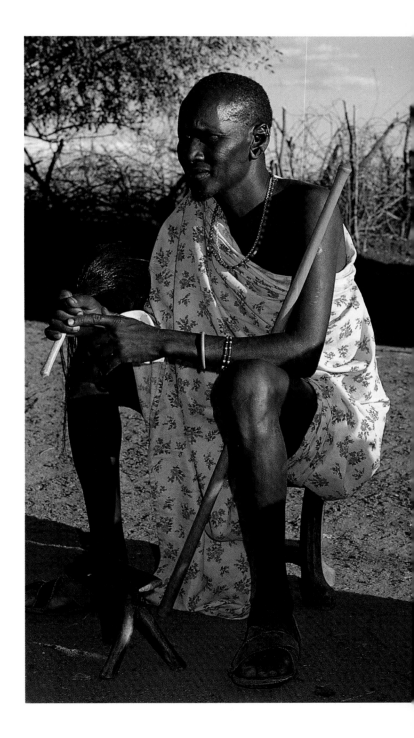

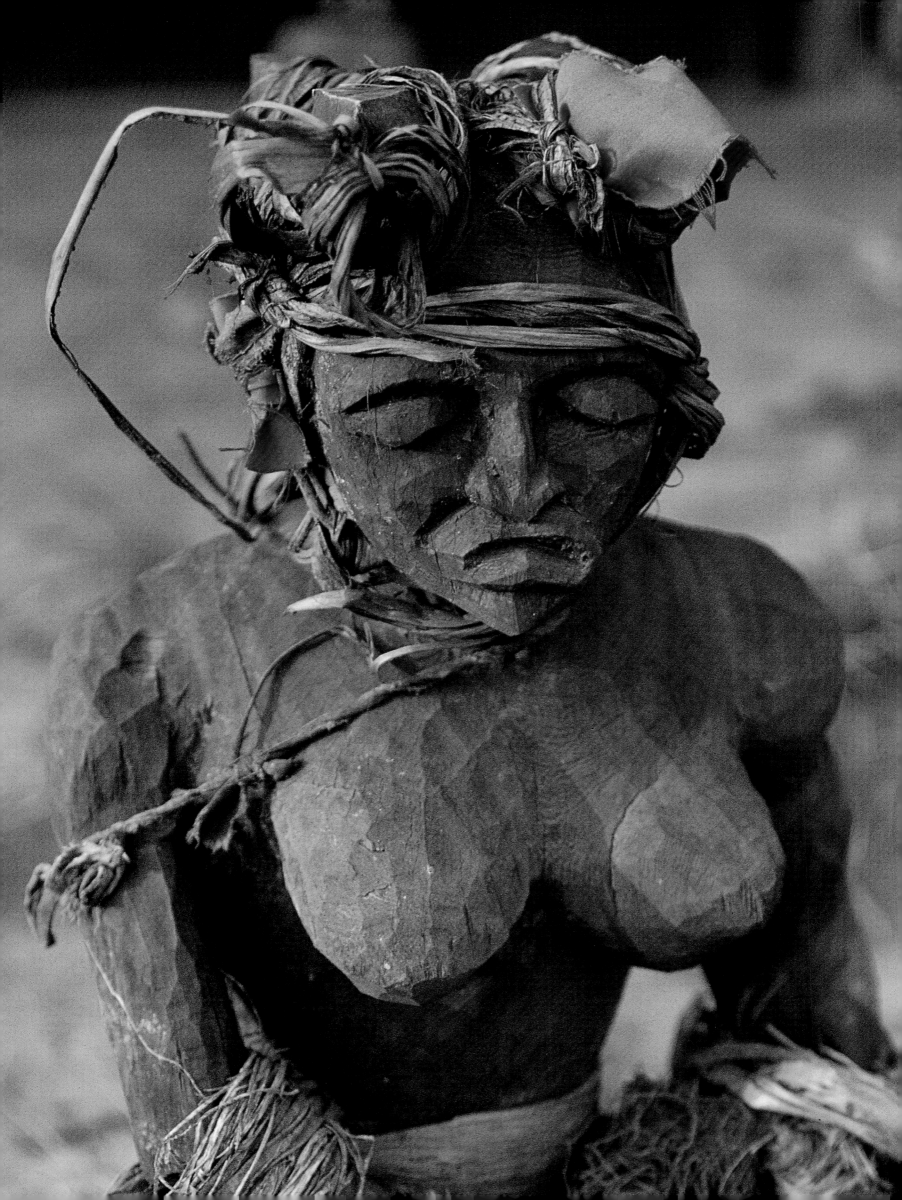

his servant carried his personal stool. This showed his position to everyone and avoided any possible loss of status. Stools made for women were generally lower than those for men, and usually less elaborately carved. However, stools were always carved out of a single piece of wood, making them very strong.

In Ashanti society, a new ceremonial stool was made for each leader when he achieved his position as *asantehene* (king). Ashanti stools feature a flat base, central structure and curved seat. African stools may have legs but the uprights often are formed by carved figures called caryatids – originally, the female figures that formed the pillars of ancient Greek temples. In African carving, the word 'caryatid' is used for any figure that supports an object. The seat of a stool can take many forms; it may be flat on top, or gently curved to form a comfortable support.

A seat that lifts the user off the ground carries symbolic importance in much of Africa, and the concept of a servant supporting a royal personage is often expressed in the carving of stools. Squatting servants, shortened into almost gnome-like shapes, hold up the seat itself. Human and animal figures are often carved into the backs of chairs to symbolize the power of the king or chief: putting these forms on such an important piece as a chair symbolically shows that the king rules over all the living creatures within his territory.

RITUAL OBJECTS

The vast Congo Basin region gave rise to rich and diverse cultures whose ritual objects express the very heart of Africa. The virtually impenetrable jungle of central Africa plays an important role in creating an environment where ancestral spirits can flourish. The lush vegetation virtually shuts out the sky, and the region provides an abundance of trees and other building materials.

For the Kongo people, who gave the countries of Congo (both Kinshasa and Brazzaville) their names, wooden objects play a major role in both real and mythic life. Fetishes, for example, are vital to the spiritual life and well-being of the Kongo. They can act in many different ways, according to the purpose intended when they were carved. Great variation in face and form indicates different purposes for the figures called *nkisi*. But the actual wooden carving is only the beginning, a base upon which are added the elements that give the figure its power; these usually include nails, which are pounded into the figure. Fetishes may be hung with smaller carved figures, chains, beads and vials that contain medicine, and a mirror is often implanted in the figure. The diviner who uses it will drive more nails or blades into the figure; as these increase in number, the fetish gains power. The piece may be nearly covered with objects, the original form almost lost from view.

Other wooden figures are used in initiation rites. Maternity figures of a detailed mother and child are made for fertility rituals. The woman's jewellery, her head cap and elements of her dress are carved so precisely it is easy to relate them

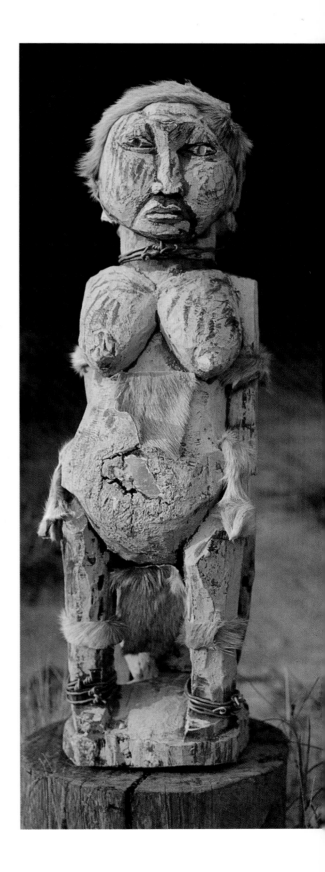

OPPOSITE AND BELOW: *Carved fetish fertility figures hold tremendous power for the people of the Congo Basin. Female forms are prevalent, reflecting the belief in the power of women who are able to bear children.*

RIGHT AND OPPOSITE: *These carved female figures display the artistry for which the Ovimbundu people of Angola are renowned. The figure opposite carries a small child carved from the same piece of wood. The X-shaped incisions on the cheeks of both figures connect them to the cycle of life and their ancestors.*

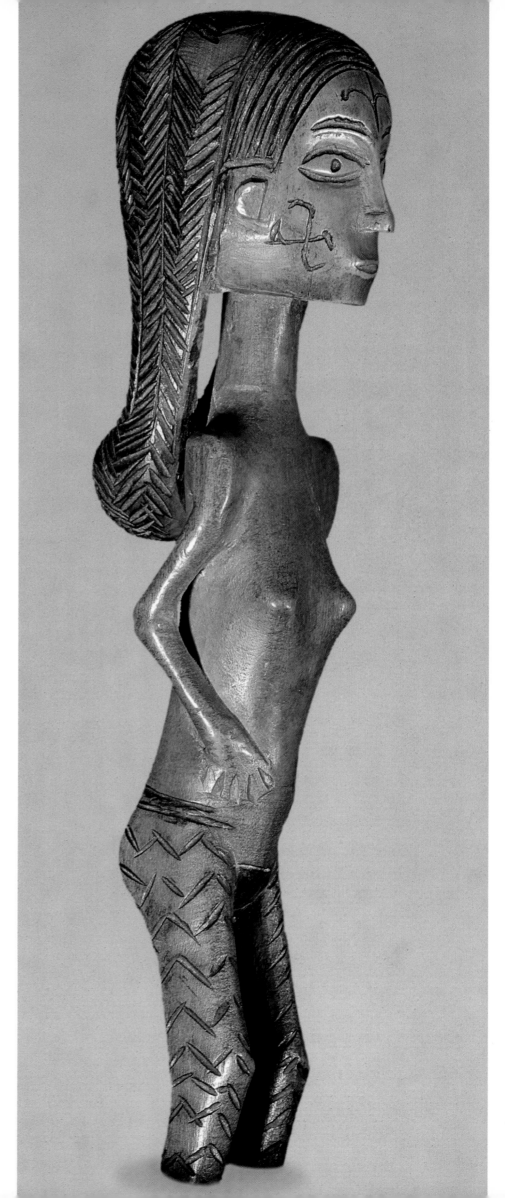

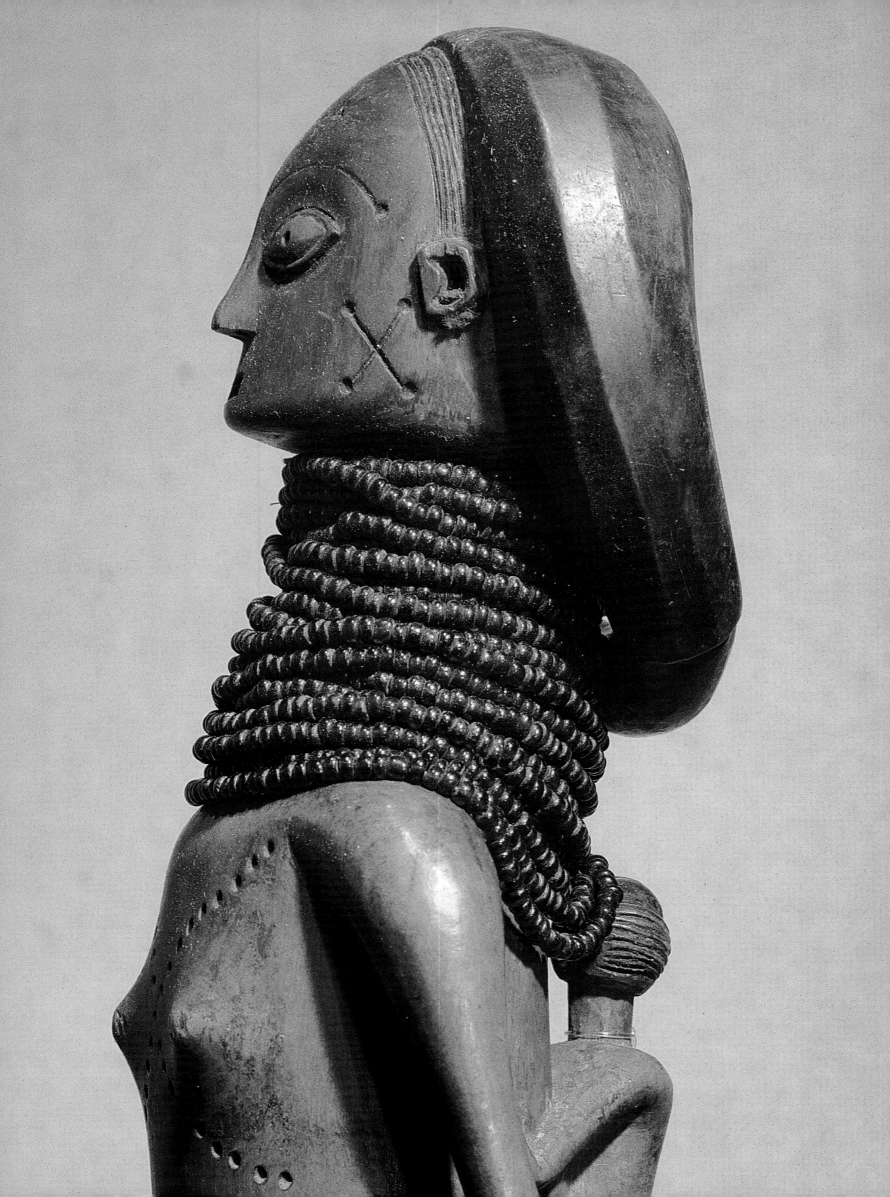

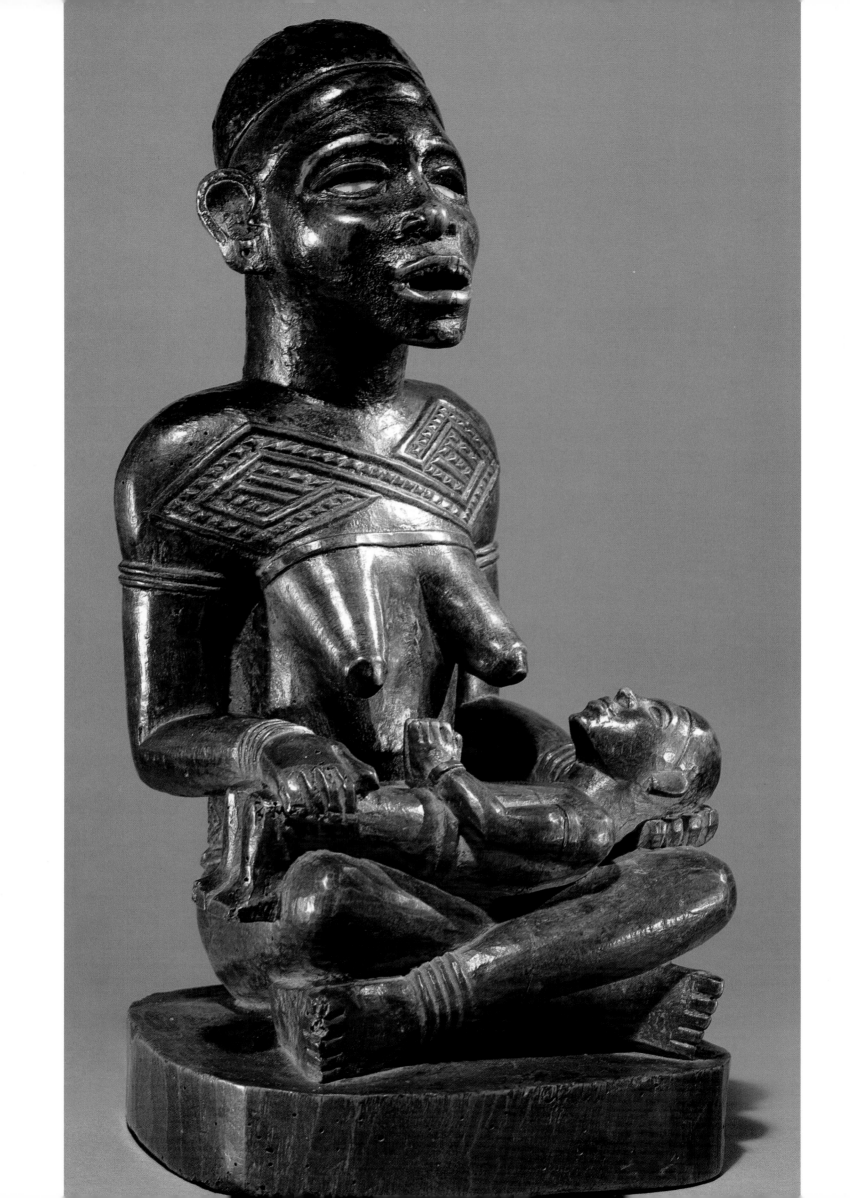

to their real-life counterparts. The child is not meant to represent a real child, but rather the child she wishes to have, a desire for fertility rather than a celebration of an actual child. Other figures celebrate and honour the ancestors. These seated or kneeling male and female forms are believed to hold the spirit of one's ancestor. In many cultures, the ancestors are considered to remain part of the family even after they have died, guiding the family in their decision-making.

YORUBA

Among the Yoruba of Nigeria, wooden figures are often based on twin images known as *ibeji*. The Yoruba have a singularly high incidence of twins, more than four times as high, proportionately, as that of other cultures. Twins seem to embody the very mystery of life because they offer duplicates of themselves, particularly in the case of identical twins. In many cultures, twins are feared because they challenge the idea of the uniqueness of human beings. For this reason, in some cultures, twins are killed at birth. This was true among the Yoruba until, according to myth, the thundergod, Shango, demanded that such births be honoured rather than shunned. This may be at the heart of the Yoruba high twin birth rate. If the women bearing twins are better fed and cared for than other mothers, the genetic predisposition for twinning could be encouraged.

OPPOSITE: *A powerful carving from the Kongo kingdom of Central Africa shows a mother and her child. The scarification marks on her chest are beautifully carved, and the prominent breasts emphasize fertility.*

BELOW: *Yoruba* ibeji *(carved wooden twins) from Nigeria. The centre pair are outfitted in a shared beaded cloak.*

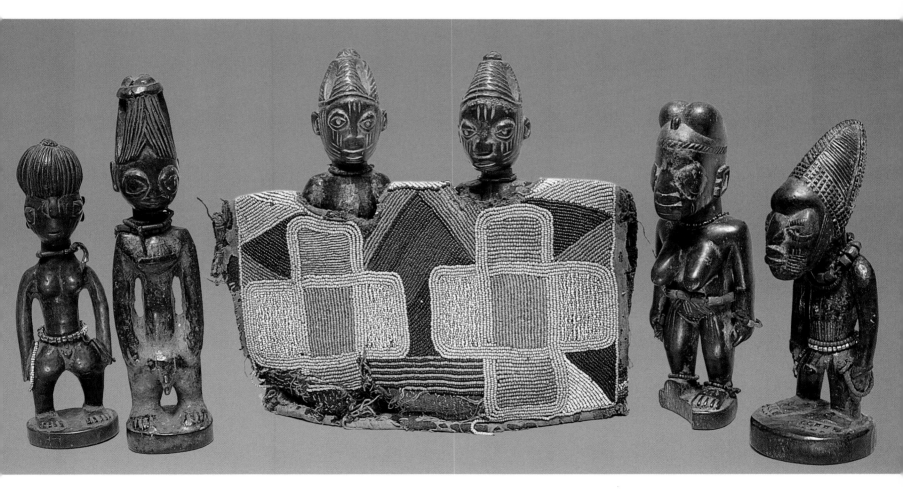

During the annual ceremonial journey to his wet-season home, the Litunga (ruler) of Zambia's Barotse people travels in a long wooden barge. The enclosed area reserved for the Litunga features a symbolic wooden elephant.

In Yoruba culture, if one of the twins dies, the mother must commission a figure to commemorate it. This figure, which is represented as an adult, whatever the age of the deceased child, becomes the container for the soul of this twin and a surrogate for the lost child. Some people believe that the surviving twin has a strong wish to rejoin the other because they share a soul. The twin figure is a memorial to the dead twin, a constant reminder that it has not been forgotten. It

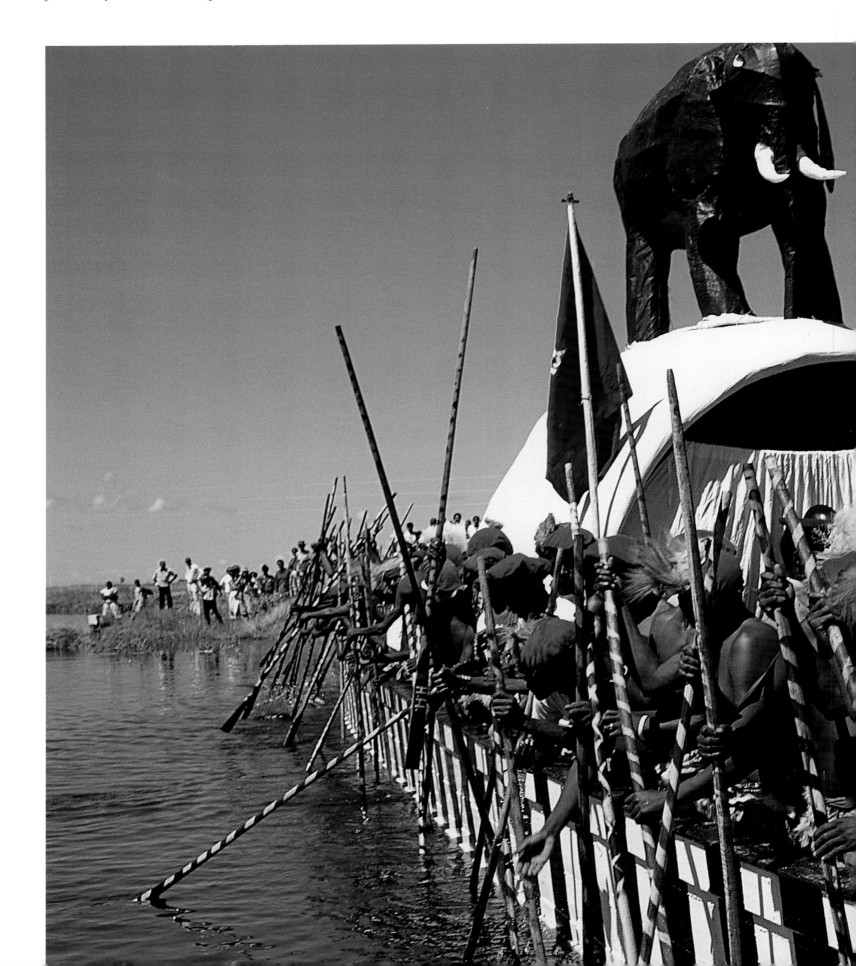

is also protective. Many of these figures are enhanced with blue beads that are believed to be sacred to the protector of children, and are often coated with a mixture made from the cola nut, which is considered a good omen. They are also dressed in cowrie shell or beaded jackets, the way dolls are dressed, and they are offered food regularly. In the case of dual deaths, or to ward off such an occurrence, the figures may be joined or stand side by side. The heads of the figures are

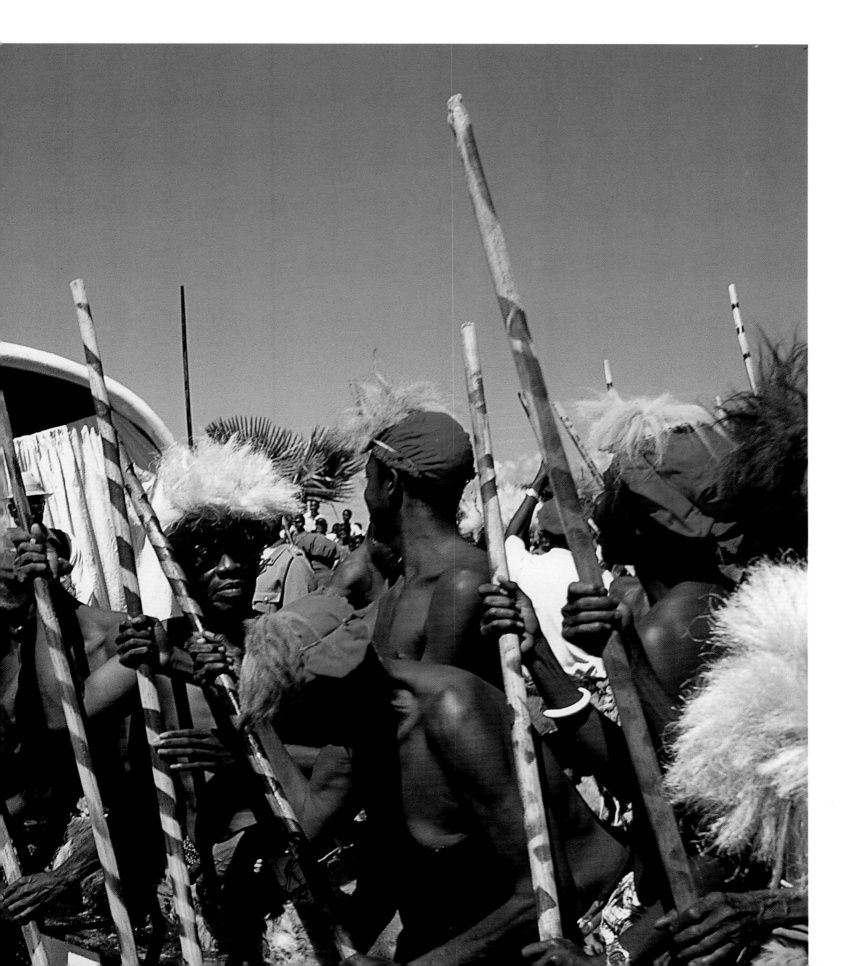

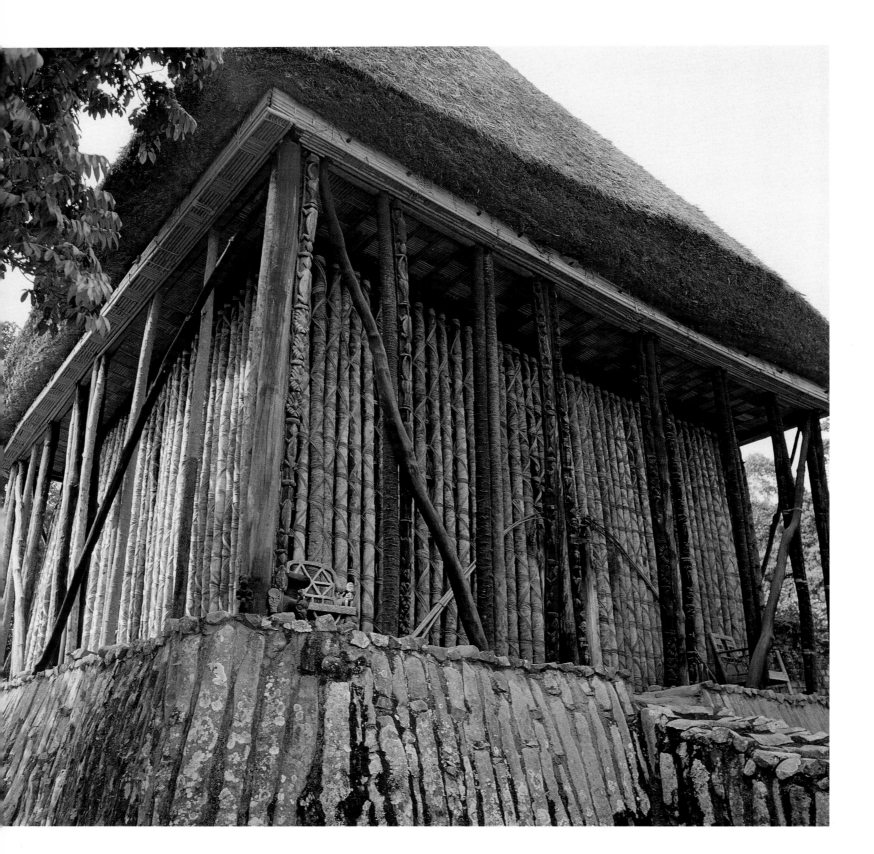

An ancient palace in Cameroon is made of hundreds of wooden staves placed vertically side by side. Inside, ribs tied up with palm fronds and plastered with clay support the structure.

disproportionately large, often occupying one third of the whole figure, because the Yoruba believe that the individual's destiny is contained within the head. *Ibeji* figures are not portraits as such, but symbols of human life. The sex of the child is included on the figure, as well as scarification marks, making the figures very individual to the touch. They are handled often and are oiled to keep the wood moist. This oil stains the wood until it darkens to the colour of the mother's own skin.

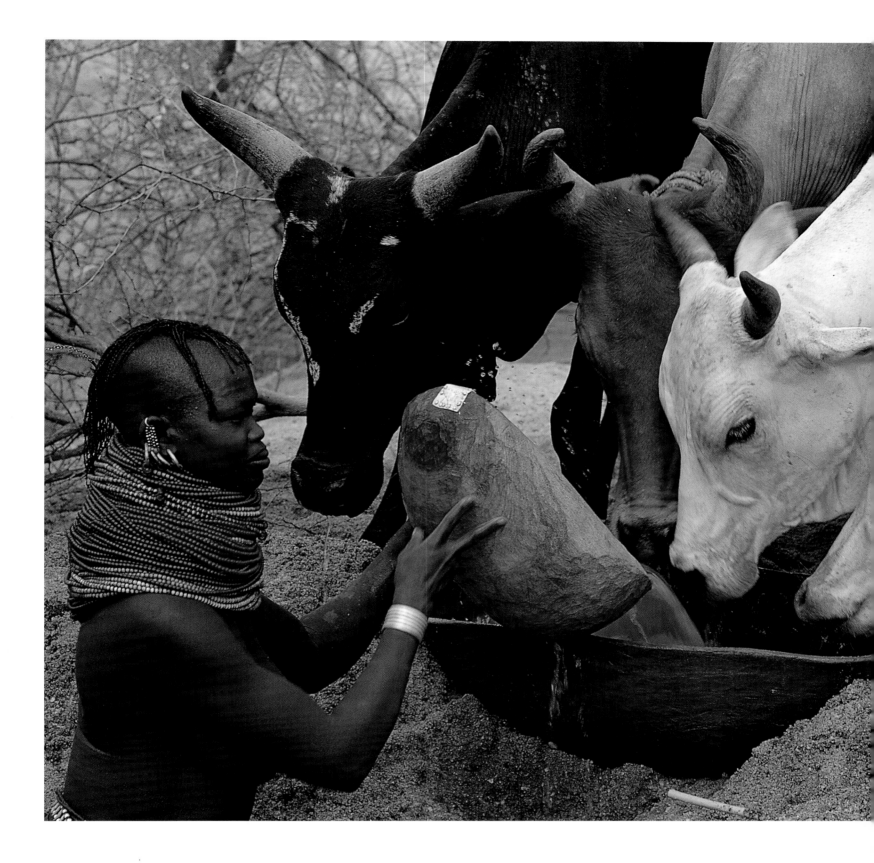

HOUSEHOLD OBJECTS

Although Kenya is located along Africa's lush Indian Ocean coast, large parts of the country are semi-desert and offer precious little in the way of natural resources. In the arid, northern reaches near the border with Sudan, the harsh environment dictates the few materials available for use as containers. The nomadic Turkana people, who live along the western shore of Lake Turkana, make their containers

In northern Kenya, a Turkana girl uses large, hollowed-out wooden bowls to water her family's cattle.

from wood, chipped out with a long metal spike from a solid piece of wood. These containers vary in size according to their purpose, but are made with a rounded bottom, just like the natural shape of the gourds used in the more fertile south. They create the long, slender neck from a separate piece of wood that is attached to the bottom with a strip of leather. The wood must be sealed and made watertight. The Turkana rub black soot and animal fat into the surface, a mixture that also helps protect the wood from insects. Ash rubbed into the interior of the wood has a sterilizing effect as well. In addition, Turkana living on the eastern side of Lake Turkana smear the containers with ochre, a practice they probably borrowed from their neighbours, the Samburu.

KAMBA

The Kamba people of Kenya live in the mountains east of Nairobi. Their heavily wooded region inspired them to become skilled at carving wood into bows, arrows and clubs, which were used both in hunting and in warfare. A warrior made his own weapons; the better his carving abilities, the better the hunter he could be. A well-crafted arrow that flies straight and true to its mark makes for a more successful hunter. This connection between craft and life was strong among the Kamba; outside sales were not needed to keep the craftspeople at their tasks. When the need diminishes, either because the lifestyle of the people has changed or commercially made goods become available to them, then the labour-intensive crafts such as carving may wither.

More than a century ago, in 1891, the British East African Company set up a trading post in Ukambani, the region where the Kamba lived, and encouraged local woodcarvers to produce items for sale to foreigners. Although the Kamba carved containers for their own use, they turned their hand to objects such as ornamental masks and carved animals, objects more suitable for sale. These objects, including the masks, had no relation to the Kamba traditions.

Matisya Munge, a Kamba carver from the village of Wamunyu, was drafted into the British army during the First World War. He was sent to Tanganyika (now Tanzania), where he saw the Zaramo carvers at work. He liked their style so much that he adopted it. When he returned home, he introduced a number of items such as salad servers, animals and human figures to his fellow carvers. None of these was based in Kamba culture but they appealed to the European buyers.

From the work started by this one man, Wamunyu grew into an important carving centre. Its workshops supplied dealers who then suggested new designs and types of items that were also not known in the Kamba culture. It was only when the Kamba carvers formed their own cooperative society in 1951 that they returned to traditional Kamba images and subjects for their designs. In Kenya, the Kamba are still known as the pre-eminent carvers of wood.

Among the household objects carved by the Turkana is the akarum *(above), which is used to hold milk and features a leather lid and straps. Turkana* elephit *(opposite, top), or wooden milk buckets, include large sizes used for milking and smaller containers for drinking. Beaded decoration is used sparingly. Animal fat, both for cooking and for cosmetic use, is stored in small* eburi *(opposite, bottom), which also feature leather lids and straps.*

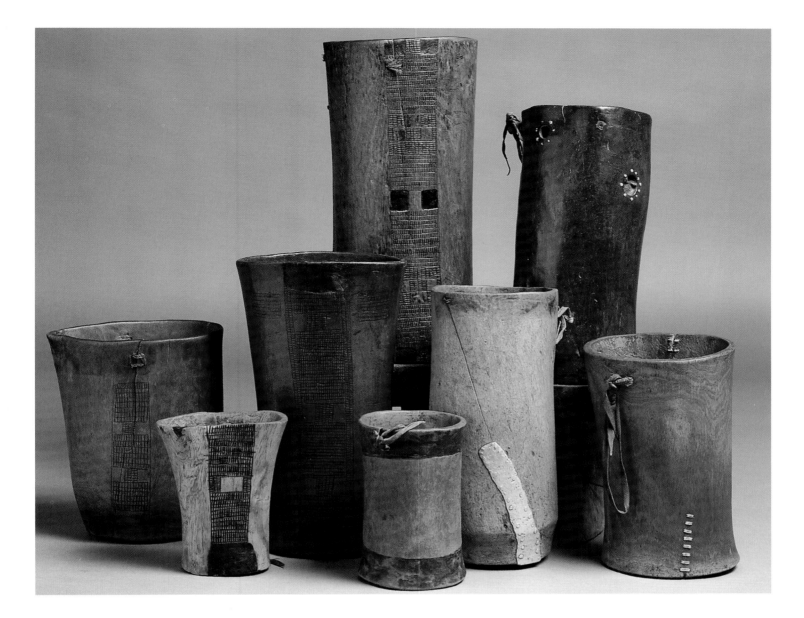

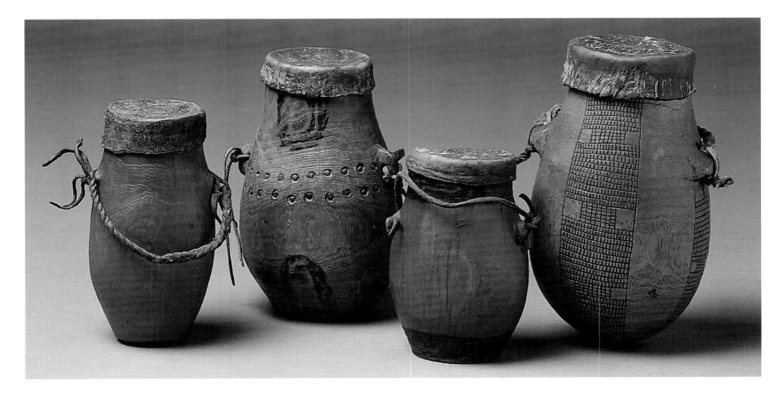

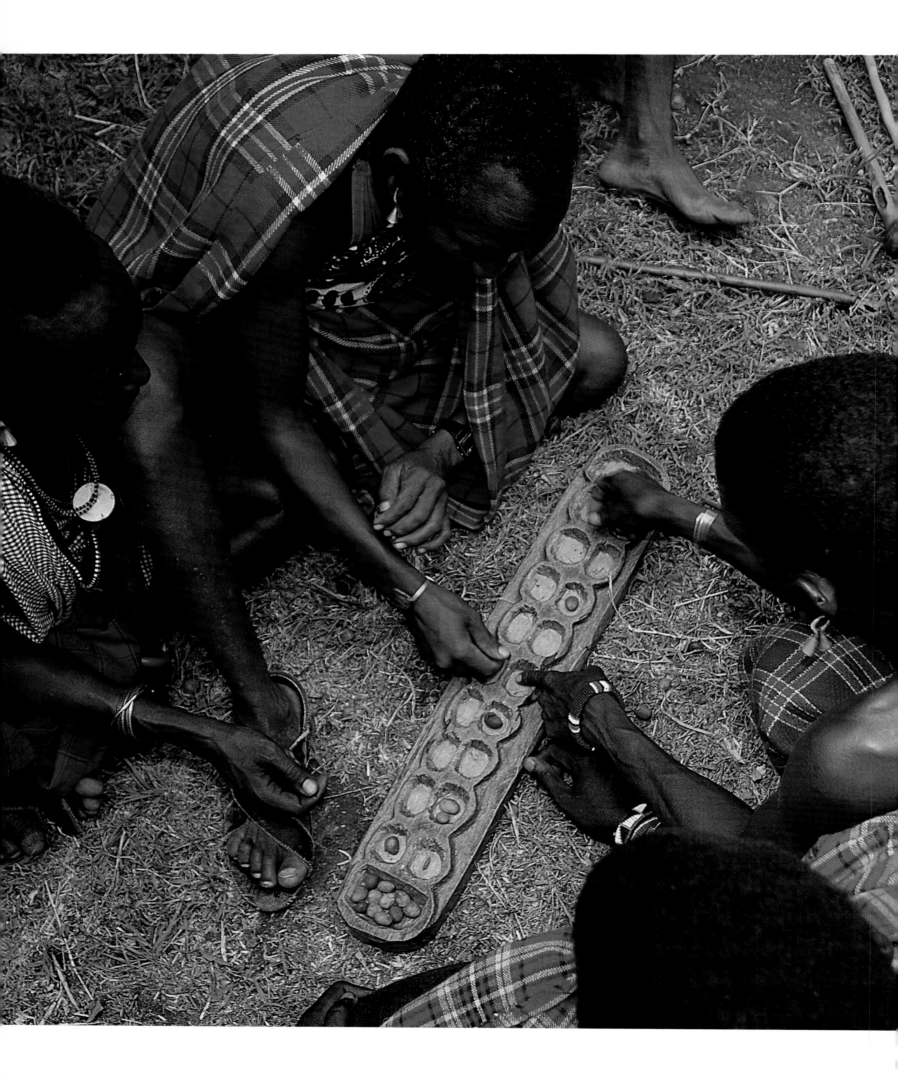

GAMES AND MUSIC

Throughout Africa, adults and children play a game in which markers are moved within cups or depressions. There are usually 12 or 14 markers, but some versions use as many as 32, and the Maasai have a 50-hole version.

The game is thought to be several thousand years old: ancient versions were carved into stones in Egypt and Sumeria, as well as at Great Zimbabwe and in Uganda and Ghana. The Ashanti kings of what is now Ghana played the game on a golden board.

This game, made by woodcarvers in Nigeria and Ghana, Kenya and Zimbabwe, Congo (Kinshasa) and the Ivory Coast, and a dozen more countries, is known by many names: *kikogo*, *mankala*, *bao* (or *bau*), *ayo*, *nsolo* and *wari* or *oware*, depending on the language spoken in each region. In many languages, the name means 'transferring', and refers to the players moving markers around. Often the game is played using cups carved into a wooden board. As the players move, they keep count of the markers they pick up. The markers may be seeds, dried beans, pebbles or whatever is available. Experienced players move the markers with such speed that it may be difficult for a casual observer to follow the progress of the game.

The boards are often carved with figures at one end, or with lids that have elegant designs carved into them, and some are set upon carved figures. The game is popular in the way that draughts (checkers) is popular in many Western countries, because it does not require much equipment – it can even be played by digging holes in the ground – and can be played at virtually any level of skill. Some people see it as a kind of war game in which pieces are captured and the enemy, the player opposite, is 'killed'.

LEFT: *Maasai elders in Kenya play an ancient game called* bao, *meaning 'wood' in Swahili. The game is known by many names throughout Africa, and the number of cups used varies from region to region.*

Whether it is something as simple as a game, a drum or even a basic stringed instrument, the desire for objects that are beautiful as well as useful is universal. This is why the weavers in the West African nation of Ivory Coast (also known as Côte d'Ivoire) choose heddle pulleys that are carved with decorative elements to guide the warp threads on the looms. The weaver, who has to look at the pulleys all day long while he is working under a tree, prefers looking at beautiful rather than plain ones. The Senufo people of the Ivory Coast, who carve these pieces, turn to their culture for inspiration. They may use the faces of spirits that also appear on masks or choose the hornbill, a bird that is much admired in their society.

In the Ivory Coast, a young Abure boy learns to play the tam tam. Drums are vital to rituals and are sometimes used in communication.

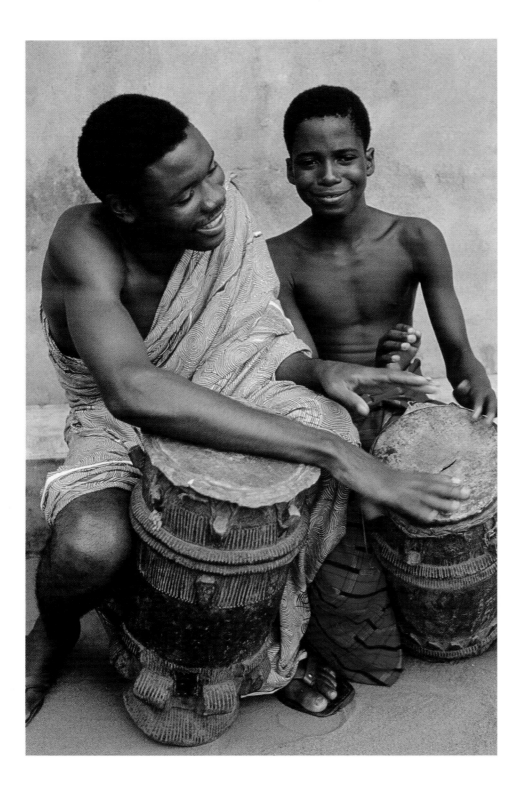

FUNERALS

The ingenuity, imagination and talent of African woodcarvers is further displayed in the recent phenomenon of 'fantasy coffins' from Ghana. Fantasy coffins, which are made in shapes taken from the person's life, or aspirations in life, are prepared well in advance of a person's death, and are often displayed proudly in the home until the time comes when they are needed. The afterlife, which plays such an important part in African peoples' lives, is honoured with this elaborate attention to the proper container for the body. The soul is taken care of during one's lifetime through attention to ritual and ceremony.

A Ghanaian 'fantasy coffin' made in the shape of a fishing canoe would probably have been commissioned by a fisherman. Such elaborate coffins are intended to honour the deceased and ensure their success in the afterlife.

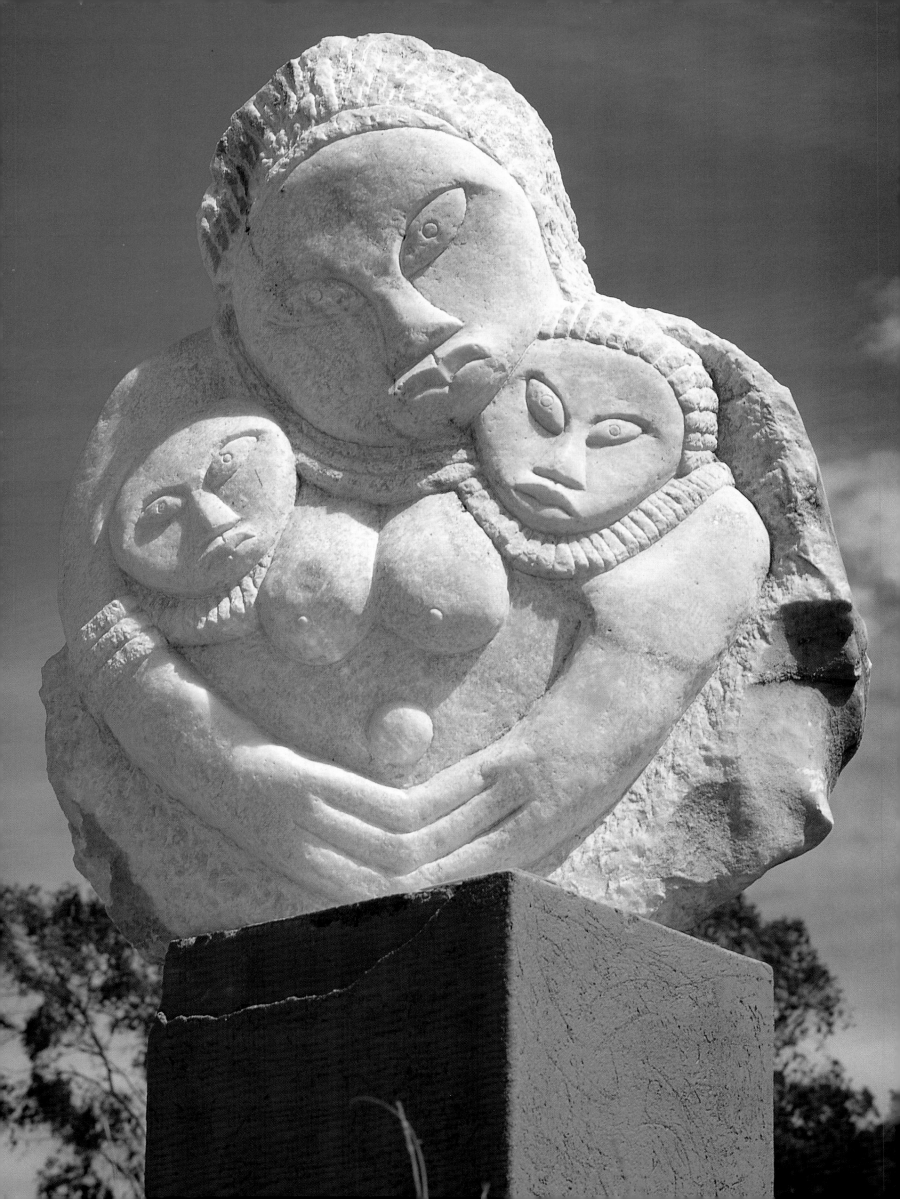

STONEWORK

Stone, the elemental building block of ancient Egypt and medieval Europe, was seldom used in sub-Saharan Africa. With rare exceptions, neither buildings nor sculptures were carved from stone. Whether they were pastoral or agricultural, small population groups focused on survival. The need to move to fresh grazing land, and the tendency for farm-based societies to break up when they grew too large to be supported on a given piece of land, left little time or desire to build permanent structures. Certainly rock was available and ready for use by any society that was inspired to do so. The limited use of stone in Africa, whether for building or for carving, stands out for its originality and, even more, for its rarity.

'Mother and Twins', a limestone sculpture by Zimbabwean artist Boira Mteki, interprets the traditional view of nurturing motherhood. It pays homage to the view of women as a source of fertility.

GREAT ZIMBABWE

Stonework encompasses the oldest and the newest traditions in Africa. Indeed, paintings on rock are the oldest artwork known (*see* page 102). Great Zimbabwe, the most remarkable complex of ancient stone structures in sub-Saharan Africa, is located in the country of Zimbabwe. Indeed, this complex of structures gave their name to the country, which was formerly known as Rhodesia. The name 'Zimbabwe' honours the people who built the complex and also honours the ancestors of today's Shona people, who make up the majority of Zimbabwe's population. The word 'zimbabwe' is derived from the Shona words for 'houses of stone', a straightforward description for this collection of splendid structures.

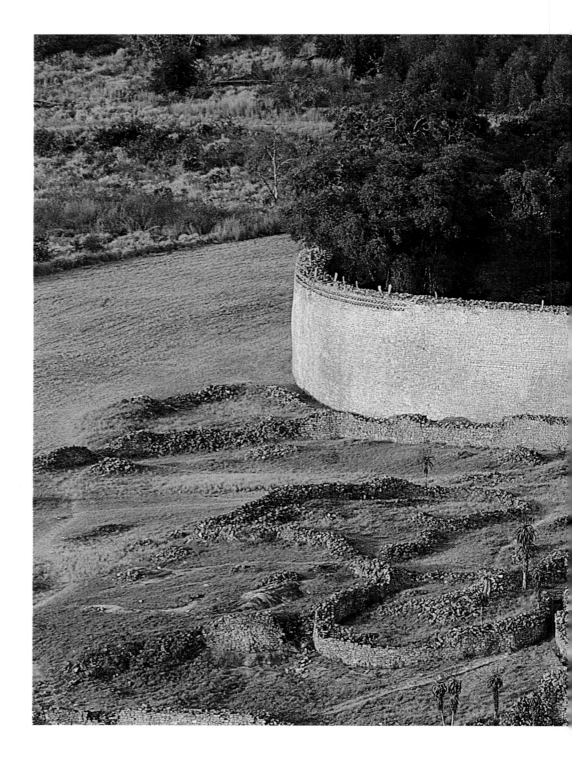

The conical tower (below), which lies within the Great Enclosure at Great Zimbabwe, is thought to symbolize the well-stocked granaries maintained by the rulers of Great Zimbabwe.

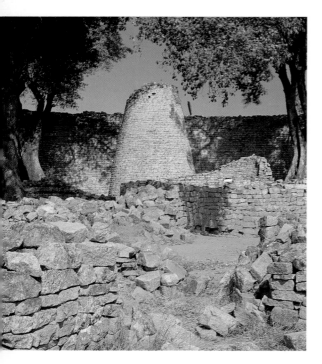

Great Zimbabwe is situated approximately thirty kilometres (seventeen miles) south-east of the town of Masvingo in south-eastern Zimbabwe. An air of mystery surrounds these buildings, and the visitor is naturally tempted to ask such questions as: Who made the structures? How was their society organized? What happened to the people? There are still more questions than answers, and the real story of Great Zimbabwe remains almost as great a mystery today as it did when the site was first uncovered. Though he never visited the ruins in person, the Portuguese historian João de Barros was the first European to describe the structures in some detail. His 1552 account was written about a century after the demise of the civilization that populated Great Zimbabwe.

The Great Enclosure (below), a high-walled citadel built of roughly one million hand-hewn granite blocks, is the heart of Great Zimbabwe.

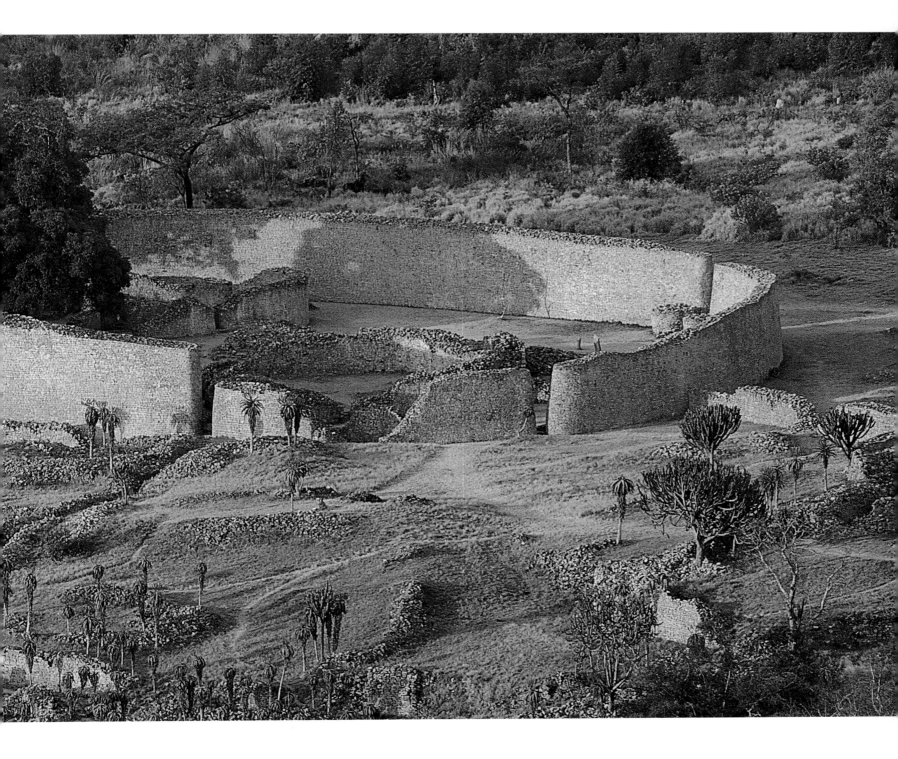

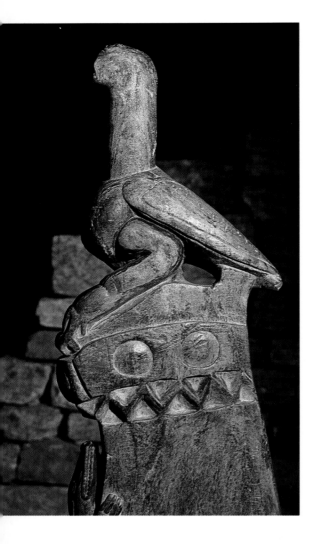

Explorers who were unwilling to believe that African people were capable of planning and executing such a grand architectural design attributed them to long-forgotten Europeans, even to people from Biblical times. Five centuries later, the wildest theories have been discarded. While the structures are now attributed to the Shona, the absolute truth about how and why they were made died with the people who once lived there.

Ancestors of the Shona people began arriving in East Africa's Great Lakes area some two thousand years ago, and are believed to have first moved into Southern Africa well before 1000. These early inhabitants grazed cattle but left no permanent structures. Centuries later, the Shona came to dominate the region under their *mwene mutapa* (master soldier – also spelled *monomutapa*), who ruled a vast area stretching from the Zambezi River to the Limpopo River, and covering much of the area between the Kalahari Desert and the Indian Ocean.

It was around the 12th century that the Shona began to build a series of stone buildings, which were constructed entirely without mortar. Nothing holds the stones in place except their own weight and the masterly way they were placed together. Although other ruins dot the landscape of south-eastern Zimbabwe, only Great Zimbabwe is still largely intact.

It is likely that the builders of Great Zimbabwe took advantage of locally available materials, principally granite. Weathering of this immensely hard rock causes it to 'peel' away into small-size blocks which can be shaped to create basic,

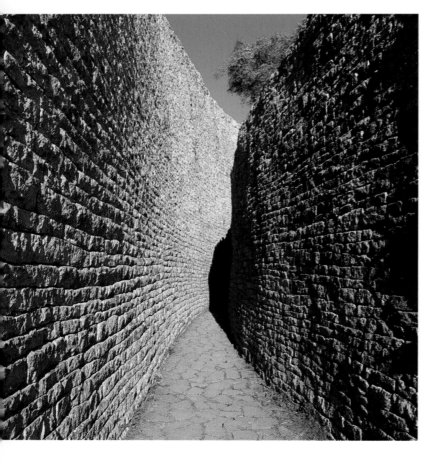

rectangular-shaped 'bricks' for building. Labourers chipped the blocks by hand until they were of the size and shape required for the walls. But the structures were more than simple piles of stones. The walls were curved and fitted with drains to allow rain water to run off, assuring that the walls themselves would withstand the ravages of the elements.

Great Zimbabwe was a trading centre whose prosperity was fuelled by the region's gold and ivory resources. Merchants would travel inland from Sofala (present-day Beira in Mozambique) and from Kilwa (on the Tanzanian coast) bearing manufactured goods, including beads and cowrie shells, glassware and ceramic products from China and Persia (present-day Iran). The society was stable, secure and wealthy enough to permit large numbers of labourers to spend their time in construction. The population reached an estimated ten to eighteen thousand people, an enormous number for that time (some estimates range as high as forty thousand people). The commoners did not live in the stone houses; it is likely they lived in the same kind of mud and thatch dwellings that most Africans of the region inhabit today. Only the king and

members of his extended family would have occupied Great Zimbabwe. The walls, as thick as five metres (seventeen feet) in places, were erected to divide areas of the town. From the placement of the walls – some atop cliffs – it is clear that prestige rather than defence was the prime consideration.

The wall of the elliptical Great Enclosure runs for more than two hundred and seventy metres (eight hundred feet), and consists of an estimated one million stone blocks. The dominant structure of the complex is the conical tower, which stands ten metres (thirty-three feet) in height and resembles a Shona grain storage basket. But the tower was not built for use; it was filled with stones and was probably erected to show the wealth of the kings. It symbolized the vast quantity of grain that they were able to store for the prosperous community.

Five hundred years have passed since these buildings were abandoned, seemingly overnight, yet the 'ruins' still offer a wonderful sense of the entire site as it looked at its peak. In 1988, Great Zimbabwe was named a World Heritage Site.

OPPOSITE, TOP: *At Great Zimbabwe, carved soapstone birds of prey stood guard. Today, the bird is the national symbol of the nation of Zimbabwe.*

ABOVE: *The earliest walls at Great Zimbabwe date from the 12th century. Security was maintained by the construction of double curved walls with a narrow passage running between the walls (opposite, bottom).*

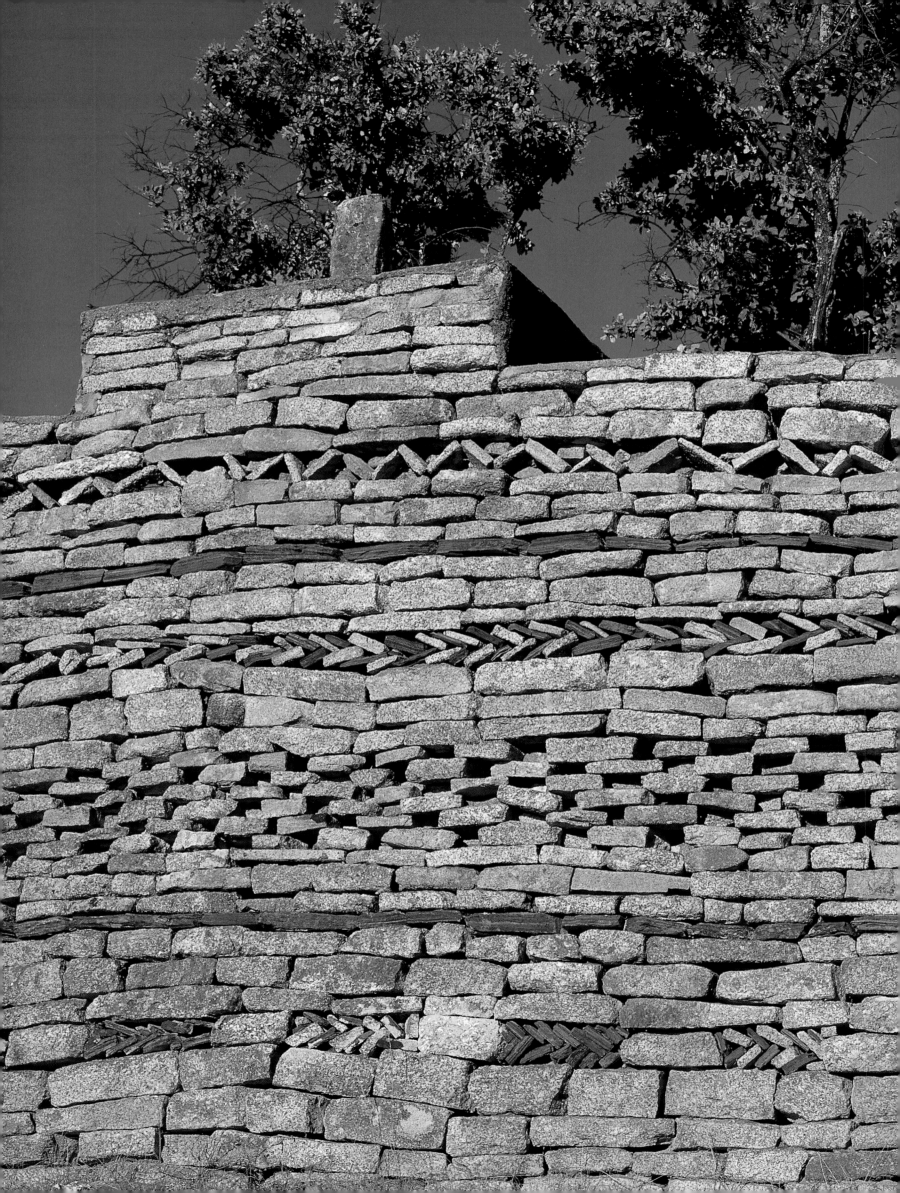

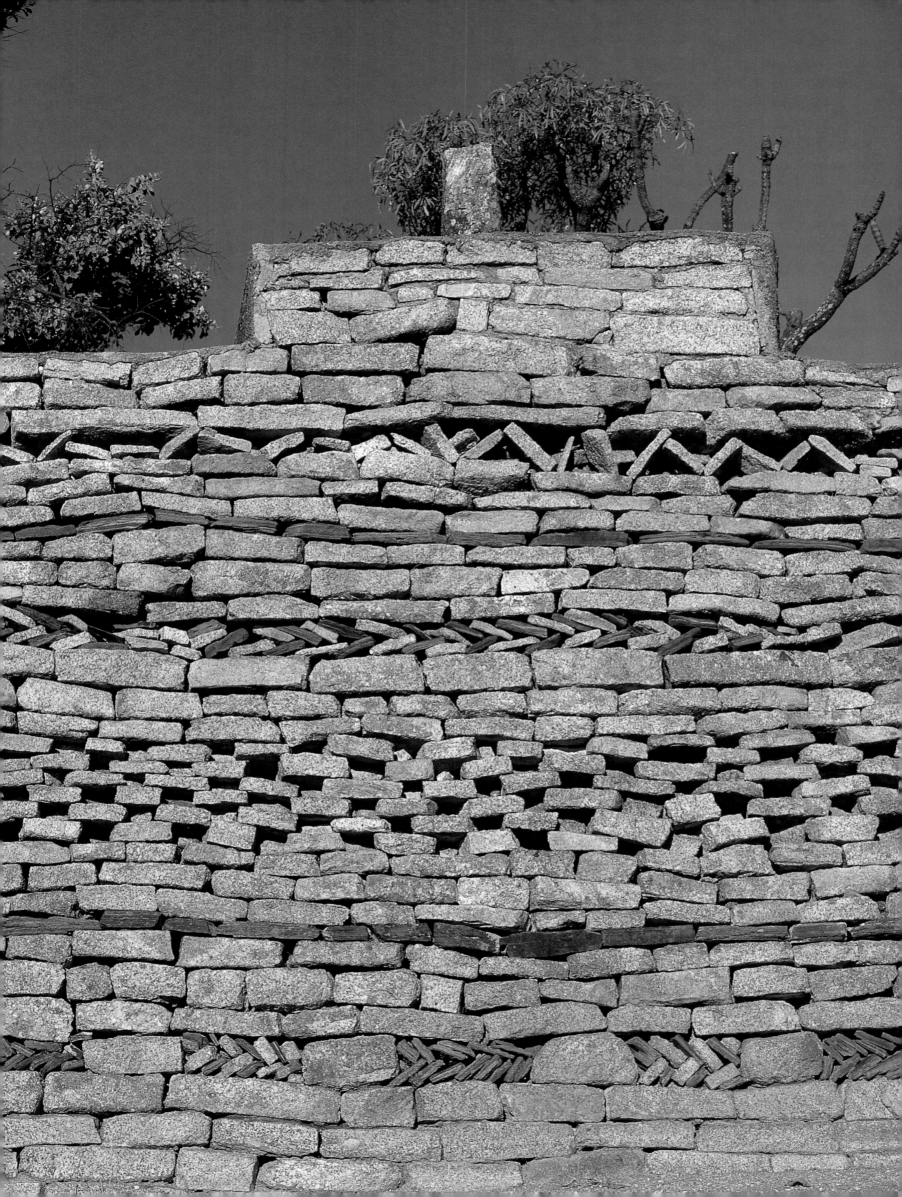

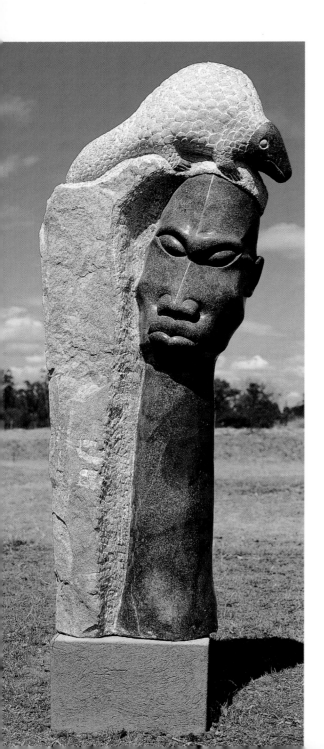

SHONA SCULPTURE

While the exact origins of Great Zimbabwe are shrouded in the mists of history, contemporary Shona sculpture is well documented. It ranks among the few material objects made in Africa whose creators are known and recognized for their work. The anonymous hands that made most of Africa's brilliant objects will never be known to us but we can celebrate the artistry of these sculptors.

Shona sculpture, as the work has come to be known, is made primarily but not entirely by Shona people. The movement began when Frank McEwan, director of the National Gallery of the former Rhodesia and the workshop school associated with it, encouraged artists to work in the Shona traditions exemplified by sculptor Joram Mariga. Three decades later, Mariga continued to express the Shona culture in his work. The first sculptors entered the programme in 1957 and have become known as the 'first generation'. They found their material, beautiful serpentine stone, readily available in the nearby hills.

By 1966, the work of these sculptors was challenged by men from Malawi, Mozambique, Angola and Zambia. They came together as migrant workers on the tobacco farm of Tom Blomefield at Tengenenge. The idea for the expansion was generated by necessity. When international sanctions were enforced against the former Rhodesia's valuable tobacco crop, in an attempt to force the country to abandon white-minority rule, Blomefield's workers needed a new way to earn money. Many of these men had made masks for their peoples' traditional dances. To Blomefield, it didn't seem like much of a stretch to suggest that they become sculptors too. Today, work from the Tengenenge farm enjoys its own reputation under the umbrella of Shona sculpture, and is based on cultural traditions.

Shona sculpture is now divided into first-, second- and third-generation work, a classification determined mainly by the country's tumultuous and racist history. Those who began to work in the late 1950s, and through the 1960s, laboured under white-minority rule. That generation's work was built on Shona traditions and spiritual myths, and also employed historical, cultural and struggle themes. By the time the battle was won and the country's independence was achieved in 1980, a new generation had emerged. This second generation of artists looked to more contemporary inspiration, and more personal expressions, while maintaining a connection with the past. The third generation of artists dates from 1990, when the country marked its first decade as an independent, black-ruled nation. These young artists had little direct experience of the brutal history that inspired their predecessors. For them, the struggle was a part of history, rather than any kind of personal experience. Both second- and third-generation sculptors rely more on self-expression than on historical and cultural themes.

Serpentine, the stone that defines Shona sculpture, varies both in colour and hardness, although in its purest form it is an extremely hard stone that polishes to a satin-smooth finish. Serpentine occurs in a range of colours, from black to brown

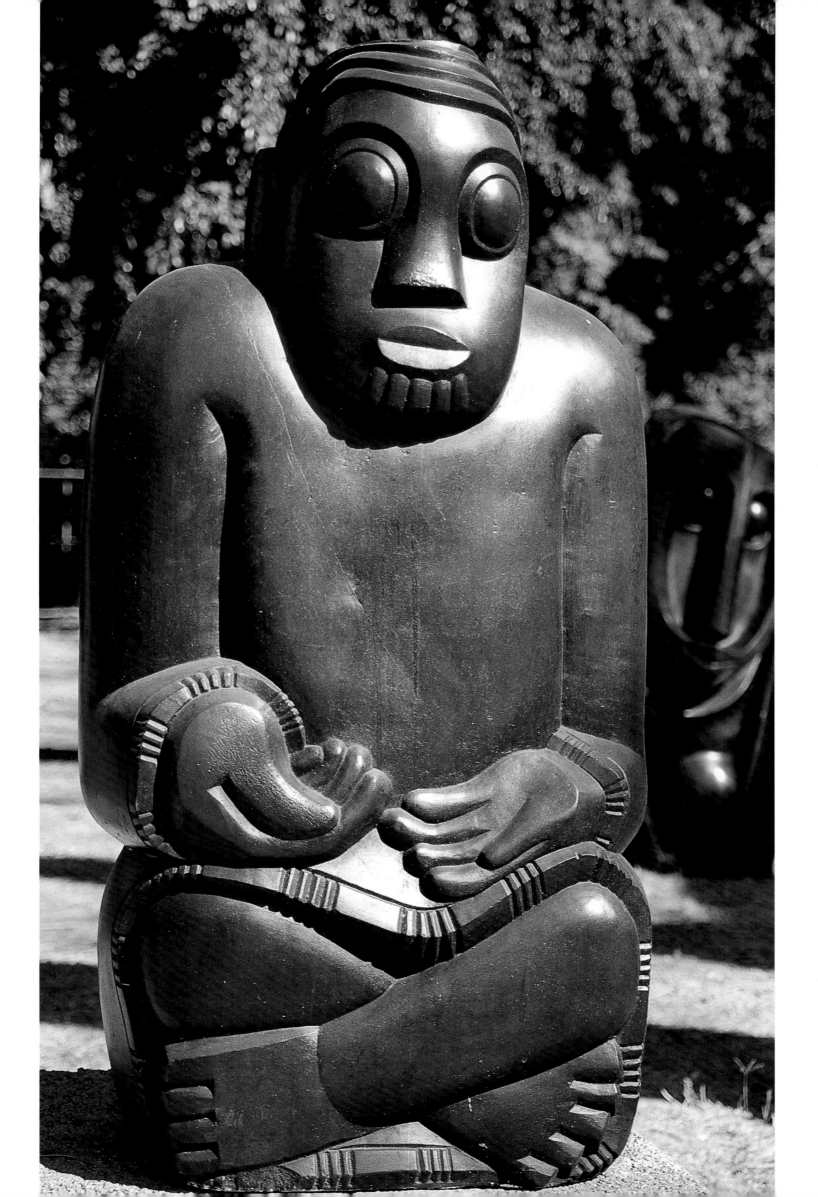

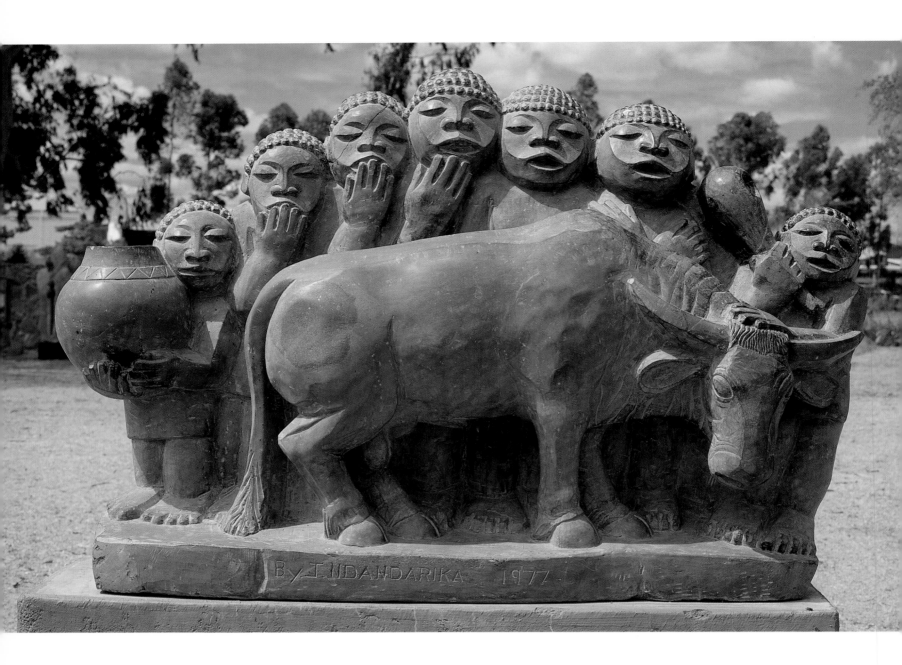

Black serpentine, an extremely hard form of serpentine, was used by first-generation sculptor Joseph Ndandarika to create 'Mudzimu Bull'.

and green, and even brighter tones – including variegated stones of red, green and mauve. The hardness of the stone requires the sculptor to expend enormous amounts of time on each piece. This has kept Shona sculpture very much in the category of highly priced artwork intended for display.

KISII STONE

Unlike Shona sculpture, Kisii stonework is made from a form of soapstone found in the highlands of Kenya, north of the Masai Mara National Reserve. The people of the region, known as Kisii or Gusii, comprise about six percent of Kenya's population. Centred around the town of Kisii, the Kisii form a minority within their region since they are Bantu-speaking, while those around them are not.

The proliferation of items, such as statuary, utensils, decorative plates and figurines, has made the name 'Kisii' familiar to people who visit Kenya. At the heart

of Kisii life are the quarries at Tabaka, a short distance from the town of Kisii. As many as five thousand Kisii people work on the stone, most from the village of Tabaka, with the number rising or falling with demand for the finished product.

Kisii stone occurs naturally in a range of soft tones, including grey and creamy tan. The creamy colour is often striated with pink or purple, sometimes showing a hint of gold. When buffed, the stone is silky smooth to the touch. The actual carving is carried out by the men. Women and children sand down the pieces and wash them to achieve the silky-smooth surface. Though porous, Kisii stone is a natural choice for bowls and pestles, and has been used by the local people for at least eighty years. The stone dust, as fine as talc, was formerly used by warriors to decorate their faces during traditional ceremonies, including funerals.

The abundance of the stone seems to have bred in the local people a talent for carving. Missionaries who settled in the area encouraged the people to carve pipes, bowls and small animals. Most typical of these was the sun-faced lion, which was being carved as early as the 1930s.

The modern phase of Kisii stone design began in the 1960s when a sculptor named Nelson Ongesa arrived at Studio Arts 68, one of the first craft shops in Nairobi, with a selection of small Kisii stone figurines created by himself and members of his family. Thirty years after he began, Ongesa is still an active supplier of Kisii stonework. But the most long-lasting contribution to the art of Kisii stone carving was generated by the African Heritage shop in Nairobi, which took the material to a totally new artistic level. Innovations included incising the stone, painting it with acrylic and shaping it for use in Western households.

Sometimes the pieces were coloured red using Kiwi shoe polish. The colour softens to pink over time, the natural result of the stone's porosity. Kisii soaks up colour like a sponge. It will absorb any colour placed on it until it stabilizes, making a carving unsuitable for use as a food container or serving vessel. For this reason, most pieces made for sale are for ornamental rather than practical use.

To make the stone less absorbent, one artist began to use opaque paints that sealed the surface. Designs that made use of West African motifs and symbols such as lizards and stylized faces were painted over a white background, giving the material a totally new look. This solution was successful; the colour remains on the surface and retains the original look painted on by the artist, although totally obscuring the natural colour of the stone. Nevertheless, this innovation has expanded and extended the design possibilities for this beautiful material.

The profusion of Kisii stone designs is an ever-changing array of motifs and colours. As one artist creates a new idea or design, it is quickly picked up by the others. Kiwi shoe polish, in a variety of colours, is still the choice for most painting on Kisii. Transparent polish is used on natural stone, which allows the natural grain of the stone to show through. It is also readily available in small quantities and is easily portable – useful qualities for people who usually work outside.

The sun-faced lion is portrayed in this small Kisii stone carving. Due to the porosity of the soft Kisii soapstone, most pieces are made for display rather than for everyday use.

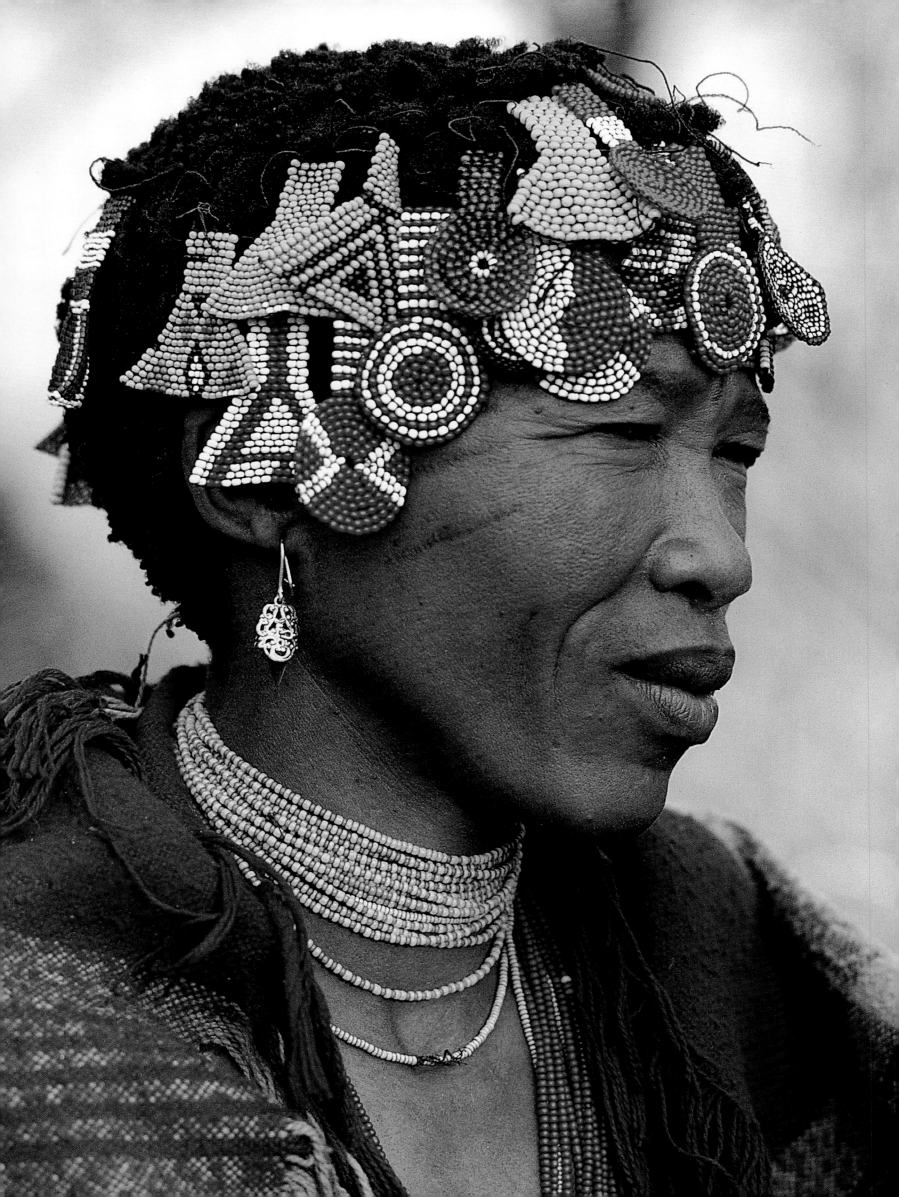

BEADWORK

The desire for personal adornment dates from the New Stone Age (around 10,000 BC) – the very dawn of human society. Objects recognizable as jewellery, such as ivory beads, as well as necklaces made from fish vertebrae, have been found in ancient graves and living sites, some of which were as old as 25,000 years. Cowrie shells – still in use today for decoration – were worn in Neolithic times.

Thriving Neolithic cultures existed over much of Southern Africa from the seventh millennium BC. The people included the San (Bushmen) and Khoikhoi. Whether their necklaces were worn as amulets, to ward off evil spirits, or because they were considered beautiful, are all secondary considerations. The important element is the universal desire for objects that decorate or enhance the individual. The form or material of African beadwork depends very much on the materials at hand, or on those that are acquired in trade.

This !Kung woman of Namibia, a member of the San (Bushmen) people, has fashioned a vibrant collection of beaded pendants to wear in her hair.

The physical expression of a culture is made apparent through ritual and dress, ceremony and ornament. The outward appearance of people is the surest way to differentiate one individual from another. The information given by the wearing of specific types of beaded jewellery spells out information as surely as if it were written down. For outsiders who want to be able to read this information, this 'language' of beads can be learned. By deciphering the messages contained in the jewellery, we are able to see past the surface of a person's elaborate and exotic beadwork. We can gain some insight into the meaning of these objects of adornment to the person who wears them.

In many parts of Africa, people distinguish and reveal themselves to other members of their community through their beaded jewellery. In East Africa, the jewellery of the Maasai of Kenya and Tanzania, and the Samburu of Kenya, follows different and specific patterns and forms, even though it is often made of the same basic building blocks: tiny glass or porcelain beads. The Zulu, Ndebele and Xhosa of South Africa employ the same beads to create their distinctive jewellery and other ornaments, which are also used to define and delineate their own cultures.

Beads are the prime example of the way in which a basic material can make a substantial impact on a culture. The availability of imported beads made the language of beads (in Xhosa culture, for example, and in many others) an integral part of the traditions and came to be one of the defining elements in explaining who belonged to that culture.

Most of the beaded work in East and Southern Africa is worn by individuals from all levels of the culture. Quite the opposite is true in West Africa. In the Yoruba culture of Nigeria, beadwork is reserved for members of royalty and for use in connection with their roles as supreme leaders. Objects may be seen rarely, only at the time of a harvest or during a royal procession. Among the Bamileke people of Cameroon, fabulous thrones are made of wood, covered with fabric and then beaded all over. The thrones are carved to resemble animal figures that have a striking resemblance to human beings. Here, beadwork is an expression of privilege. Whether they are restricted to royalty or available to everyone, though, beads have become powerful elements in African life.

MAASAI AND SAMBURU

The Maasai and Samburu live in regions where the last of East Africa's great concentrations of wildlife are found. The Maasai, who live on both sides of the border that separates Kenya and Tanzania, are closely associated with the reserve that bears their name – the Masai Mara National Reserve in Kenya – as well as with the Serengeti National Park in Tanzania. The reserves, like the people, are divided by a border conceived by their former colonial rulers. To the north, in Kenya, are found the Samburu, who are associated with the Samburu National Reserve. These parks

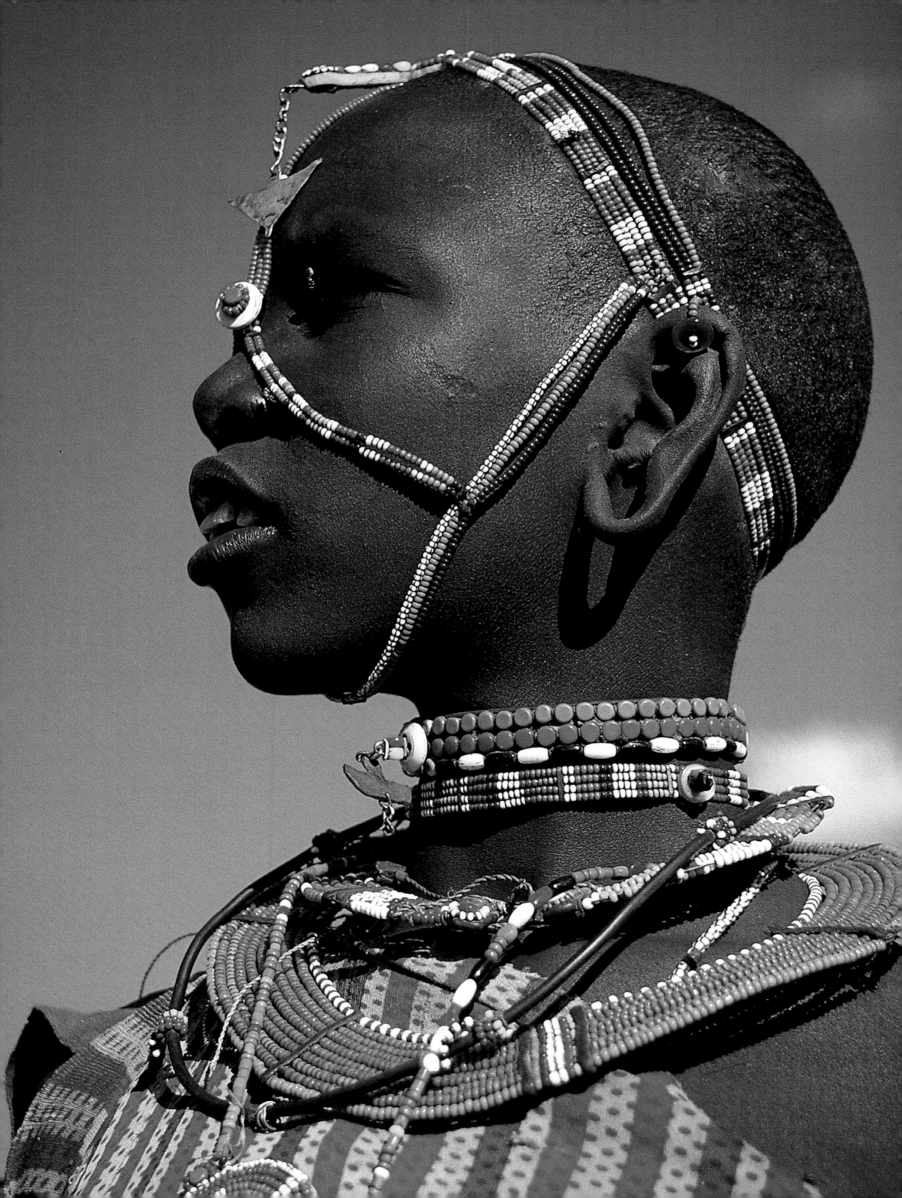

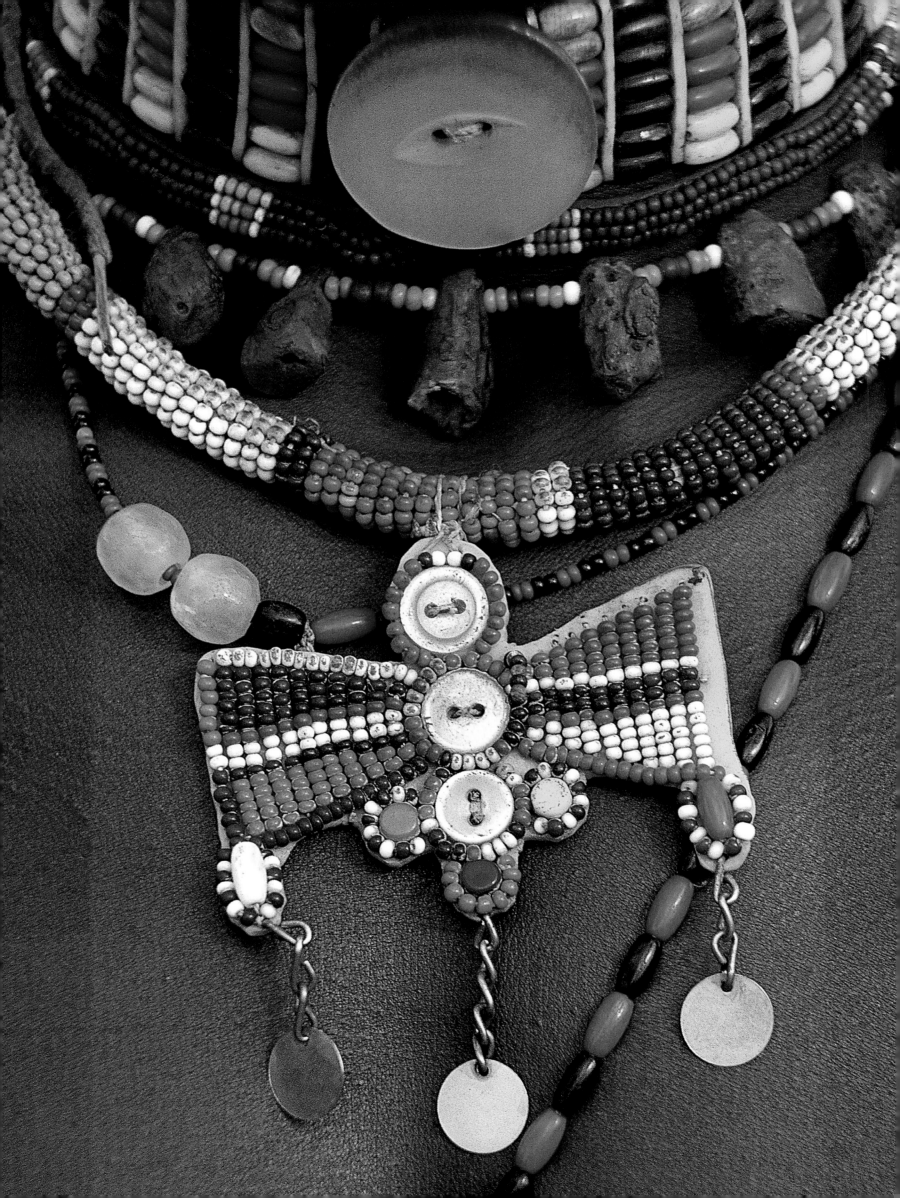

are aptly named since it was the presence of these peoples, and their attitude toward wild game, that ensured the survival of the animals within these parks. After Kenya gained independence, the Maasai and the Samburu were made official guardians of the country's wildlife. Neither group hunts wild game for meat or for their skins, and certainly not for 'trophy' heads, horns or antlers. They profit from, and are partly responsible for, the care of the reserves that bear their names.

The material culture that defines the Maasai and Samburu symbolizes Africa to outsiders. They seem to have captured a bit of the sun as they emerge from their thatched houses or appear out of the forest, garbed in elaborate, beaded jewellery, red cloth wrapped around slender figures, and hair dressed with red ochre. This is how the Maasai, the Samburu, as well as some of Kenya's lesser-known peoples – including the Rendille, Pokot and Turkana – present themselves. Equally vivid expressions of bead-work and costuming are found among the Zulu, Ndebele and Xhosa, but they are less well-known outside South Africa. Although visitors are unlikely to see traditionally dressed Zulu and Ndebele outside of tourist-oriented cultural villages, their crafts are now widely available.

To Westerners, traditionally garbed people such as the Maasai, Samburu and Ndebele may appear to be dressed up or adorned for a special occasion. For the people, however, every day is that special occasion. Although some pieces of jewellery are made to be worn at particular moments of life – marriage or circumcision, for example – most of the jewellery is worn throughout an entire stage of life. A married woman will, as an expression of greater wealth, amass beaded necklaces as she grows older. As she moves through her life, she wears jewellery that is appropriate to her status. For example, the beaded leather ear flaps that look like bookmarks are worn only by married Maasai women. They slip easily through the extended openings in their ear lobes. Marriage beads transmit the same information in these societies as gold wedding bands and red dots on the forehead do in other cultures.

The pieces made for use by members of these cultures are synonymous with the culture, and are not merely a decorative expression. While there is no law that says a married woman must wear either a gold wedding band or a beaded neck-lace, depending on her culture, it is the accepted expression of her status within that culture. This jewellery carries a world of significance and symbolism. The spe-cific look of a piece of jewellery – the shape, the patterns, the colours – all speak of the culture of the wearer. When one person within that culture sees another,

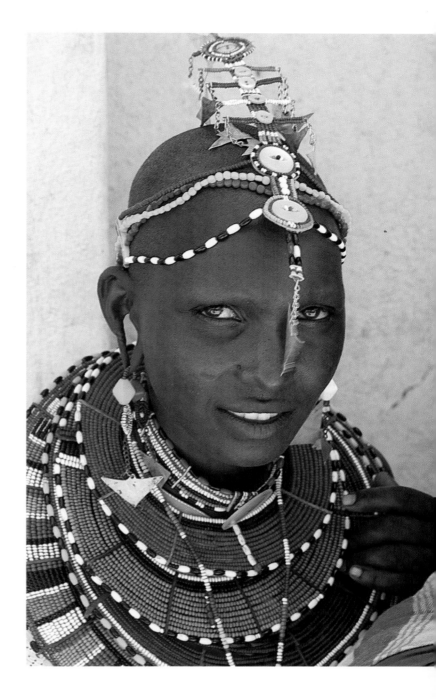

OPPOSITE: *Samburu men accumulate beaded jewellery made by girlfriends. The colour blocks shown here are typical, as is the band of larger beads across the chest. Sewn-on buttons have become standard additions.*

ABOVE: *This Maasai woman wears traditional beaded forms, including the elaborate fitted headpiece and series of flat neckpieces.*

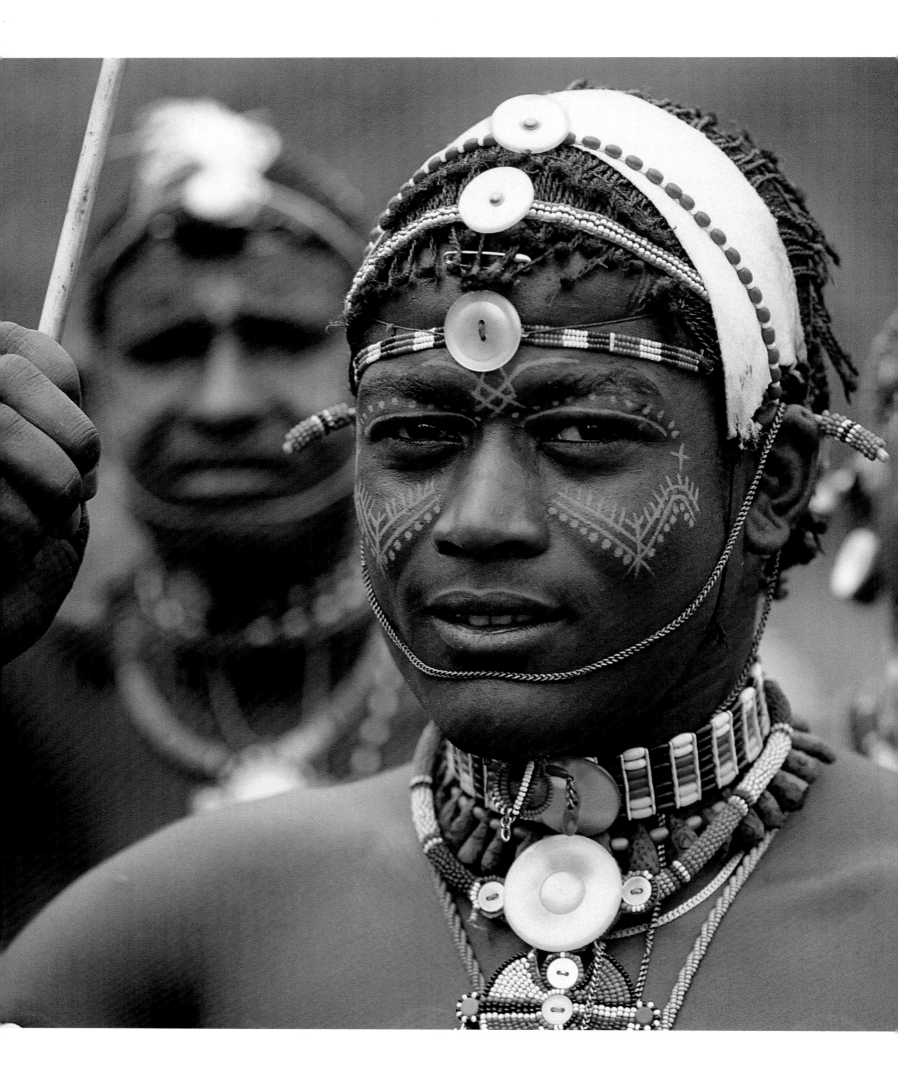

each can read the exact status of the other: age set, marital status, even whether the wearer has given birth to a son.

In spite of the rapid urbanization of East Africa, some people have managed to keep this physical expression of their traditional cultures intact. Although the cities seem to offer an endless supply of jobs and amusement, most migrants wind up in the worst sections – the slums that accommodate the influx of rural people looking for work. Many Maasai and Samburu have managed to resist the siren song of the cities. It is only in the rural areas that these people can maintain their traditions.

TRADITIONAL BEADWORK

Beaded jewellery is a rich tradition but one with fairly recent origins. Nearly all the beads that are identified as 'African' were brought from Europe as objects of trade. Little more than a century ago, East African peoples were first offered the small colourful beads that are now such a part of their material culture. Before that time, ornaments were made from locally available material. Some of the earliest ornaments of the East African peoples were made from iron, laboriously fashioned into armlets and leg circles by blacksmiths. Though heavy and uncomfortable, they spoke to a need for ornament.

Over many centuries, Arab traders introduced a variety of goods, including beads, to East Africa, often in exchange for ivory. However, the earliest known Maasai and Samburu jewellery items were made from large red beads produced in Holland and thought to date back to about 1850.

LEFT: *In northern Kenya, young Samburu men enjoy their time as warriors, and pay careful attention to grooming and to jewellery. The beaded headpiece helps each man keep his braided hair in place. A single row of beads runs across the cloth that covers his hair.*

But the look of jewellery in East Africa, particularly among the Maasai and Samburu, was transformed about a century ago, when traders brought in a new item: tiny, colourful glass beads, uniform in size and hue, imported from Italy (mainly Venice) and what is now the Czech Republic. These small beads, with their precise, pre-drilled centre holes, could be strung onto wire or sewn onto leather. They could be arranged in geometric patterns, in contrasting colours.

A whole mythology grew up around the beads, based on existing Maasai beliefs about the natural world that surrounds them and guides their lives. Blue represents the sky, which itself expresses the Maasai belief in *Nkai* – God. Green represents the grass, a sacred element that is revered because it nourishes the cattle that play a central role in traditional Maasai and Samburu life. Red and white are the life-sustaining colours: red represents the blood of the cattle, and white stands for their milk. Traditionally, milk, sometimes mixed with blood, comprises the people's entire diet. Only during ceremonies marking stages of life do they

A Samburu warrior living near Isiolo, Kenya, tucks his knife into this beaded belt made by a female admirer. The beading is stitched onto leather.

slaughter cattle for meat. Hides provide clothing and material for pouches and slings, and straps for the gourds that contain the milk or blood. Cattle play such a central part in Maasai life that they are celebrated in song and loved as individuals.

By working blocks and bands of these colours in their beadwork, the Maasai spell out the essential beliefs and elements of their lives. Girls begin to amass the distinctive, flat circular necklaces at an early age. The beads are expensive and, these days, must be bought with cash. A woman, who wears her wealth in the form of jewellery, usually earns the money to buy beads for herself or her daughters by selling an animal from her own herd. Her domestic livestock are kept separately from those of her family. A Maasai man, who counts his wealth in his cattle, will rarely part with a cow from his herd.

Each of the necklaces is made in a different circumference. When worn together the whole set of neckpieces covers the girl or woman's upper body from her neck to her shoulders and part-way down her torso. In dance, the necklaces

Samburu boys wear these blue beads at the time of their circumcision, usually between the ages of twelve and twenty. These Samburu live in Kenya, near Maralal.

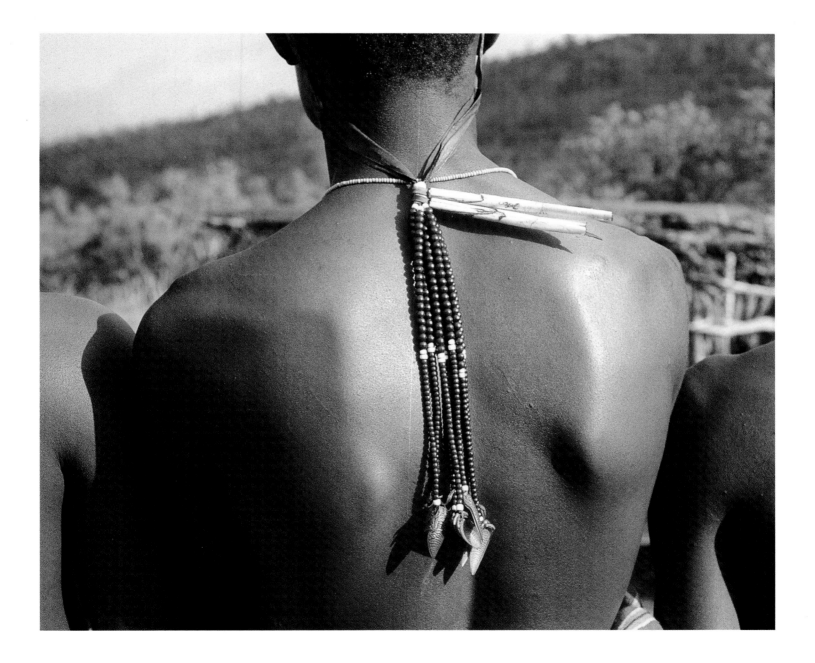

are set in motion as the wearer bobs her head and body in a distinctive ducking motion. The neckpieces seem to float up and down, dazzling the eye of the intended – the young man with whom she is dancing. When a row of dancers is in motion all at once, they create the impression of a well-rehearsed and orchestrated chorus. Their dance shows the unity of the people, the closeness of the age group.

The Maasai avoid symmetry in their beadwork and in their choice of what constitutes a 'pair'. There seems to be an innate need to create a balance from different elements. According to Maasai thinking, two things that are alike cannot be a pair. The work begins with a colour block at one end, and proceeds round to the other end. Each pair of colour blocks is set apart by one or two rows of contrasting beads. Single rows of beads are strung from headbands and draped across the cheeks, drawing attention to the face. In the earlier work, beads were sewn onto leather or separated with 'spacers', narrow strips of leather. Today, the beads are threaded onto wires.

At first glance, it seems as if the colours of Maasai jewellery have never changed. All the neckpieces feature blocks of bright solid colours set apart with blocks of white beads. But photographs of Maasai taken twenty years ago show a colour palette that is noticeably different. At that time, red and blue were used almost exclusively. Today's palette is far more varied and individual. This difference may be a reflection of the far greater contact the Maasai and the Samburu now have with Westerners, or simply a practical acceptance of the colours that are available at the local trading stores. The wholesale purchase of the beads is made by outsiders, people who are not from the culture. In the past, these wholesale buyers were Arabs; today the buyers are Indians from South Asia, who control much of the trade in East Africa. The trader buys the colours he

BELOW: *A circumcision belt made for a female Kamba circumcision in Kenya. The beads are sewn around a thick fibre core.*

OPPOSITE: *The strands of red beads worn by these Samburu girls in northern Kenya represent great wealth. It is unusual for two girls to have identical headpieces. Also unusual are the beaded pendants affixed to their strands of beads.*

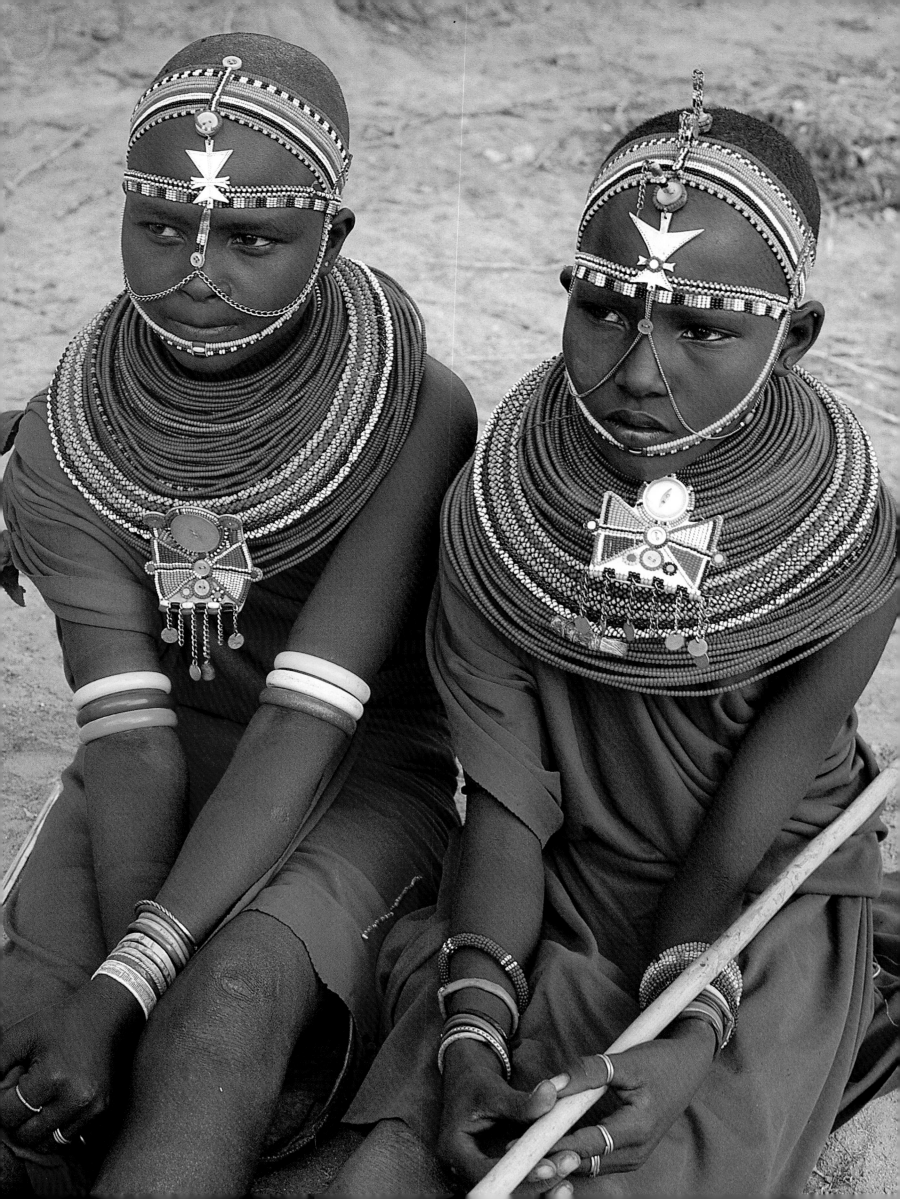

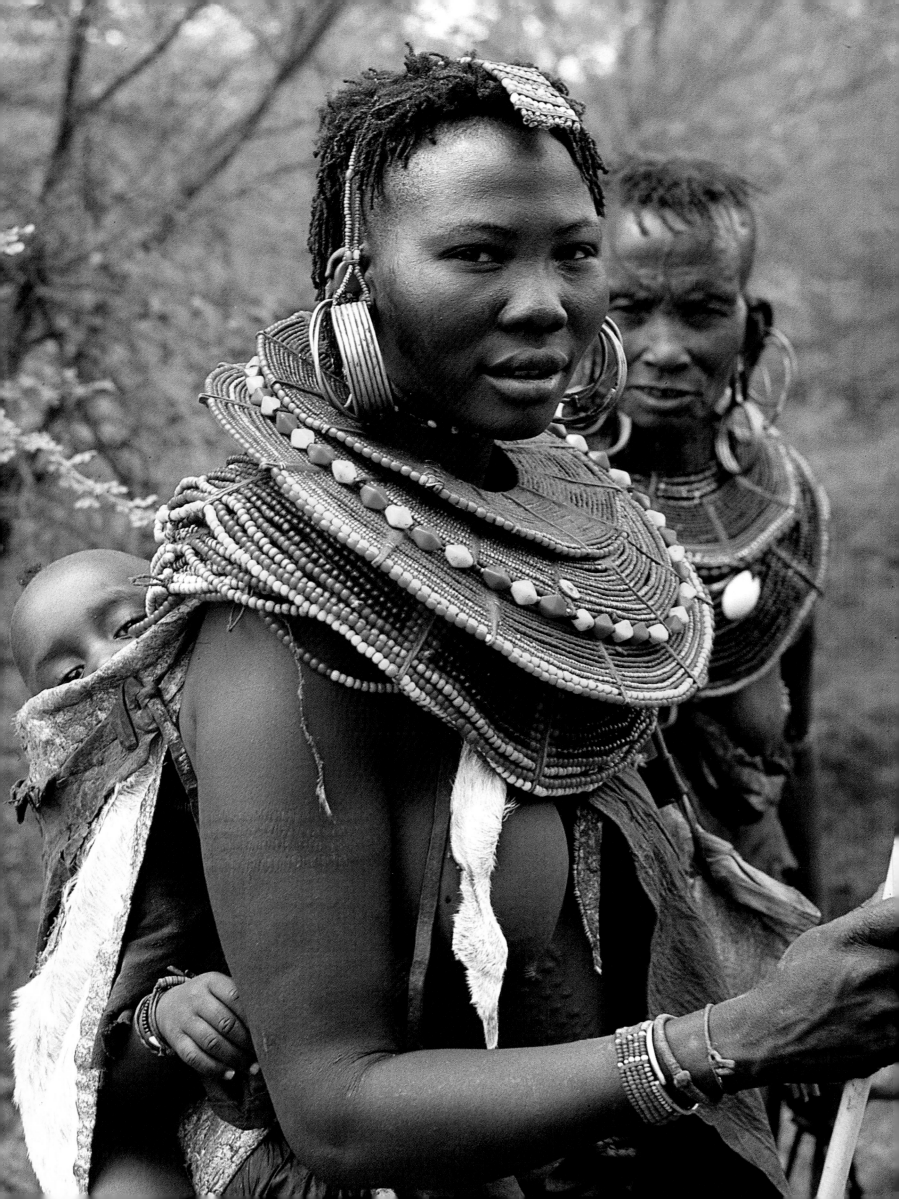

or she thinks are needed, colours that are in ready supply, or well-priced. Originally, white became crucial to this beadwork simply because it was in abundant supply, a supply dictated by the Buganda of Uganda, who were major purchasers of beads. The traders passing through East Africa always carried white beads to satisfy their demands. If there were disruptions at the source in Italy or Bohemia, sometimes the trader would have to take what was available. One year, for example, there were no white beads to be found.

Cowrie shells, once the principal form of money in various parts of Africa and still widely used for decoration, are sewn onto headbands and worn after a girl has been circumcised, a practice still followed in rural areas. The Maasai wedding necklace, worn only for the wedding ceremony, is passed down through the generations. This piece, called an *entente*, features a tight collar of beads with numerous strands of beads hanging down to the knees.

Samburu jewellery is readily distinguished from that of the Maasai. Samburu women favour single strands of red beads, which are given to them by admirers. These strands are piled up until they seem to merge into a single neckpiece. The popular saying is that a Samburu girl is not ready to be married until she has enough necklaces to support her chin.

Maasai and Samburu men and women both wear a profusion of earrings. Multiple ear piercings are the norm. Older men and women traditionally stretched the ear lobe hole, made when they were children, by inserting progressively larger objects. Over time, the hole could be stretched to more than two and a half centimetres (one inch) in diameter. One earring design is in the form of a strip of leather, about five centimetres (two inches) in diameter, and folded into the shape of a bookmark. The entire piece of leather, enhanced with sewn-on beads and pieces of aluminium, is inserted into the ear lobe hole. These earrings are worn only by a married Maasai woman. A woman will sometimes wear a series of these 'bookmark' earrings, graduating in length up to about fifteen centimetres (six inches). Among some Samburu men, ear decorations may be permanently woven around the ear lobe, through the large opening.

WARRIORHOOD

Jewellery as ornament is only part of the grooming routine of the Maasai and Samburu peoples. Elaborate grooming customs focus on the young men. These begin at the time of circumcision, which usually takes place when boys are between the ages of twelve and twenty. Circumcision signifies a boy's readiness to be initiated into the warrior age set. It is the ultimate fraternity of men, a bond that goes beyond family and embraces the larger society. Before a boy is circumcised, he has value to his family as a herder but he has not yet earned his place in the community. That place is assured only when he has successfully passed through the

OPPOSITE: *This Pokot woman wears a series of flat neckpieces made of doum palm, edged with red and yellow beads. The Pokot are among the last of Kenya's people to wear skins.*

circumcision ritual and has demonstrated his bravery. He must not even flinch as the knife changes him from a boy to a man.

Circumcision marks the beginning of his life as a *moran*, a warrior. Candidates for circumcision wear special beads that signify their status to all in the community. Following the ceremony, the boy gives these beads to his mother. She now wears the coiled metal earrings called *surutia*, which say, 'I am the mother of a circumcised boy', thereby increasing her status in the community. Boys who are circumcised as a group are united by this common experience. They are given a unique group name that identifies them throughout life.

Following their circumcision, the boys go into seclusion and are then trained in the lore of their people. During this period the boys grow their hair long. They spend hours making tiny braids and dressing each other's hair with a mixture of ochre and fat. Strands of wool or cotton are added to their braided hair to make it look even longer. While dancing at ceremonies, they flaunt their long hair and proudly display themselves. This is the most glorious time of their lives.

Although there is no longer a real place for a *moran* in modern East Africa, the rituals associated with warriorhood, now adapted or scaled down, are still maintained in the rural areas of Kenya. For example, *morani* may no longer kill lions to demonstrate their prowess in hunting, but instead must be content with shooting small birds using the bow and arrow (*see* pages 169–170). However, they yield nothing to modern times in their attention to ornament and body decoration.

The use of beading extends beyond jewellery. Beads are sewn onto many of the household goods as well as onto clothing and objects used by men and women. Long leather skirts, rarely worn these days, are enhanced with rows or

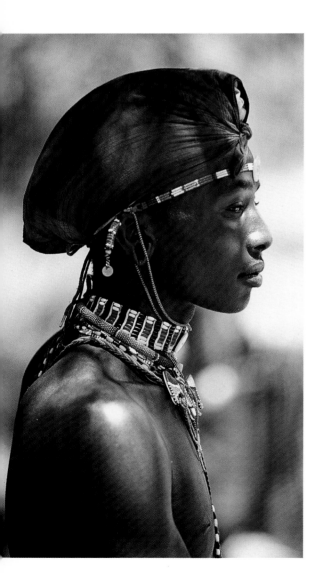

BELOW: *This Samburu warrior's fine set of jewellery includes a closely fitting collar – one of several necklaces that are worn together.*

RIGHT: *Two Pokot girls wear typical wide collars made of incised water reeds strung on doum palm cords. The collar extends over the shoulders and upper body. The Pokot have resisted Westernization fiercely.*

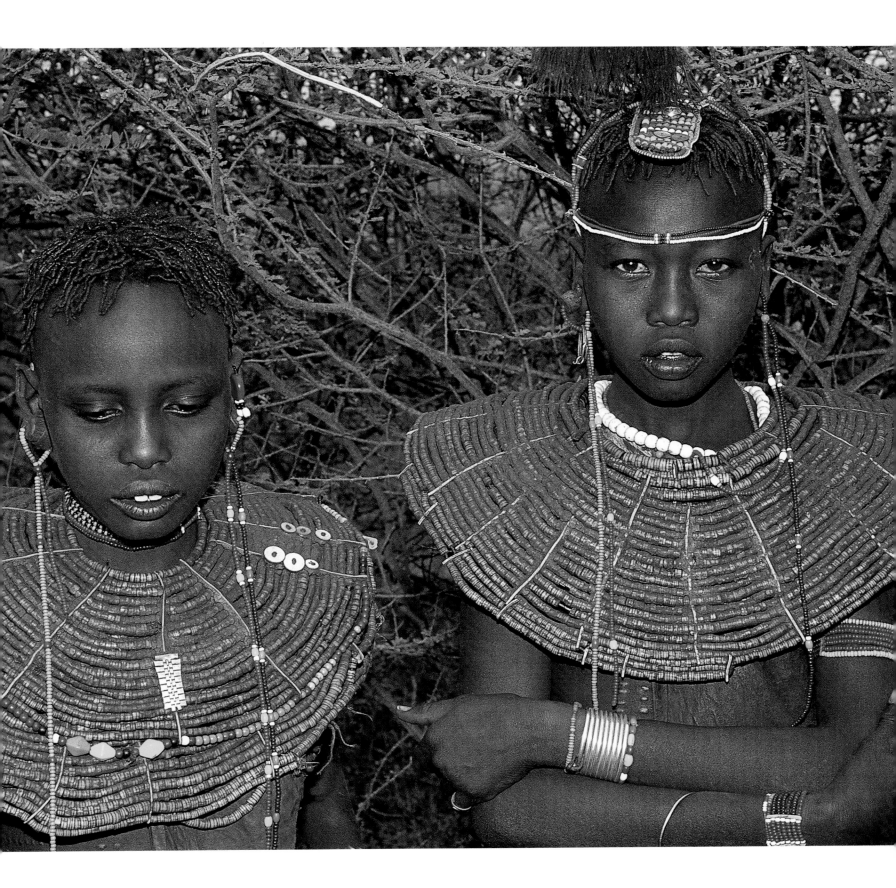

patterns of coloured beads. Small leather bags, decorated with beads, are made by Maasai women for their own beadwork. To keep their kangas (printed cloth that is wrapped around the body like a sarong) in place, men wear a beaded belt that also serves as a sheath for their short knives. These belts, usually made by a girlfriend, provide an opportunity to show ingenuity and individuality, and are among the

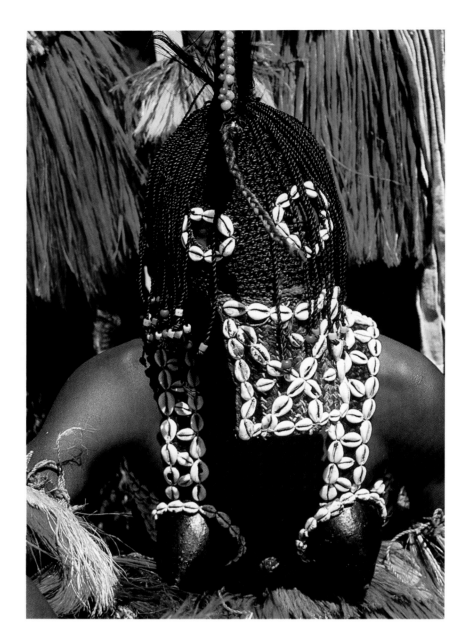

most distinctive items worn. The beaded belt ornament is placed at the small of the back, and is often shaped like a small shield. The brightly coloured beads are sewn onto a leather backing. Girlfriends also provide them with beaded ornaments, including bandoleers that cross the chest. Men also wear a choker made of a goat's stomach lining into which are sewn aromatic seeds.

RENDILLE AND TURKANA

Kenya has more than forty ethnic groups, although the differences between them can become blurred through intermarriage and overlapping territories. The Rendille and Turkana are among the few who still pursue a traditional lifestyle. The Rendille resemble the Samburu and live just south of Lake Turkana. Their beadwork features larger beads, most of them bright red. Unmarried women wear a combination of necklaces: a large draping collar combines more than a dozen rows of beads strung on wires, set off by small, flat white and yellow beads. The collar rests on the girl's shoulders, with strings of beads massed from her chin to her shoulders.

Above: Cowrie shells outline parts of the mask and the straps of this Dogon dancer's costume. Cowrie shells are often associated with fertility and were formerly used as units of currency.

The Turkana, a nomadic people who live in the least hospitable part of Kenya, around Lake Turkana (*see* page 41), are related to the Maasai but differ considerably in appearance. Turkana women's faces are quite broad, with a distinctive appearance. The women bedeck themselves with strands of brightly coloured beads massed around their necks and shoulders.

Opposite: A trio of Hamar girls from southern Ethiopia wear garments made of animal hides, ornamented with simple strands of beads and rows of cowrie shells. They pay the greatest attention to dressing the tiny braids that make up their hairdos.

NDEBELE

The Ndebele of South Africa, who form part of the Nguni-speaking group of peoples, have been recognized as a distinct culture for several hundred years. After breaking away from the powerful Zulu kingdom in the early 19th century, the Ndebele established control over a great stretch of land between the Limpopo, Vaal, Crocodile and Molopo rivers in north-central South Africa. As their numbers increased, they would migrate to a new area and settle there, and then repeat the

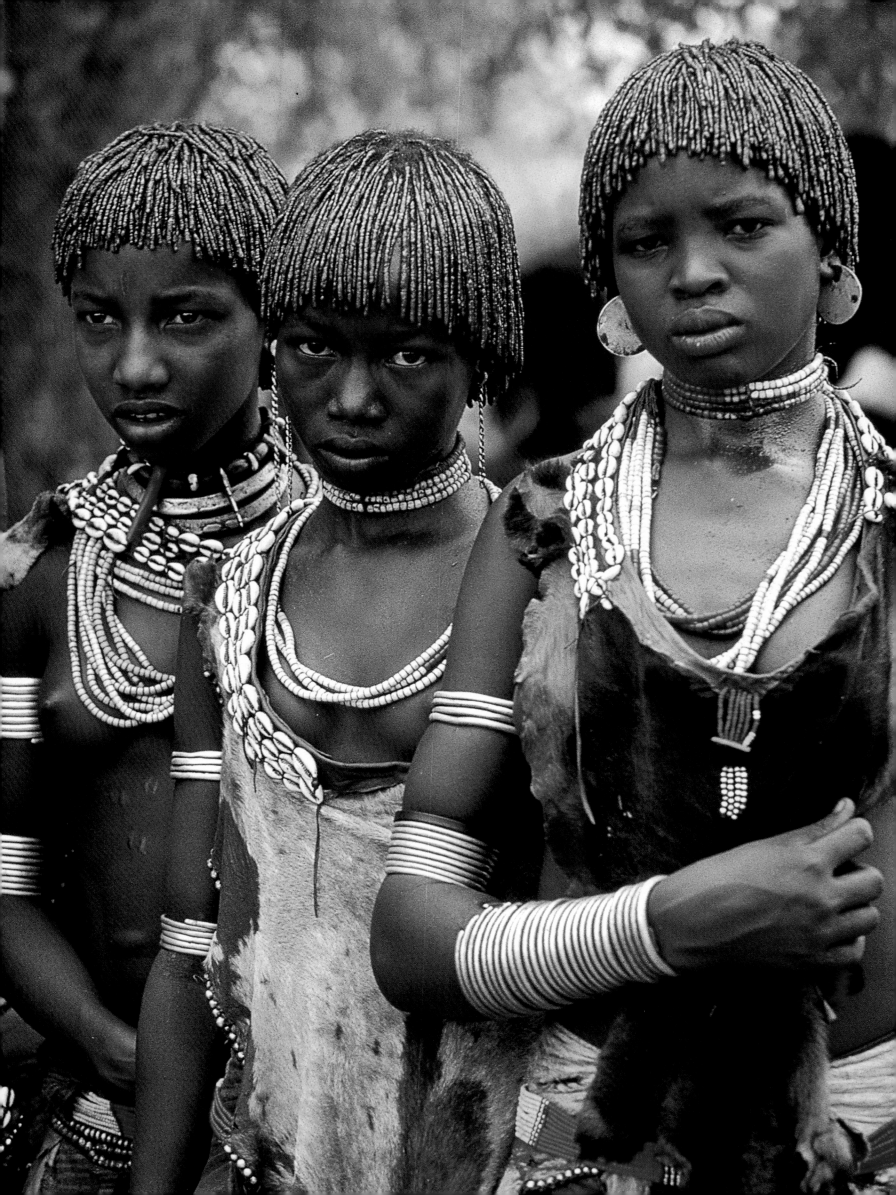

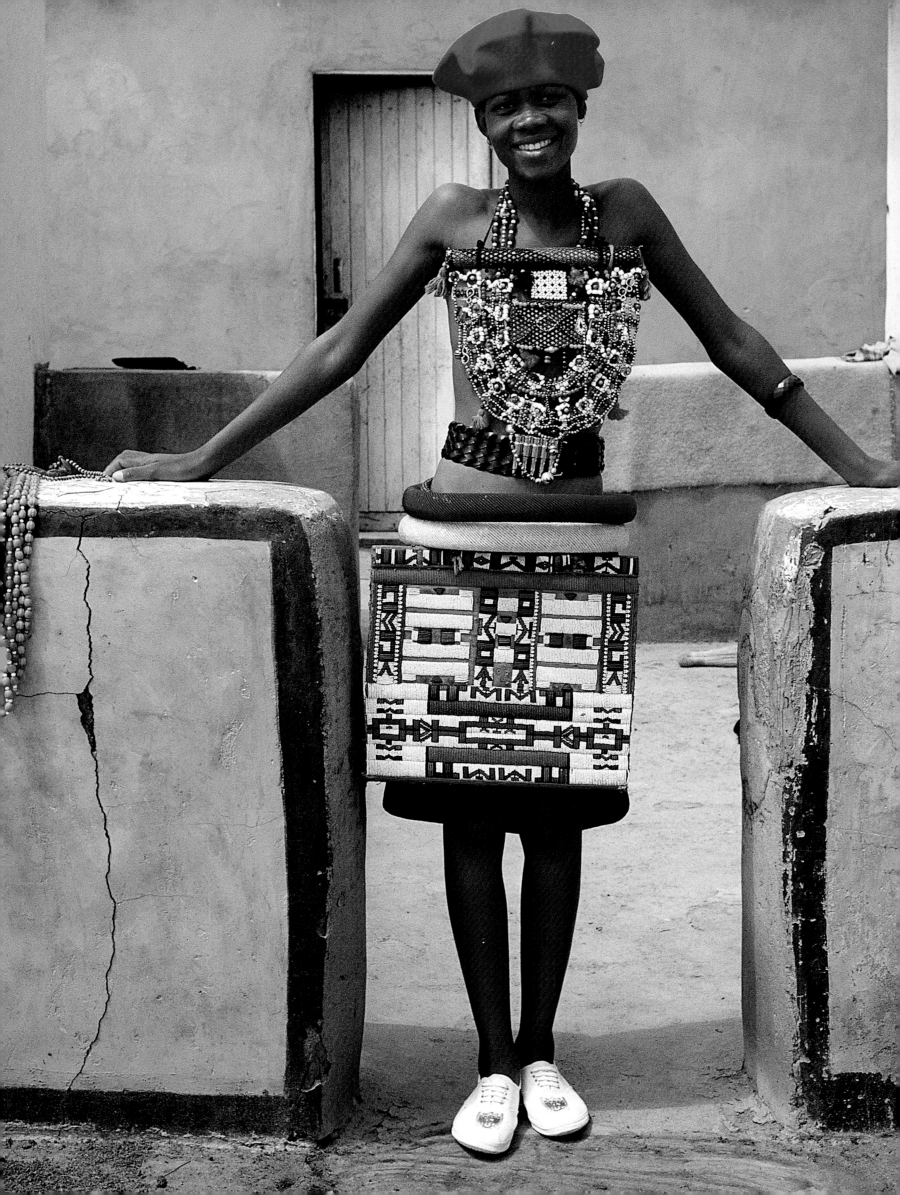

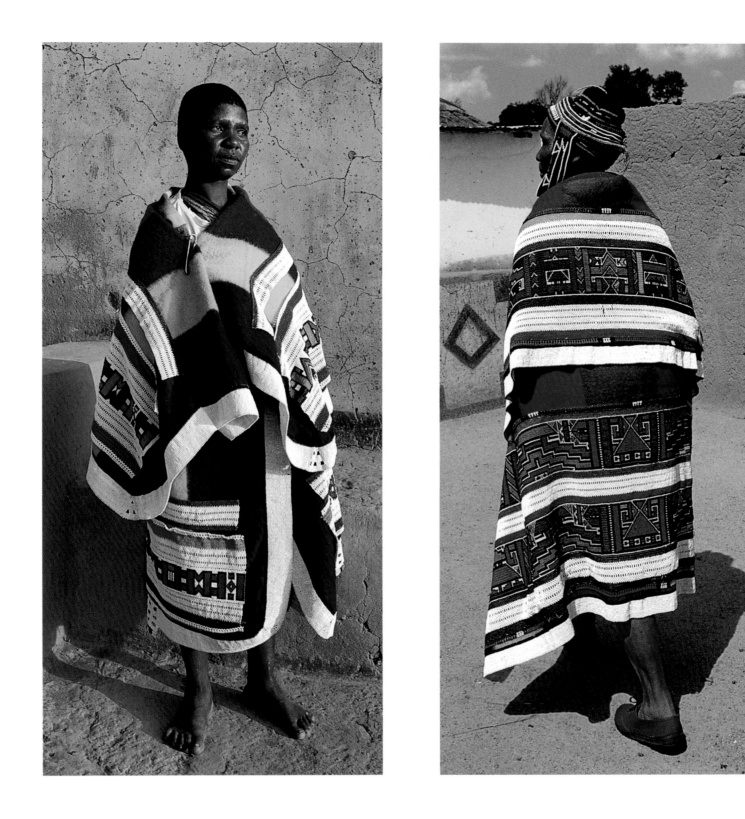

OPPOSITE: *A young, modern Ndebele woman of South Africa wears the traditional beaded apron, or isiphephetu,*
worn only by unmarried women, and combines it with a very untraditional chest covering.

ABOVE: *The impressive Ndebele marriage blanket, or nguba, is worn by married women outside the home.*
The simple design and sparing use of motifs on the lefthand blanket suggests it was made as long ago as the 1920s,
while the blanket worn on the right is typical of designs made in the 1960s.

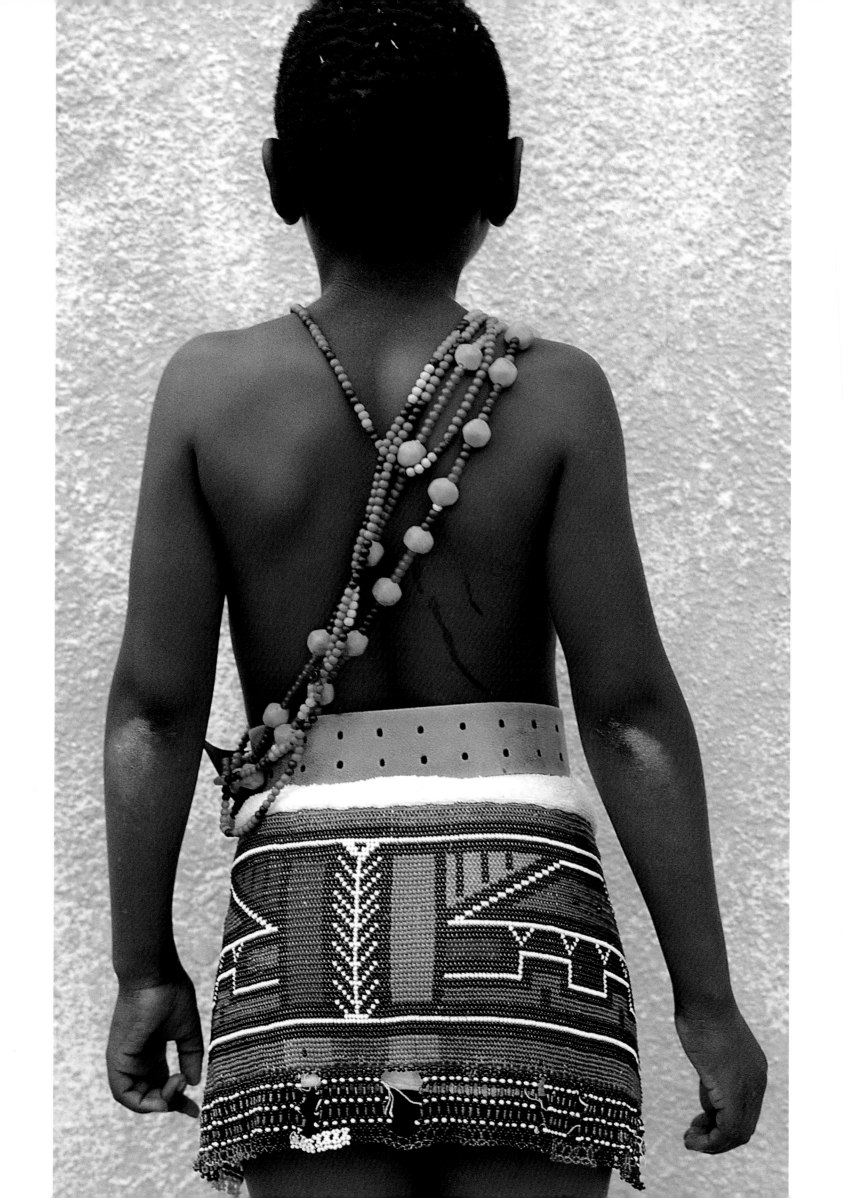

pattern as they needed more land for their growing population. In the mid-19th century, the Ndebele splintered into a number of factions, and, in the 1880s, a destructive war with the Afrikaans-speaking white settlers of the former Transvaal effectively destroyed their traditional way of life. The remnants of one faction, the Ndzundza, gathered at Roos-Senekal, and, in 1974, the apartheid government created the KwaNdebele 'homeland' for them. The Ndebele are thought to number about one million people today.

Thanks to their distinctive appearance and their vivid style of house painting, the Ndzundza Ndebele are instantly recognizable. Their house painting and beadwork are mirror images of each other. The exuberance of the objects and patterns created by the Ndebele may be a visible expression of their tumultuous history and a celebration of their survival.

Ndebele beadwork shares the attributes of beadwork throughout Southern and East Africa: it is specific to stages of life, and closely follows recognized and codified shapes. The beadwork is highly developed, elaborate and technically superb. It uses the same small glass beads that are favoured by the Maasai and Samburu. Yet the effect is unique, both in the shape of the pieces produced and in the designs used on them.

Ndebele beadwork is created by the women and reflects two worlds: that of the maker and wearer, as well as the world she has seen and incorporated into her work. One of the original design elements, worked on a huge scale, was the safety razor blade. Although its use faded, the razor-blade design lives on because it is pleasing to the artist. An Ndebele woman takes designs – from objects she has seen in the world around her, in the homes of people she has worked for or in magazines – and re-creates them in beads or paint. These 'aspirational' aspects of Ndebele art and craft include light bulbs, aeroplanes and telephone poles – objects that relate to modern life.

In older work, white beads were used extensively, with only small designs to break up the surface. Then, starting in the 1930s and 1940s, the beadwork underwent a revolution. Multicoloured design elements took up more of the surface, with white beads forming the background. For a period in the 1970s, blue and purple beads predominated, densely covering the surface, with the white beads used only for outlining. More recent work has moved toward a more varied palette.

Ndebele women make both plain and patterned beadwork. The monochrome work is a circle of beads, worked on a core of wild grasses. Called *izigolwani*, these rings are stacked up on the legs from ankle to knee, forcing the wearer to walk with her legs slightly

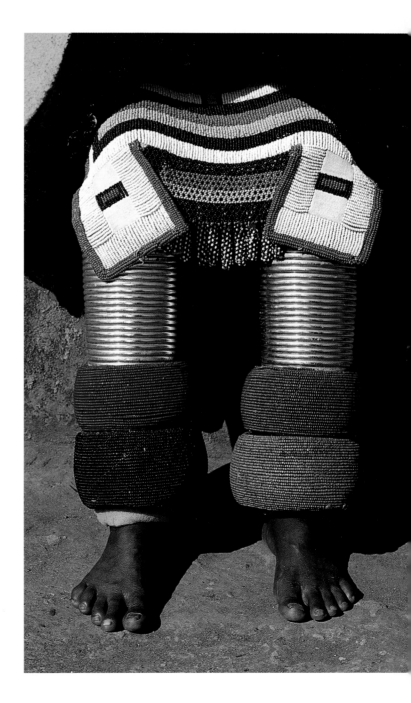

OPPOSITE: *Before undergoing initiation rituals, Ndebele girls wear beaded skirts made for this time in their lives.*

BELOW: *The Ndebele sew glass beads onto tubes to form the leg rings called* izigolwani. *The beaded marriage apron is made of the same beads.*

apart. Sometimes a woman will wear a single *golwani*, of great dimension, around her neck. More comfortable to wear are the large-diameter *izigolwani* that rest on the shoulders and frame the traditional brass neck rings called *dzilla*, which are used to stretch the neck. Similar rings are also worn on the ankles, in association with the *izigolwani*.

The Ndebele woman's artistic ingenuity comes to the fore in the variety of beaded 'aprons' that denote the marital status of the wearer. The first, and smallest, is the *lighabi*, a tiny loin cover with suspended beaded tassels worn by girls. Simple zigzag patterns or other geometric designs are formed into a band at the top of these small aprons.

When a girl undergoes initiation rites, during which she learns the ways of her people, she is given the *isiphephetu*, a stiff beaded apron. If her mother is a talented beader, this may be very intricately worked. Themes are developed in rows of beaded sections. Houses, light bulbs and aeroplanes are common. Aeroplanes, in particular, feature so often in the designs that they are known as *Ufly* in the Ndebele language. Since the aprons cover only the front, there is an associated backskirt called the *isithimba*, made of leather that is sparsely beaded.

Specific beadwork, such as the beaded bridal train called a *inyoga* (meaning 'snake'), is made for a wedding ceremony. The train is about twelve centimetres (five inches) wide and is worn hanging down the woman's back, suspended like a pennant on a wall. A married Ndebele woman is easily recognized by her marriage apron – either the *liphotu* or the *ijogolo*. The *liphotu* is considered the simpler, less formal apron although it is similarly beaded all over and measures sixty centimetres by sixty centimetres (two feet by two feet). It may be beaded on goatskin or canvas. The *ijogolo* is distinguished by five rounded panels at the bottom; these represent the proven fertility of the woman, as the *ijogolo* is worn only after the woman has had children. Bearing children finalizes the marriage; a woman without children is only a wife, but a mother has value and status within the community.

After a son has returned from his initiation ceremony, a mother wears the *linga koba* (long tears). This piece is made of two narrow beaded strips, worn attached to a headband, suspended from either side of her head. The name derives from the woman's sorrow at losing her son to the next stage of his life. Unlike the beaded aprons, it is made without backing, on a mesh network of thread. It is

A rare example of the older style of Ndebele beadwork, produced from the 1880s to the 1920s. It features simple geometric motifs on a background of closely worked white beads.

considered one of the rarest of the Ndebele beaded items for this very reason – the lack of backing material makes the pieces likely to disintegrate over time. The beads are not lost but are instead used to make new pieces.

A beaded blanket is the married woman's traditional outer garment. The blanket might have one strip of beading or many strips. A fully beaded blanket may weigh as much as four and a half kilograms (ten pounds). Whether elaborately beaded or simply decorated, the blanket is an essential item of apparel for the Ndebele woman whenever she is outside her home.

Ndebele designs are readily adaptable to other objects and easily imitated, resulting in an explosion of geometric designs. It is even said that the South African

This richly beaded isiphephetu, *worn only by an unmarried Ndebele woman, combines geometric forms in a distinctive pattern.*

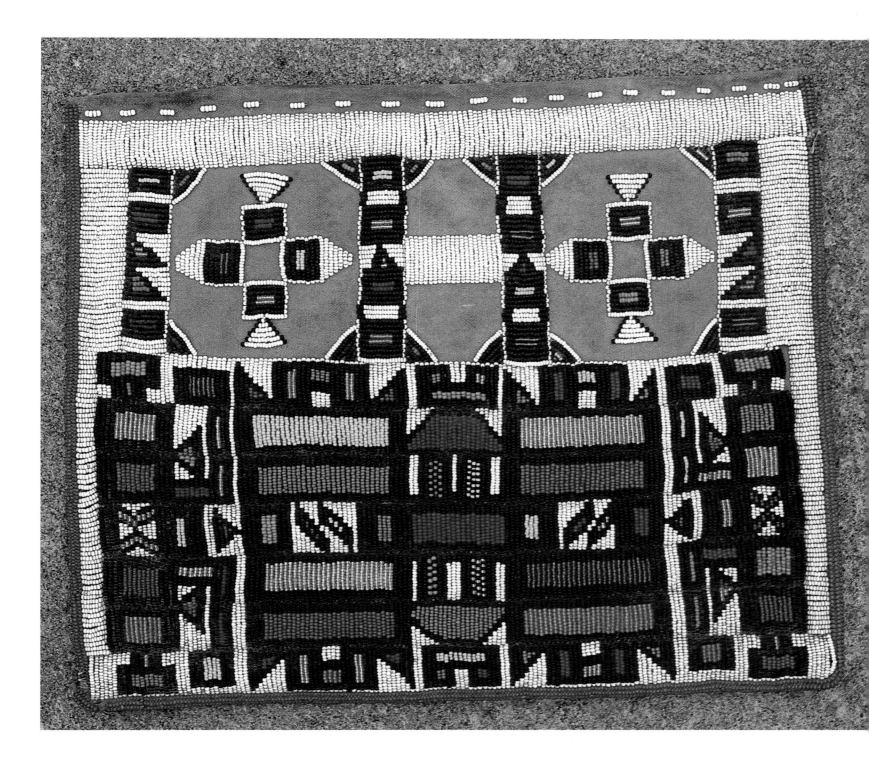

flag takes its inspiration from Ndebele design. The beadwork has gained in value, in particular the older pieces. Today, Ndebele designs are found on everything from wheelbarrows, mugs and magazine advertisements to a beaded and painted radio created by Emily Mmasanabo. Automobile manufacturer BMW even commissioned Esther Mahlangu to paint one of its luxury automobiles in an Ndebele pattern. The car has been exhibited all over the world and now graces posters, signed by Esther when she makes personal appearances.

ZULU

In the early part of the 19th century, Zulu warriors were feared throughout Southern Africa. Their fierce leader Shaka changed the face of the region during his brief reign (1816–1828) by inventing a short stabbing spear called the *iklwa*, as well as new tactics to encircle an enemy, leaving no way to escape. His successors continued these warring ways with devastating effect. In 1879, Cetshwayo, a nephew of Shaka, led the Zulu to victory at Isandlwana, where they became the first black army to defeat a British military force. The humiliated British set out to crush the Zulu once and for all. In the next confrontation, at Ulundi, they roundly defeated the Zulu army and finally brought Zululand under British control. Today, the Zulu form what may be the single largest cultural group in Southern Africa, numbering about eight million people, some five million of whom live in the South African province of KwaZulu-Natal.

Imported beads reached Southern Africa as early as the 8th century, and were traded by Arabs or local middlemen for the region's ivory and gold resources. When the Portuguese first arrived along the Indian Ocean coastline and landed in Delagoa Bay, they quickly established trading posts. By the 16th century, small, brightly coloured glass beads were available to the local inhabitants. The beads spread throughout the region, and by the end of the 18th century had reached the northern part of what is now KwaZulu-Natal – about the same time as the Zulu people were being forged into a cohesive cultural group under Dingiswayo. Beads became so highly valued that Dingiswayo, uncle of Shaka, claimed their trade as his personal privilege. This monopoly was continued by Shaka and later Zulu kings. The increased availability of beads soon led to regional preferences for colours, and traders had to keep up with the trends or be excluded from the market. Beads quickly assumed a monetary role, dividing those with means from those without.

As in the rest of Southern Africa, much of the material evidence of Zulu culture was suppressed by missionaries who campaigned for the end of such customs as women baring their breasts in public until they were married, the extensive use of beadwork in ornamentation and the wearing of traditional clothing. Today, the beadwork is kept alive in rural areas, where many of the people live, and in homesteads closer to the cities where tourist purchases help to support traditional crafts.

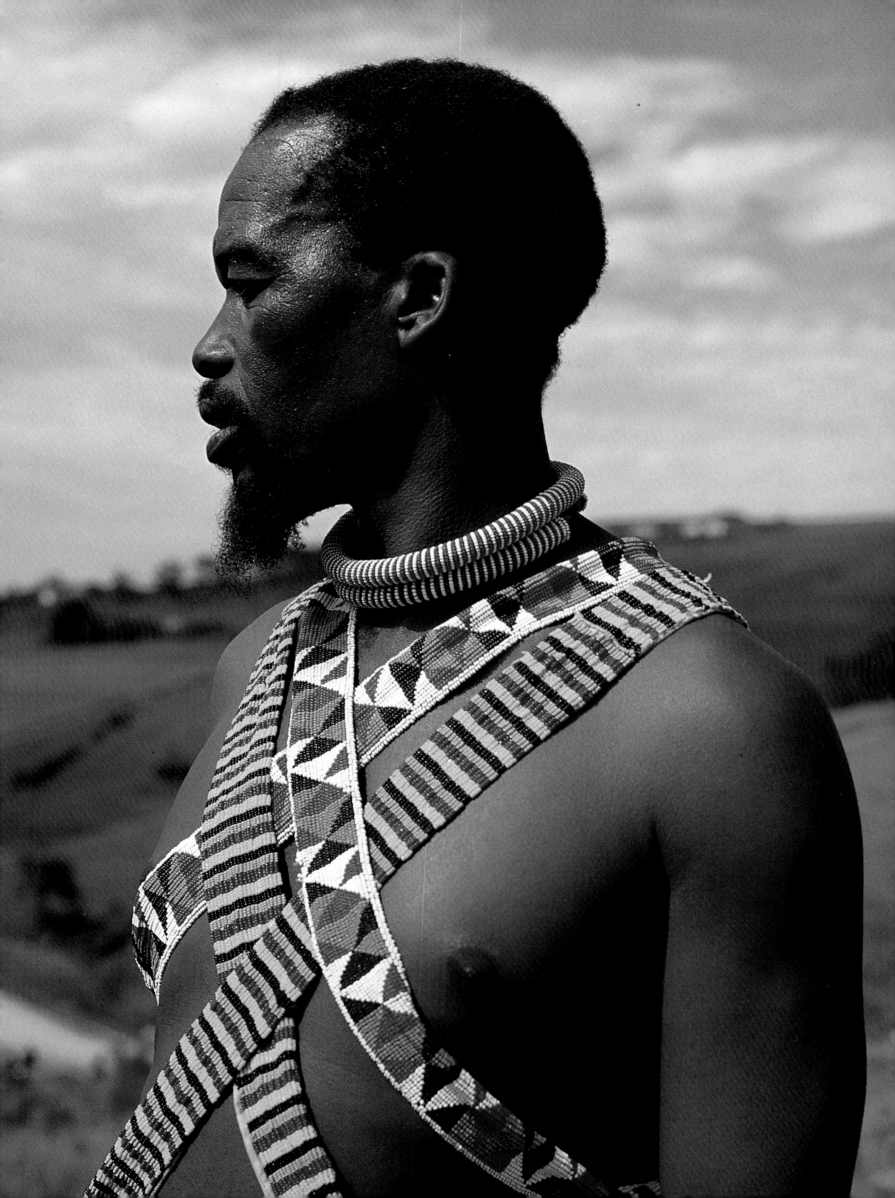

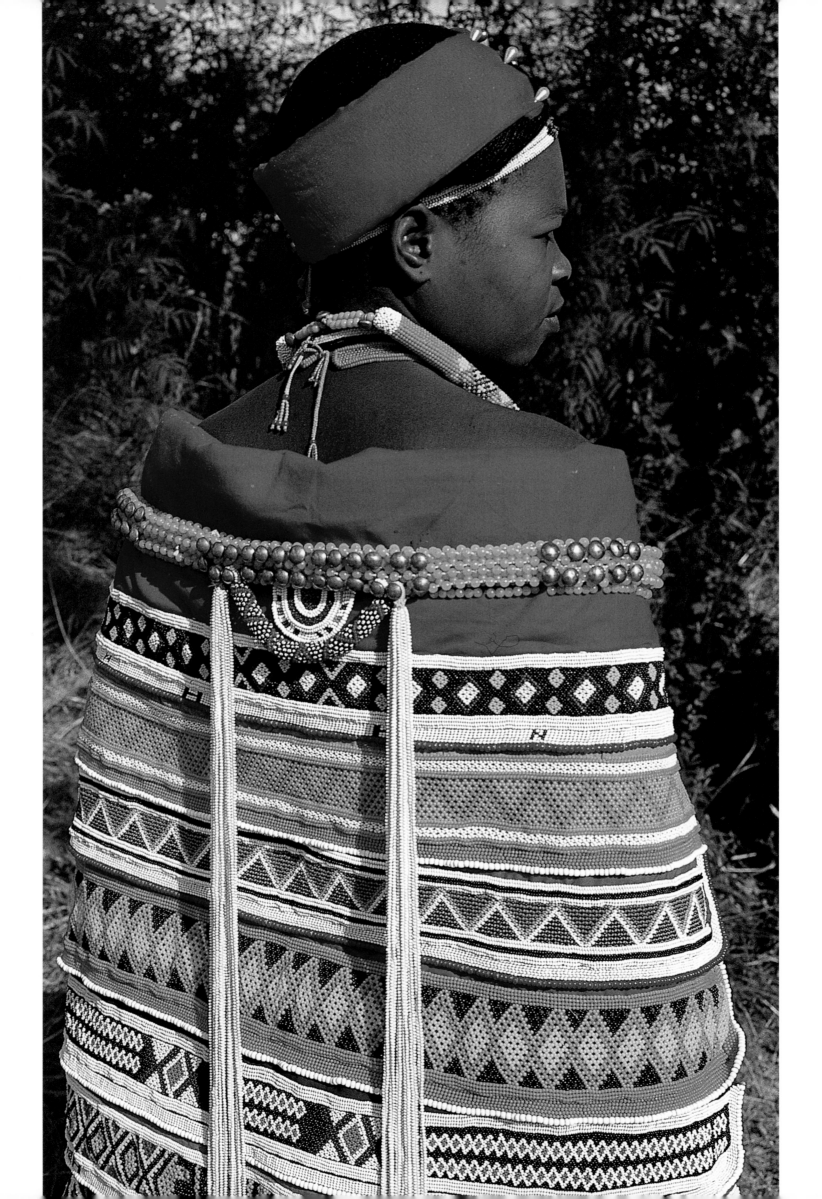

The rural nature of life in the Zulu homeland, especially in the more remote areas, forms a natural barrier to Westernization. The most traditional of the Zulu are subsistence farmers who have little connection with the country as a whole or even with their urbanized cousins. But, as the Zulu continue to enter urban areas, their use of traditional clothing and beadwork will ebb, for such dress and ornament finds no place in the cities.

It is not only urbanization that affects the Zulu style. Regional differences in dress are considerable, a reflection of the large numbers of Zulu people and the vast size of the land they inhabit. Those who live in the southernmost reaches of KwaZulu-Natal are strongly influenced by the traditions of the neighbouring Xhosa people. Their beadwork and clothing are markedly different from the Zulu who live in the heart of KwaZulu-Natal, near the Tugela River. Different types of capes, cloaks, belts and aprons are worn in various regions. Even the size, colour and patterns of the beads varies from north to south.

The formidable geography of the Drakensberg Mountains, in the western margins of the province, helps to create differences by separating Zulu lineages. In some areas, people wear traditional dress on a daily basis. Elsewhere, it is worn only for ceremonial occasions such as weddings and rites of passage.

Traditional Zulu beaded garments included skirts or girdles worn by unmarried girls. Married women wear beaded aprons over leather skirts, some with beaded sections on fabric skirts. Capes or cloaks are also worn by married women, and the styles vary widely. Cloaks covered all over with beadwork are made and worn by wealthy married women. Men and unmarried girls may display beaded bands across their chests. Most patterns are simple geometric designs, often chevrons worked in a rainbow of colours. Beads are sewn onto leather or wrapped around a tightly coiled length of grass, bound up with cotton. Tubes of cotton are also used to support beaded neck rings.

In spite of variations in dress, certain items carry universal messages. The traditional married woman's hat is derived from 19th-century hairstyles, and is made of tightly woven fibres that have been dyed red. Shapes vary, with the wider, round hat favoured by those who live south of the Tugela River, and taller, narrower hats worn by those north of the river. Whatever the shape, beadwork bands ornament the hats on the base or the crown – or both, according to the region and the wearer.

Certain colours convey specific meanings for the Zulu, although these meanings are not uniform amongst all Zulu. Blue denotes loneliness; it may mean 'I will wait for you'. Green is for the grass; it implies 'I will wait until I am as thin as a blade of grass' or that 'my love is as sweet as a shoot of new grass'.

OPPOSITE: *A magnificent Zulu beaded cape, worn by a woman from the Estcourt region of South Africa in the mid-1970s. This cape was used only on ceremonial occasions.*

BELOW: *Viewed from above, a married Zulu woman's headdress is richly adorned with beaded bands featuring a shield motif. The woven hat is stiffened into a puffed, platter shape.*

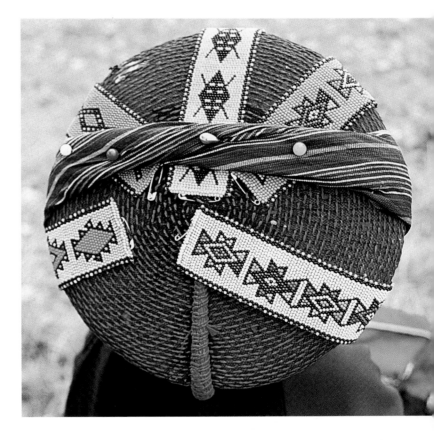

White is for purity; it communicates the message that 'My heart is clear and pure and I am waiting for you'. Red is for love, and indicates that 'My heart is bleeding for you'. Yellow is for jealousy, and says 'I am jealous but I shall still love you'. Pink is for poverty; it means 'You are wasting your money and have no cows to pay for my *lobola* (bride wealth) and I don't love you'.

Because the colours of the beads carry such specific meaning, they were used to carry messages known as *ucu*, a term that translates loosely as 'love letters'. Some of these are specific in their meaning while others incorporate words more for aesthetic appeal. These beautiful, silent messengers can tell the state of a romance. A girl cannot accept a boy simply by telling him in so many words. She must give him a special necklace. Some of these messages are deeply coded, the meaning known only to the maker and perhaps one intended 'reader'.

Zulu traditional healers, or *izangoma*, are often women, and wear distinctive beaded headpieces which obscure their faces behind a veil of predominantly white beads. A great *sangoma* is accorded the respect of a chief. The *sangoma* is a positive force, a person who can give advice about a sickness. She, or he, differs from a *nyanga*, who casts spells. The *sangoma* helps chase away evil spirits, and provides a link between the living and the dead – crucial to Zulu culture, which does not divide a person's time on earth between living and dying. According to this view, a person never dies but moves out of his or her body into a spirit form.

In contemporary Zulu life, beadwork is exuberantly individual in pattern and colour combinations while remaining fairly close to the original forms: aprons, cloaks, belts and headpieces. Beads are inextricably tied up with wealth and status, and married and single women still wear items that inform the viewer of their status. Within these constraints, however, items may be piled upon one another to create the most eye-catching display of colour and pattern.

Items made for sale to tourists are sometimes worn by the people, a continuation of the acculturation process that occurs whenever two peoples come into contact with one another. Beaded fertility dolls, which are known in only one area of KwaZulu-Natal, have become a very popular item; the tourist version of these dolls may have facial features while authentic dolls do not. In time, this difference is likely to be lost as the lines between authenticity and commerce continue to blur.

XHOSA

Among the peoples with a beadwork tradition, beaded items can convey powerful messages about a culture. Consider the choice made by Nelson Mandela in August 1962 when he wore his Xhosa beads to appear at his sentencing hearing at the courthouse in Johannesburg. Although he was an attorney who usually dressed in impeccably tailored business suits, on this occasion he chose to wear the beaded clothing of his people. He communicated the message that traditional beadwork is

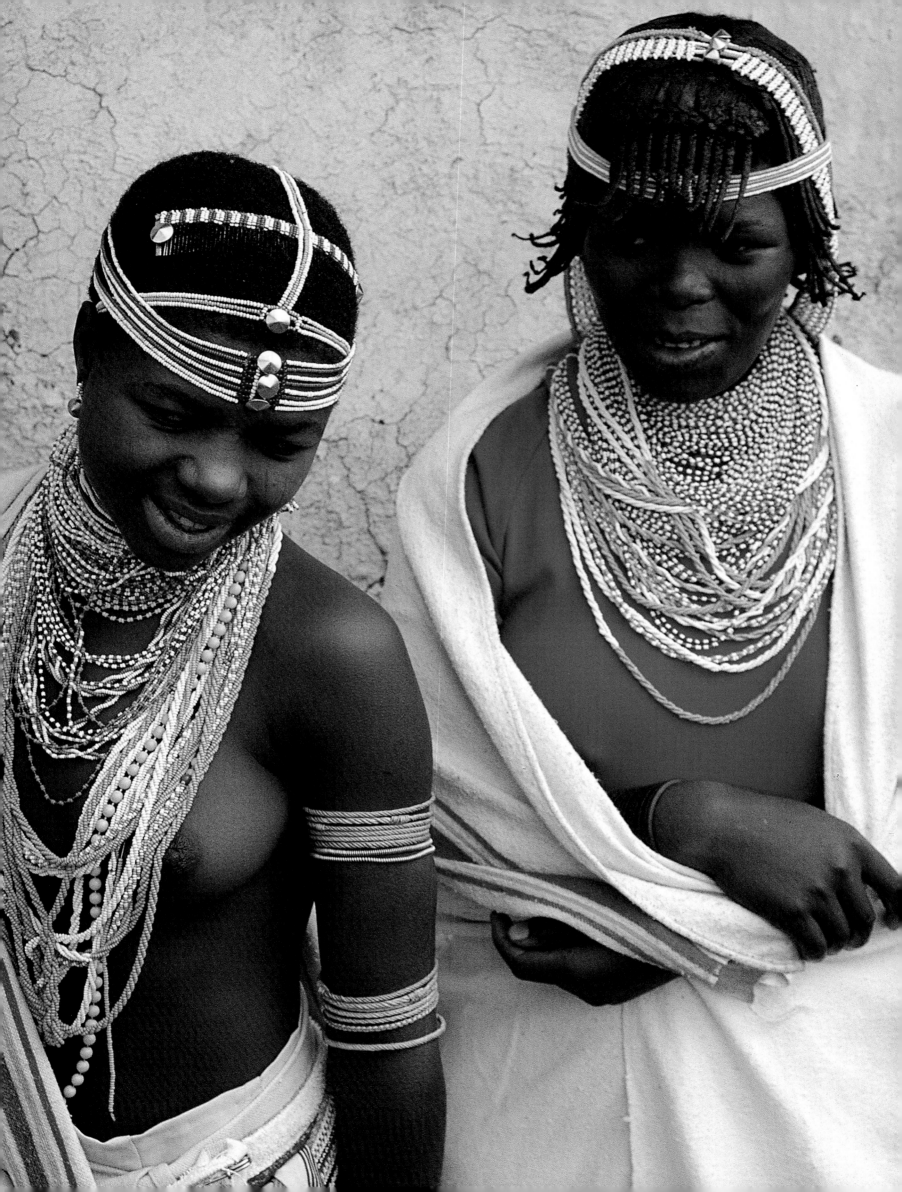

An older Xhosa woman, at a cultural village in South Africa's North-West province, holds a long-stemmed beaded pipe. The universal use of tobacco by Xhosa men and women has led to considerable attention being paid to the creation of pipes. These are often beaded around the stems. Since women use very long-stemmed pipes – in order, it is said, to keep the ashes away from nursing children – their pipes sport elegant, beaded stems. The beading also serves to make the stem cooler to handle.

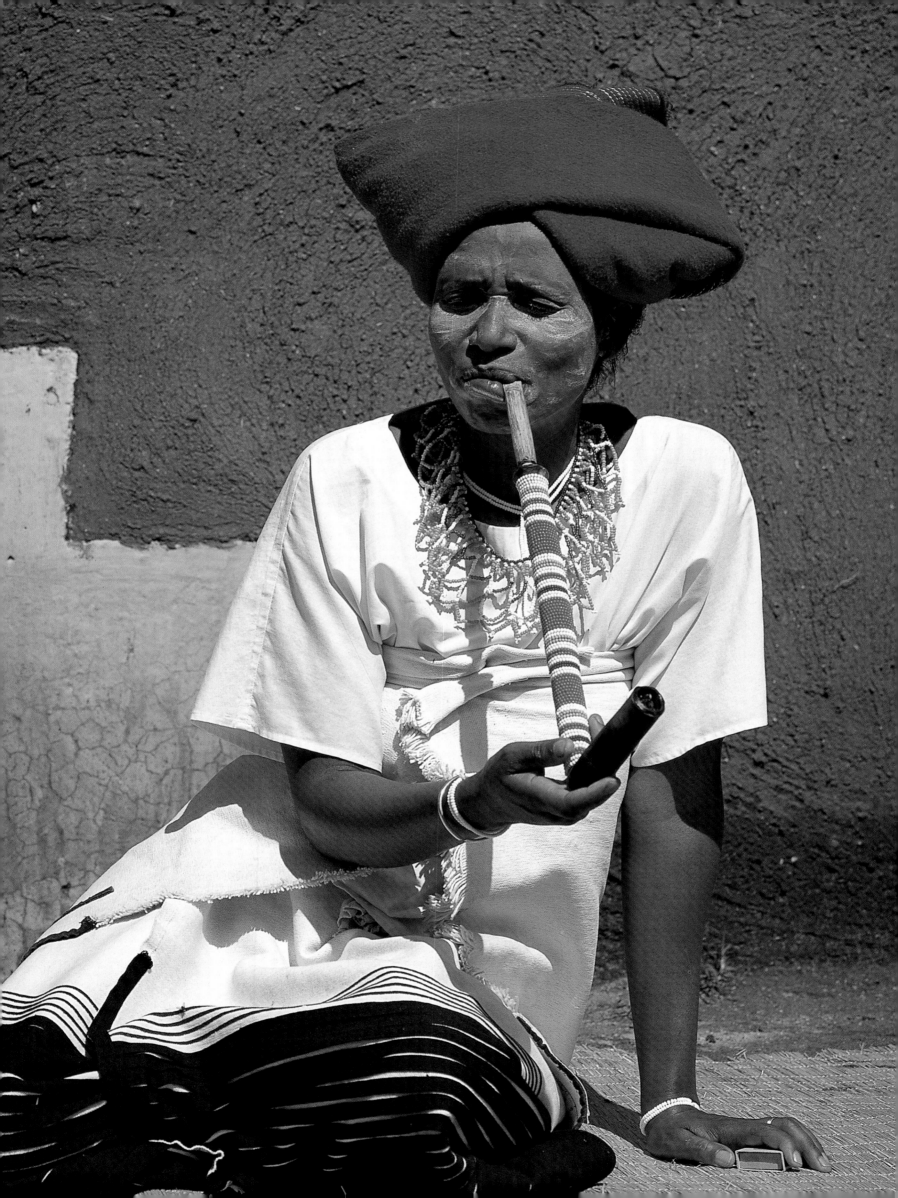

the essential, treasured visual expression of a people, and that only those people could determine how they lived. Implicit was the message that such beadwork symbolized a potent threat to outsiders who would crush that culture and its expression. Some even believed that coded messages with revolutionary content were contained in the beadwork.

Traditionally, the Xhosa lived in the south-eastern part of South Africa along the Indian Ocean coastline, in a territory that ranged as far as one hundred and sixty kilometres (one hundred miles) inland. During the 19th century, the more traditional among them became known as the 'Red Blankets' for their distinctive outer garments, while those who embraced Christianity and Western education became known as 'school' or 'church' people.

Historically, the Xhosa have been closely tied to mystical beliefs. A vision reported by Nongqawuse, a fourteen-year-old Xhosa girl, led them to destroy their cattle and their crops in 1856–1857, believing that, in return, they would be blessed with freedom from the British and an abundance of cattle. Instead, many thousands of Xhosa lost their lives in the ensuing famine. It was the ultimate expression of the Xhosa belief in a magical world.

The same small glass beads used by the Maasai, Samburu, Ndebele and Zulu also formed the basic building block for Xhosa beadwork. These beads were made in Italy and in Bohemia (now part of the Czech Republic), and became highly sought-after in trade between Africans and merchants from Europe and the East. Beads were exchanged for, among other things, land and cattle, copper and ivory.

Xhosa beadwork has been documented as early as the 1820s, when merchants in Cape Town began to import the beads. Frontier outposts were supplied through wholesalers, who sometimes dealt directly with missionaries. Ironically, missionaries were also the principal force aimed at ending the use of beads: once a missionary successfully converted an African to Christianity, traditional beadwork had to go, as it was at odds with the 'proper' dress required of a Christian. Since missionaries often offered the only chance to learn to read and write, many Xhosa gave up their beads to gain this powerful white man's weapon. At the same time, those who continued to wear their beads proclaimed their resistance to the imposition of white rule.

Traditional Xhosa beadwork is made by stitching small glass beads onto backings made from cowhide and goatskin. The beads were sewn with sinew before the women had access to commercially made thread. Because the beads were quite expensive, their use distinguished the wealthy from the rest of the Xhosa society. Beadwork also came to represent a Xhosa woman's dowry.

BELOW: *Detail of the Xhosa woman's dress seen at left on the opposite page. The simplicity of the decoration complements the lacy beadwork necklaces.*

OPPOSITE: *A Xhosa bride (on right in photograph) and her attendant wearing embroidered fabric. Because the Xhosa use beads sparingly, their openwork designs require fewer beads than the extremely dense work produced by the Ndebele.*

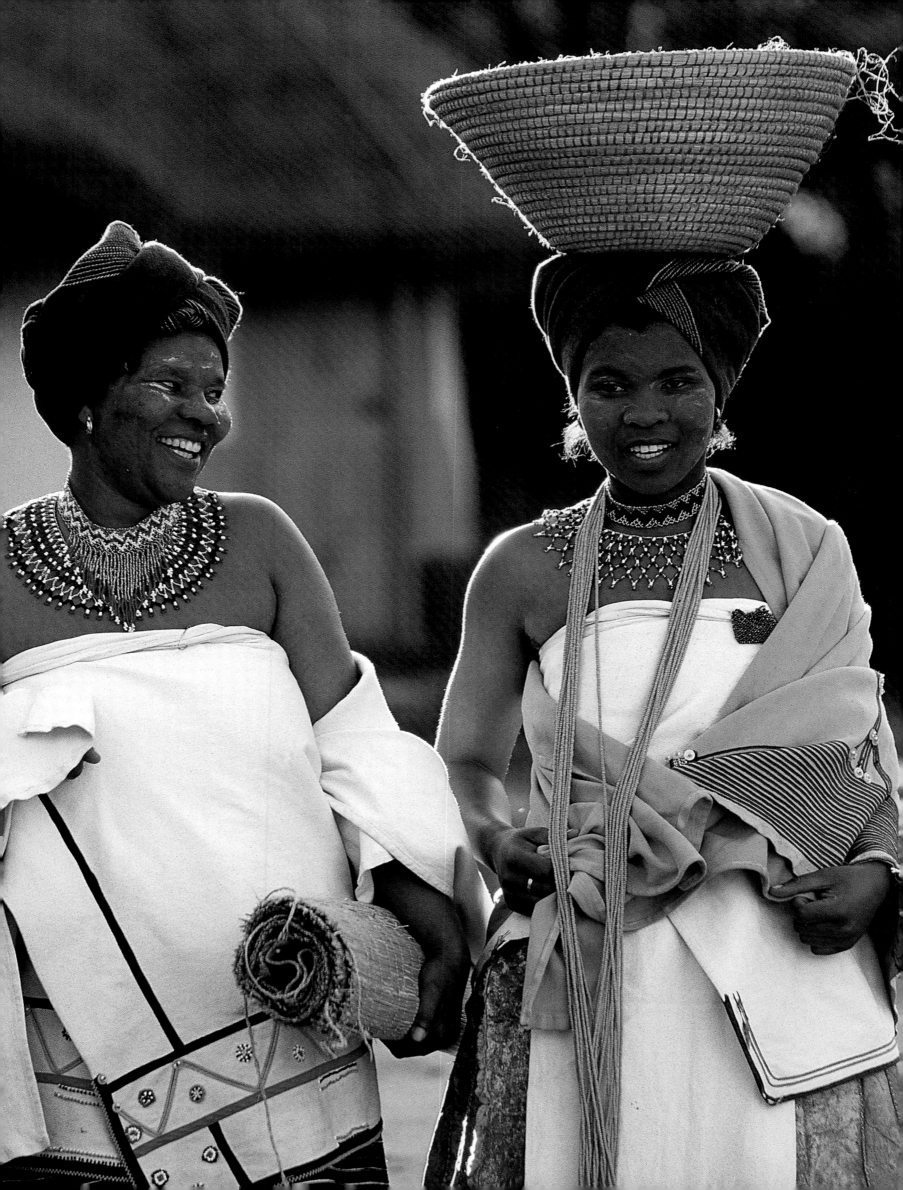

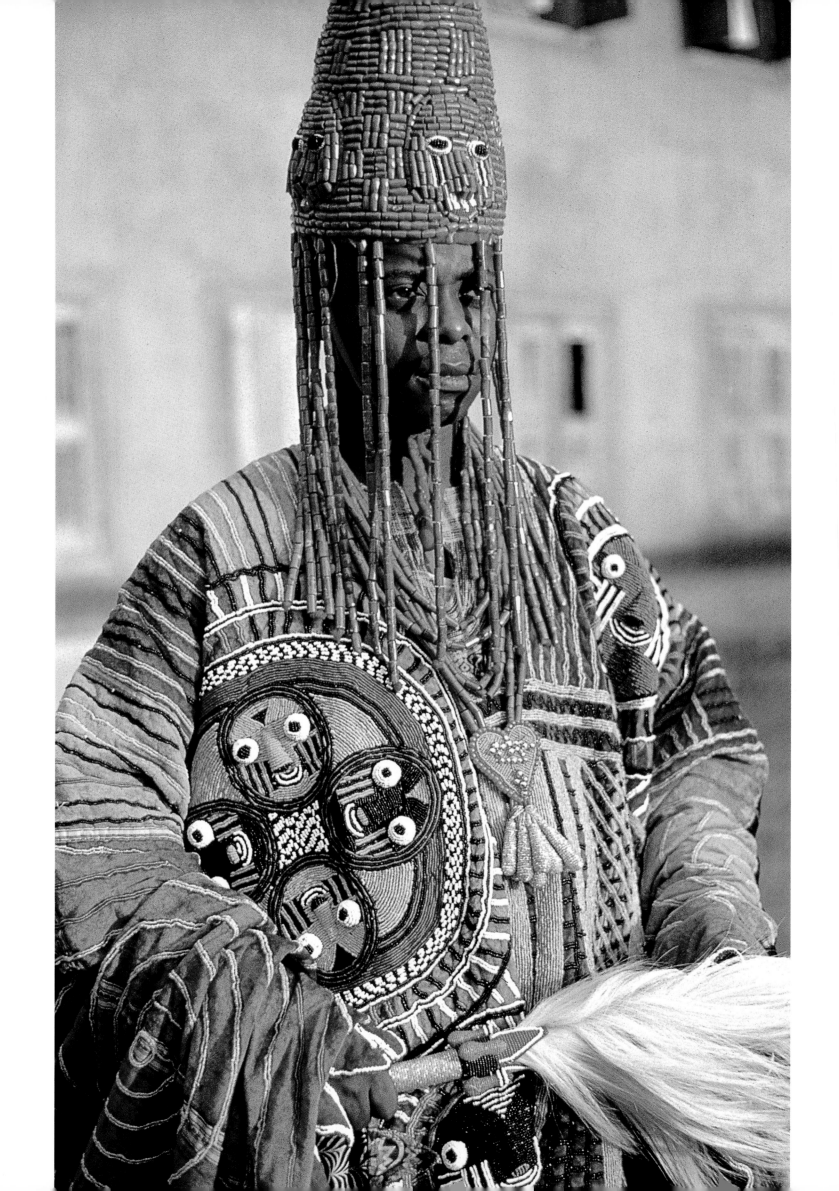

Unlike their counterparts in East Africa and other parts of South Africa, Xhosa men amass and wear quantities of beadwork made by female admirers. A man who is popular with the young women of his region may collect so many pieces he cannot wear them all at one time. One such man, Dumane, was said to have more than seventy pieces of beadwork, ranging from bandoleers to arm and leg bands. Men and women both wear beaded openwork bib collars that resemble lace.

Xhosa beadwork is built upon a vocabulary of traditional motifs. Unique pieces include headdresses made from thousands of white beads, with some pieces supporting dense drapes of single strands of beads. Beaded circles are worn around the waist – as many circles as can be acquired. There are also ritually specific pieces such as the necklaces that are worn by a woman who is nursing and also by a woman who has just had her first child. Once a woman stops nursing, she no longer wears these neckpieces.

There are practical pieces as well, such as beaded blanket pins. A traditionally dressed Xhosa woman always wears a blanket, usually red or yellow ochre, as her outer garment. In place of buttons, the beautifully beaded pins provided the vital closing. The most typical beaded object is a tobacco bag, worn draped over one shoulder by mature men. Beaded motifs, often in the form of 'love letters', are stitched onto a goatskin backing with beaded tassels attached at the ends.

Unlike the rigid collars of the Maasai or the constricting *izigolwani* of the Ndebele, Xhosa beadwork moves easily with the wearer. Pieces are placed on top of one another, in a very definite order. Individuals vie for attention with the variety and quantity of beadwork they wear. The openwork designs enable the beader to create an article that covers a large area while using relatively few beads.

White is the predominant colour in Xhosa beadwork and has always been closely identified with the culture. The *igqira* (diviner) and *ixhwele* (herbalist) wear white beads exclusively. In addition to white, favoured colours are red, pink and multiple shades of blue – particularly dark blue, sky blue and turquoise – which are used with an eye to aesthetic rather than symbolic appeal. Some shades of red are not acceptable, while the Thembu lineage favours a particular deep blue.

Although governed by very strict conventions, Xhosa beadwork is strikingly individualistic. Supple and inventive, it reflects the personality and temperament of the people who make and wear it. Xhosa beadwork is exuberant and personal, and occupies a unique place in the history of beadwork in Southern Africa.

ROYAL BEADWORK

The beadwork of the Yoruba of western Nigeria reveals a completely different notion of the place of beads within a culture. While the beadwork of East and Southern Africa is made and used by people at all levels of the cultures, Yoruba beadwork stands out because its use is so highly restricted.

OPPOSITE: *Among the Yoruba of Nigeria, beadwork is reserved for the ruling elite. This fringed crown and heavily beaded dress is worn by Oda Ademuwagun Adesida II, the Deji of Akure. The three-dimensional appearance of the face motif is achieved through the use of padding underneath.*

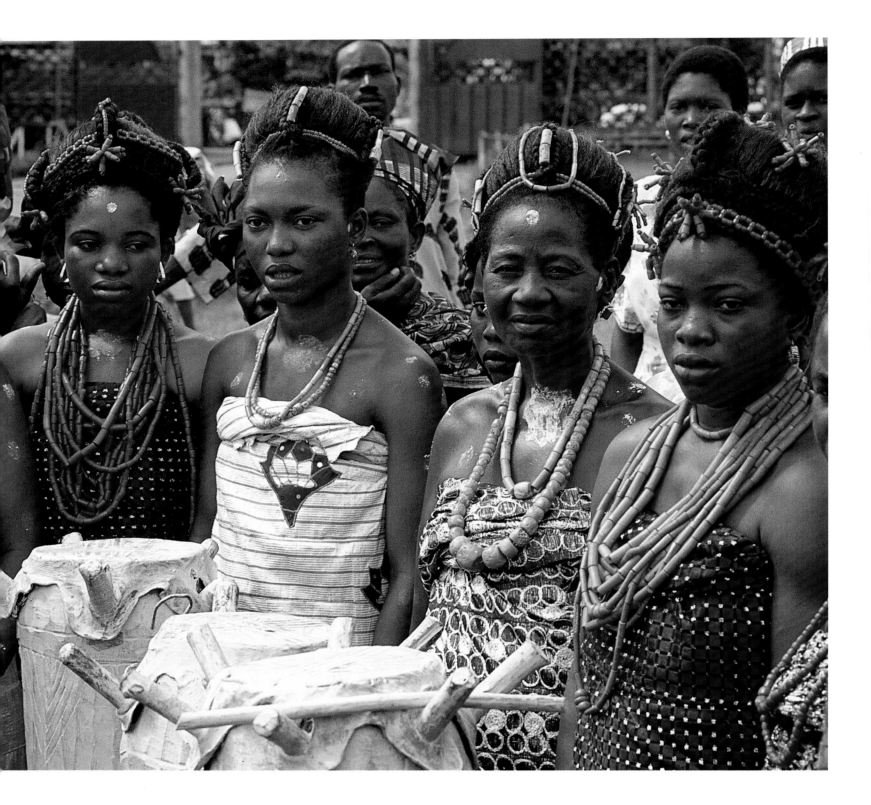

ABOVE: *The beads worn by these Nigerian women are made of coral, a material acquired through trade.*

OPPOSITE: *This Wodaabe woman of Niger wears customary beaded jewellery even as she pounds millet.*

With a population of some twelve million centred in the south-western Nigerian states of Ogun and Oyo, as well as Lagos State and the neighbouring country of Benin, the Yoruba dominate their region. Historically, the Yoruba comprised a series of more than two dozen kingdoms, each operating as a city-state. Chief among these was Ile-Ife, where the Yoruba believe the earth itself was created. The Yoruba are thought to have inhabited the same region for more than a thousand years, but far more than sheer numbers or even longevity accounts for their importance in the world of crafts.

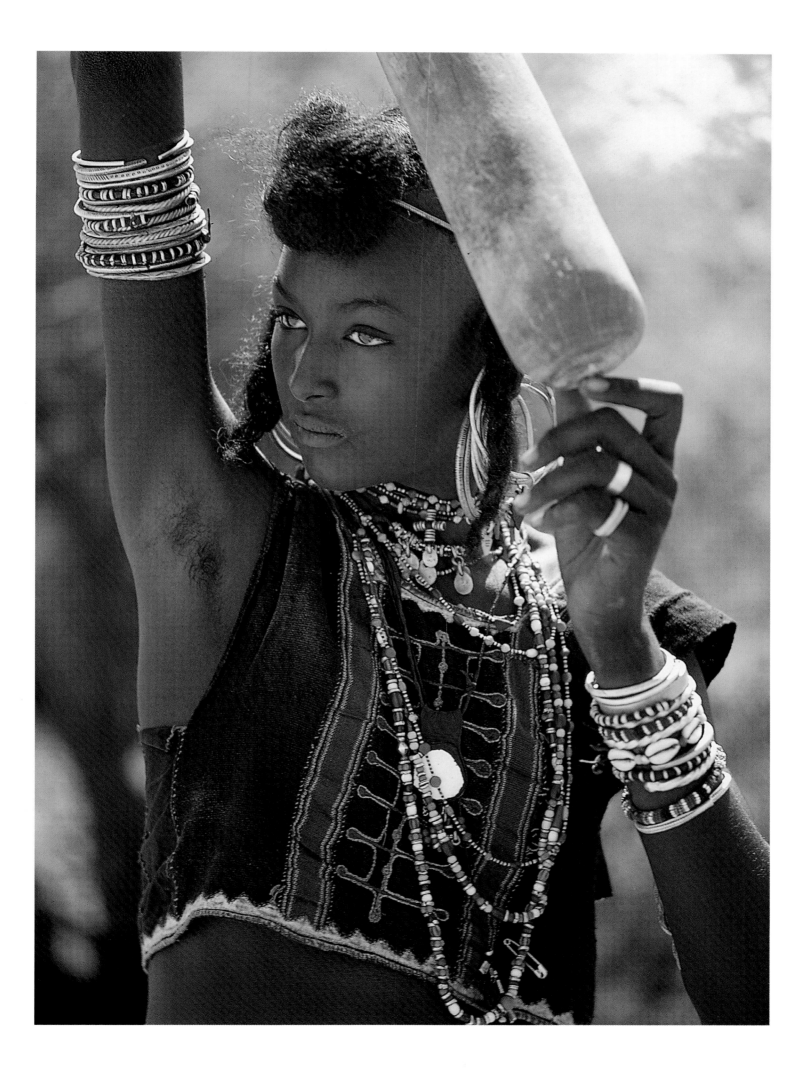

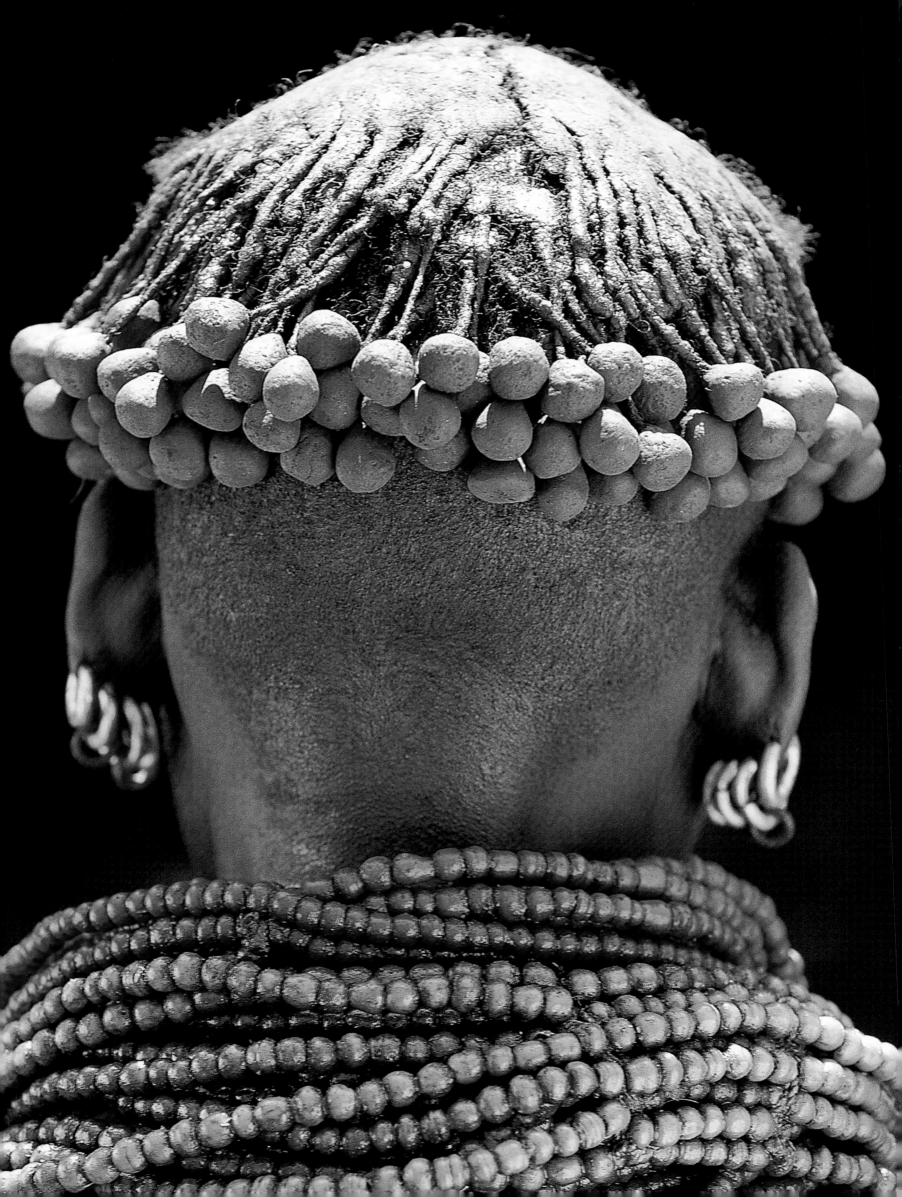

The use of beads among the Yoruba dates from the mid-17th century when beads were imported as part of the West African slave trade. Prior to that, crowns were made of coral, brought in by the Portuguese at the end of the 15th century. Some cowrie-shell crowns may still be found; cowrie shells and beads hand made of local agate or jasper were used even before coral.

The extraordinary beadwork of the Yoruba is a flamboyant expression of the belief that their kings, or *obas*, are direct descendants of the god Oduduwa. Only the *obas*, who number more than seven hundred, are permitted to wear or use the beautifully beaded objects that embody Yoruba belief. All Yoruba beadwork – right down to their unique beaded slippers – is restricted to royal use. The main beaded objects – crown, slippers and fly whisk – were made to order for the *obas*. Each *oba* had his own crown maker, who was a bead specialist. Only a few bead-workers remain, and these travel around making beadwork for the royal families.

Yoruba beadwork covers every surface, imbuing the pieces with rich imagery, sheer weight and a sense of luxury. The *oba* appears ceremonially dressed in a fully beaded floor-length cape. His slippers are beaded all over, with individual toes. His royal feet rest on beaded footrests, and he reclines on a beaded pillow.

Of all the pieces of beadwork made for royalty, the beaded crown is supreme. It is the most important symbol of Yoruba kingship because it represents the authority of the *oba* himself. The crown is built up from a base of palm ribs that are covered with starched white cloth. The beading is done over the cloth, and features such as eyes and noses may be brought into relief with additional backing.

The beaded crown always has an image that represents *okin*, the royal bird, whose single, long tail feather makes it easily recognizable. In spite of its tiny size, about seven and a half centimetres (three inches) in length, it is considered the 'king' of birds and a worthy symbol for the *oba*. Full-size representations of the bird, beaded all over, are often found perched on the crown. They have a startling realism, and look as if they are about to fly away. The crown also has a fringe of beads, intended to hide the *oba*'s face from view and mask his identity. Multiple faces worked in coloured beads suggest the constant presence of the *oba*, everywhere. It is the office that the crown celebrates, rather than the person wearing it.

The *oba* is submerged in the power of the dynasty, all of it made tangible in the crown. Many colours are combined on a crown to show that the people are united in the *oba*. The crown is not only the symbol of the king's magic power, it also provides him with immunity from attack.

For the Yoruba, just as for the Maasai, Samburu, Ndebele, Zulu and Xhosa, beads have helped to shape cultural beliefs, ornament, trade and expressions of status. The differences between the various beadworking traditions show that cultures are not shaped by material but rather shape it to their own liking. Just as artists working in widely differing styles may use the same kind of paint, African beaders have created a wide body of work that expresses their cultural differences.

OPPOSITE: *Strands of bright beads highlight the ochre used on the hairdo of this Bumi woman from southern Ethiopia. Each tiny braid is tipped with a ball of dried mud.*

PAINT & BODY DECORATION

The desire for decoration is universal. Decoration can be as ephemeral as a daily coating of chalk or ochre, or as lasting as prehistoric rock art. Whereas in Central and West Africa a person may be transformed with a mask, in cultures where body painting is practised, people accomplish the transformation with their bodies. This is one of the most striking elements of African decoration. Among the Ndebele of South Africa, for example, decoration focuses on wall painting, while Kenya's Kamba people produce beautifully decorated gourds. But whether the surface used as the canvas is as soft as a human face or as hard and unyielding as a rock, whether the medium is painting or etching, decoration always conveys messages and information.

Using his entire body as a canvas, this Karo man from southern Ethiopia creates a pattern of dots.
Paint is usually applied before a celebration or a dance.

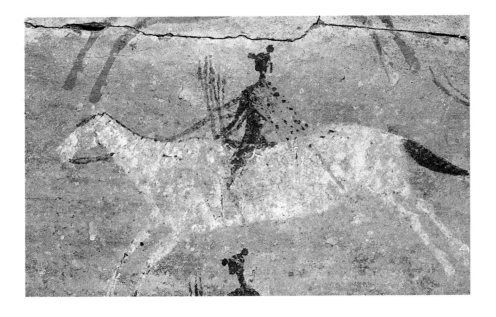

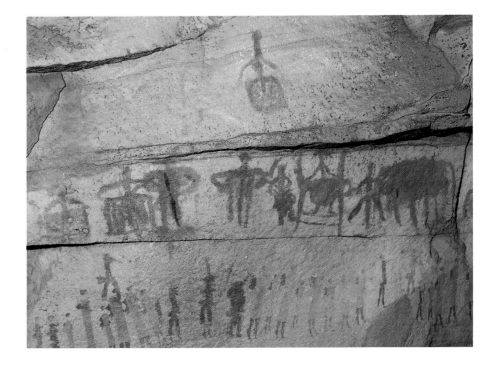

Today, people use decoration to express personal status, to frighten or excite, or to beautify a useful object. Paint is used on masks, and on walls and leather clothing; it is applied to the body itself to create patterns of beauty and intrigue, and as part of coming of age ceremonies.

Decoration identifies and unites people by lineage, age group, or gender. In traditional cultures, it marks people in the most positive way possible, through a sharing of symbols that can be read at a glance. A man or woman who grows up knowing these symbols is thoroughly connected to that culture.

PAINTINGS ON ROCK

Paintings on rock faces and in caves are the world's oldest known art form, and express the human thirst to capture and share a vision that transcends language. African cave and rock paintings that date back nearly thirty thousand years establish a link with the ancestors of today's African peoples. Rock art is found throughout the continent, from the Atlas Mountains in the north to Namibia and South Africa in the south, from Mali in the west to Ethiopia in the east. These

TOP AND ABOVE: *The earliest life of Africa is depicted in San (Bushmen) paintings found on cave walls. These vividly portray the daily life and the wildlife of the region.*

paintings illustrate a need to record and celebrate the history of the peoples.

Over the ages, people have moved in response to changes in geography, geology and climate. Some of these changes are recorded on the continent's stone walls. Nowhere is this more evident than in the Sahara where wall paintings reveal that this arid wilderness was once a fertile land of lakes, rivers and game animals. When the climate changed, the lakes and rivers dried up. Some time before 1000 BC, the inhabitants of the region migrated to the south and east. From paintings found on a wall at Tibesti, in Niger, we know that giraffe once thrived in what is now the nation of Chad. Only close observation of these and other animals could have enabled the artists to record them so faithfully. Today, Chad is deep within the Sahara and giraffe no longer race across the landscape.

Rock paintings are plentiful throughout Southern Africa, from the Cedarberg and Drakensberg in South Africa to Twyfelfontein, north of the Brandberg in northern Namibia. Some of the paintings found in Namibia date to 27,500–25,500 BC, which places them among the earliest found in the whole of Africa. Their creators, known as Stone Age people because of the implements they used, left such evidence at many sites in Africa.

In central Tanzania, the archaeologists Mary and Louis Leakey studied and documented the paintings of Stone Age inhabitants of the region. Prolific paintings of animals indicate that they were abundant at the time, and hunters are also depicted. Though most of the animals are drawn only in outline form, they can be easily recognized. As the paintings faded, new ones were added, often superimposed, but the traces of the old paints can still be seen. The extremely dry air of

A trio of San (Bushmen) hunters march across the wall of a cave near Vanrhynsdorp in the Western Cape province of South Africa.

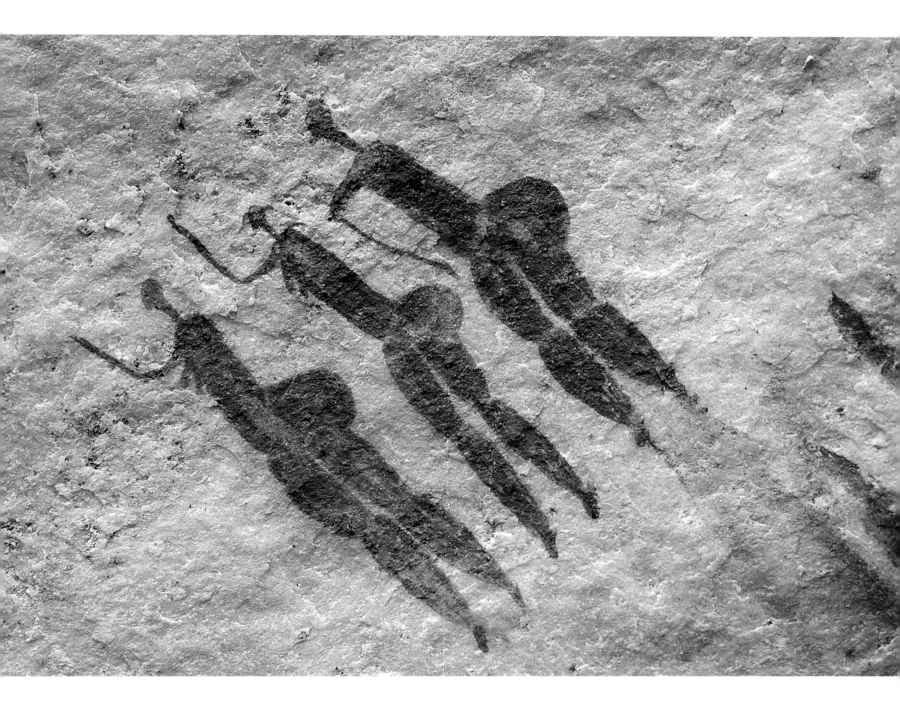

the region kept the paintings fresh enough to be seen even today. Rhino, elephant, ostrich and various antelopes may be identified at a glance from their characteristic profiles, and their horns and antlers. Animal skin clothing is clearly shown on elongated human figures, with variations such as cloaks, back aprons and skirts, some figures even sporting earrings. Musical instruments and dwellings are also portrayed. These paintings have endured because they were executed on granite, an extremely hard rock that is resistant to erosion.

More recent paintings may be seen at various sites in Zimbabwe, for instance, in the Matopos Hills, and near Bulawayo and Harare. Paintings found in the vicinity of Marondera, seventy-four kilometres (forty-six miles) south-east of Harare, are very recent, dating to the first millennium AD.

WALL PAINTING

In a very small area of South Africa, a handful of Ndebele women keep alive the fifty-year-old tradition of painting their houses. In spite of the limited number of people practising this art and its brief history, Ndebele wall-painting motifs have become as well known as any symbol associated with South Africa. Although some of the images used are taken from the relatively small pieces of Ndebele beadwork, the paintings are executed on an enormous scale. Ndebele women have the ability to greatly enlarge a symbol – representing, for example, a house – without losing the sense of the design or its proportions. It is this skill, as well as their superb artistic ability, that defines this outstanding craft. The artwork is the exclusive province of the women; the men build the houses but it is the women who decorate them. Because most of the paints used in the past were made from natural dyes, they washed away during the rains and had to be reapplied every year. Even the bright commercial paints that are used today require frequent retouching.

Ndebele wall painting was first observed in the 1940s, and is thought to be an outgrowth of the 19th-century practice of tracing patterns on the outer walls of homes before the mud-dung mixture was dry. The earliest paints were made from natural colourants, which were soft and muted. When commercial paints became available, the palette brightened considerably, and became the vivid range of today.

OPPOSITE: *An Ndebele woman wearing dzilla – the brass and copper neck and arm rings. Her house painting features a strong geometric design. A detail from an Ndebele wall painting* (below) *features similar strong abstract forms and vivid colours.*

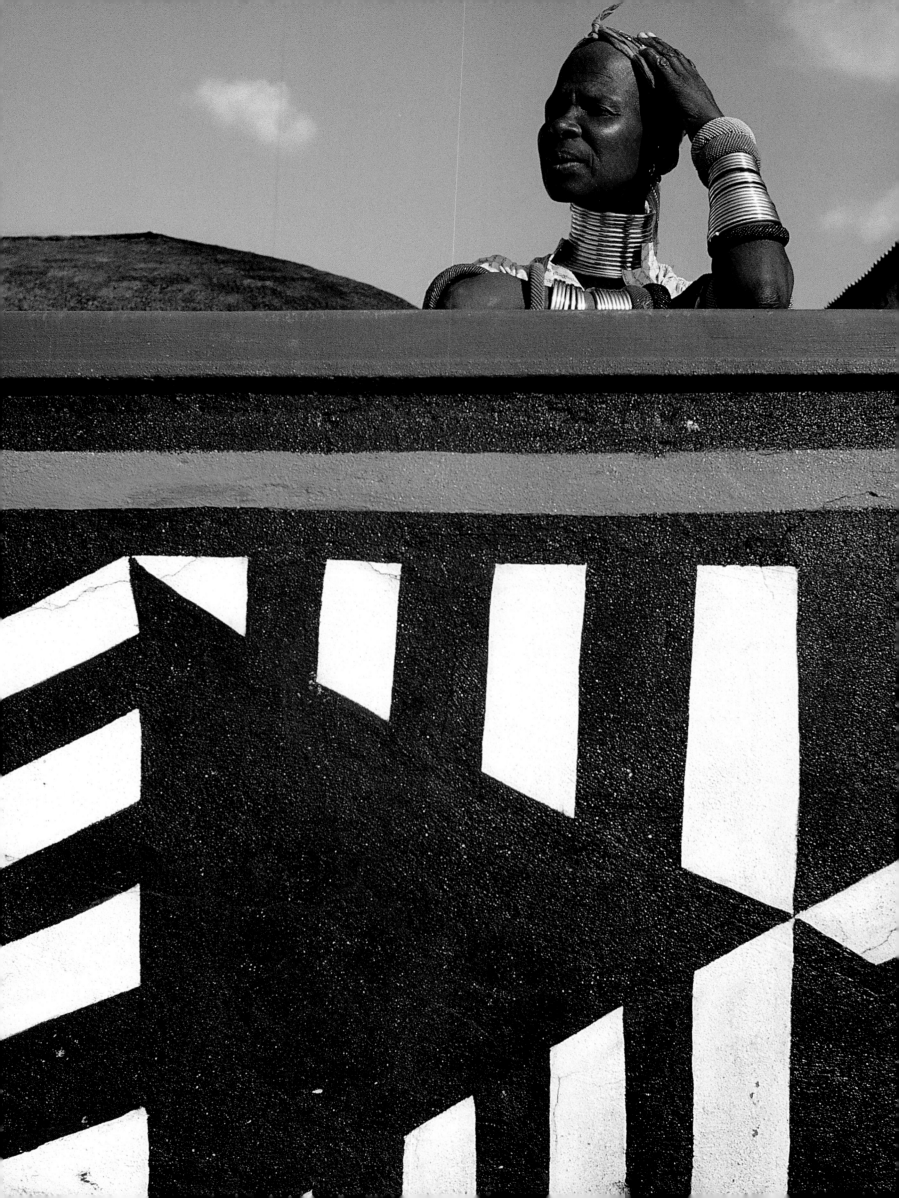

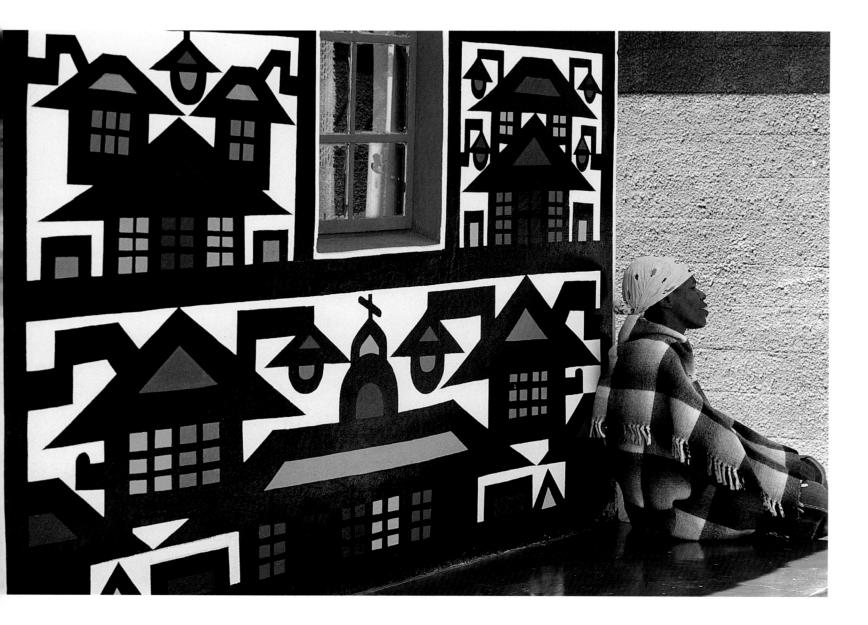

An Ndebele wall painting by Margaret Skosana, who is shown seated outside her house. The highly stylized street lights above the houses capture the aspirational quality of Ndebele art, which is entirely created by women.

The skill of the women is particularly remarkable since they work completely freehand. Esther Mahlangu, one of the acknowledged stars of the Ndebele world, offers this explanation for being able to draw straight lines along the length of a wall: 'My lines are straight because my heart is pure'.

The frequent upheavals that have marked Ndebele history are said to have inspired their unique style of house painting, which shouts, loud and clear, 'Here live Ndebele people'. However, this does not explain why many other people in Southern Africa who suffered similar upheavals did not respond with similarly brilliant art. The whole history of the black peoples of South Africa is one of forced removals to hard, infertile land. Even among other African people who do wall painting, there is no correlation between that painting and their ornamental beadwork, as there is among the Ndebele.

When the Ndebele moved from building grass houses to mud and dung structures, they traced decorations on the plaster walls. The repetitive patterns created with the fingers in the drying mud and dung plaster were designed to protect the

Text on wall painting: ITS- LWE J KAIZER YAEC LILAND

house from the spirits that cause sickness and misfortune. If a house were covered with designs, the ancestors would be pleased, but a house without such designs was liable to be visited by illness. The symbols and colours used for house painting do not seem to have ritual significance. When colour came to be used in house decoration, this protective quality appears to have disappeared. The colours, the shapes, even the performance, seems guided more by personal choice than by custom, even though it all follows very much the same book of themes.

A detail of Margaret Skosana's house, featuring the Ufly motif. Aeroplanes like this have figured in Ndebele wall painting since the 1960s.

BODY DECORATION

No ornament or adornment is more personal than face and body painting, and the use of the body as a canvas is a widespread practice in sub-Saharan Africa. Among the Nuba of the Kordofan province of Sudan in north-eastern Africa, body painting is the people's visual expression of art. Young Nuba men 'dress' exclusively in paint. They cover their naked bodies with ochre or with ash and then draw

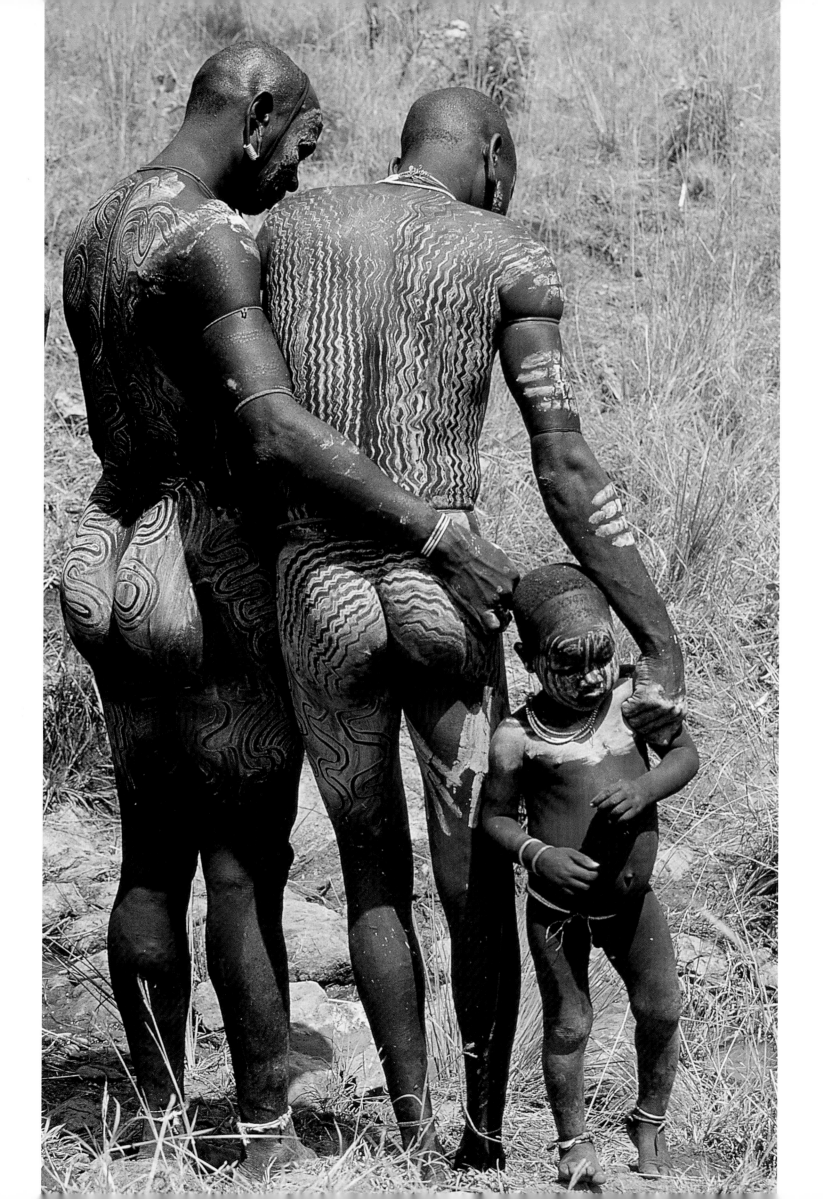

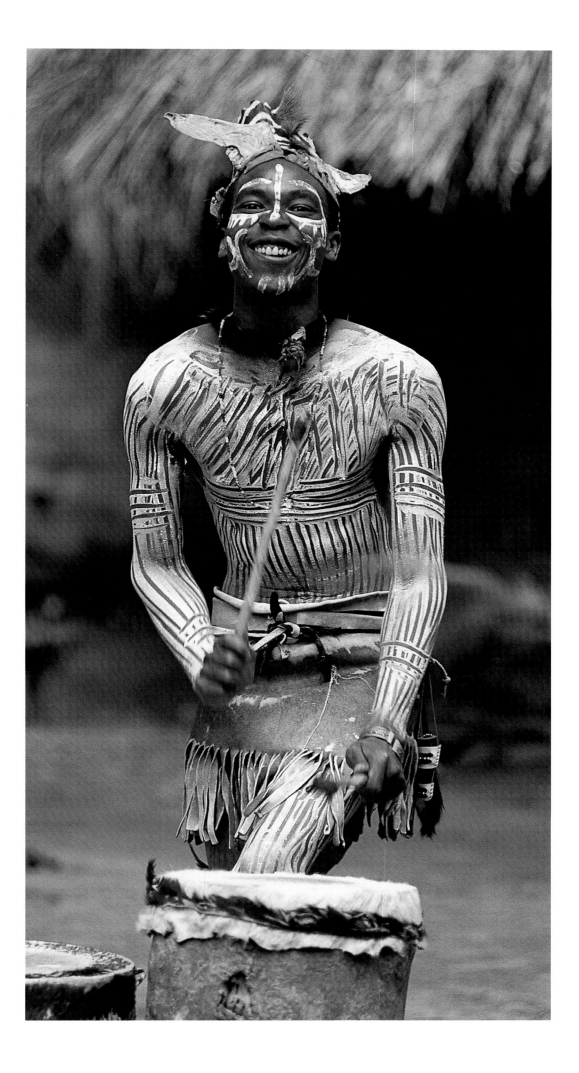

OPPOSITE: *Surma men with a child, along the Omo River of Ethiopia. The men cover their bodies with a mixture of chalk and water and then draw the patterns with their fingers.*

LEFT: *A traditional Kikuyu drummer from Kenya decorates his body with patterns drawn through a chalk mixture. Kikuyu men, like people in other cultures, draw the patterns on one another.*

OPPOSITE: *Bumi women of Ethiopia undergo scarification to emphasize their beauty. Each cut is carefully made and rubbed with ash to ensure it will result in a welt.*

patterns through the coating with their fingers, creating a white-on-brown or brown-on-white effect. In addition to beautifying the body, the ash is believed to impart strength to these young warriors. It also has medicinal qualities, helping to keep the bare skin clean and providing protection from insects. Each morning they 'put on' a new outfit by creating a fresh design in a new coat of ash.

In the extreme south-west of Ethiopia, where the land borders on Sudan and barely touches the northernmost part of Kenya, a number of cultures, including the Surma, Karo and Bumi, exist in very close proximity to each other on both sides of the Omo River. This region is remote and barren, yet these people have heightened their precarious existence by living in a state of perpetual hostility. In spite of their difficult lives, all these people practise the art of body painting, and their flamboyant appearance contrasts vividly with their surroundings.

Surma men paint their bodies and their faces as a means of emphasizing their physical beauty and intimidating their foes. They cover their skin with a mixture of locally available chalk and water, upon which they draw patterns – similar to the way the Nuba decorate themselves with ash. Each day they create a new design, starting just above the knees and covering the entire body, including the genitalia and the face. The men engage in fierce stick fights among themselves, which are fought nearly to the point of death. The fights are watched by the girls, whose faces and cheeks are painted with flowers and geometric patterns.

Using the same chalk mixture as the men, Surma children enjoy painting their legs white and decorating their entire faces with white stars on the nose, forehead, cheeks, and especially around the eyes. The children often duplicate the same pattern on a close friend, which makes them look like twins.

The Surma are still known to wear lip disks. Young women of marriageable age pierce their lower lip and then insert a small clay disk. The skin is stretched as each successively larger disk is inserted, until the desired size is reached. Within about six months the skin has become elastic enough for the disk or plate to be easily removed. There is a correlation between the size of disk and the cattle dowry or bride wealth that the family expects to receive for this girl. Surma women make the plates themselves using locally available clay. The clay is coloured with ochre and charcoal, and then baked like any other piece of pottery. The wearing of a lip plate involves its own etiquette: the plate must always be worn in front of men and is removed only when eating or sleeping.

The neighbouring Karo people of the Lower Omo River delight in painting their faces and bodies with dotted designs created with chalk. The patterns emulate the look of guinea fowl, and are painted before a dance or ceremony. In addition to chalk, local substances are used to make yellow and black paints which are combined to produce bright varicoloured patterns all over the face and chest.

Karo women display extensive scarification. Cuts are made in the form of numerous dots or small dashes that combine to create an overall pattern. To raise

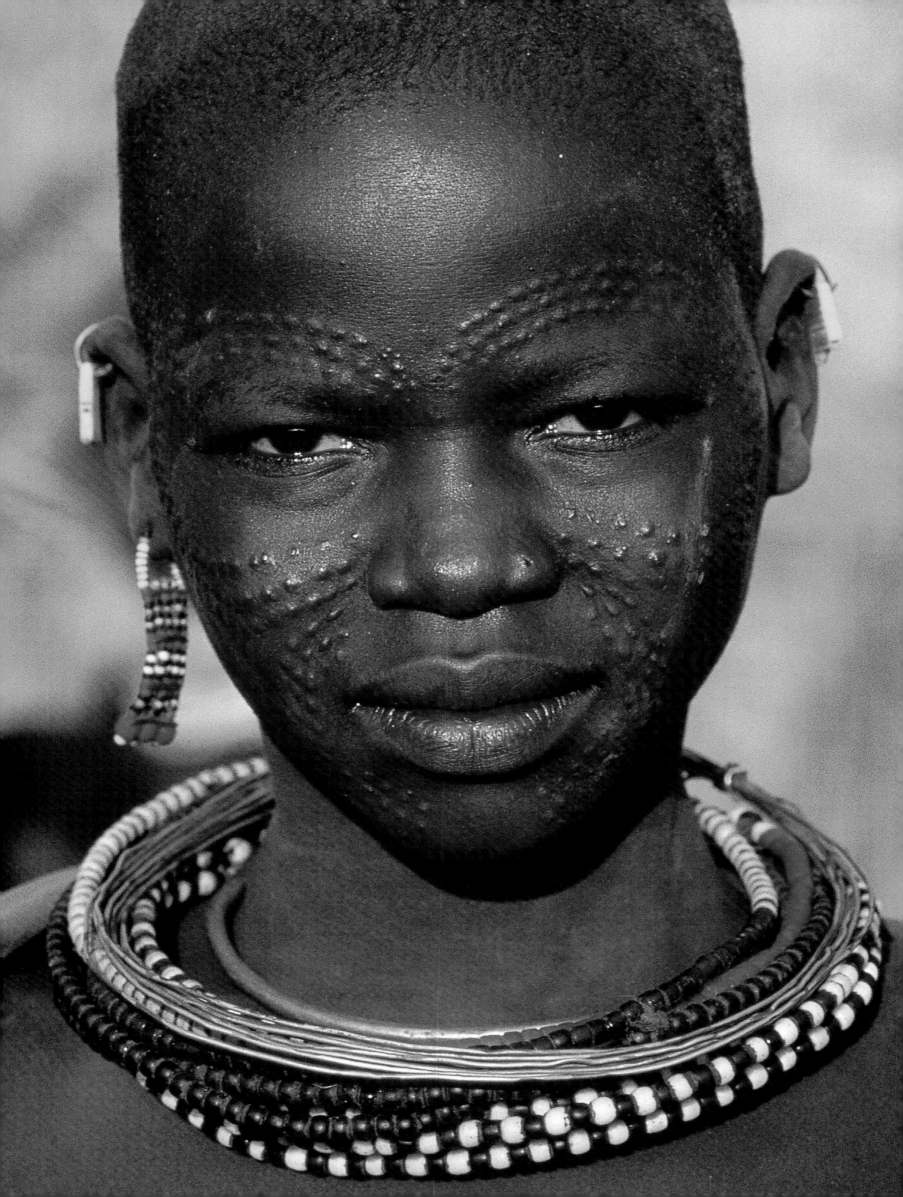

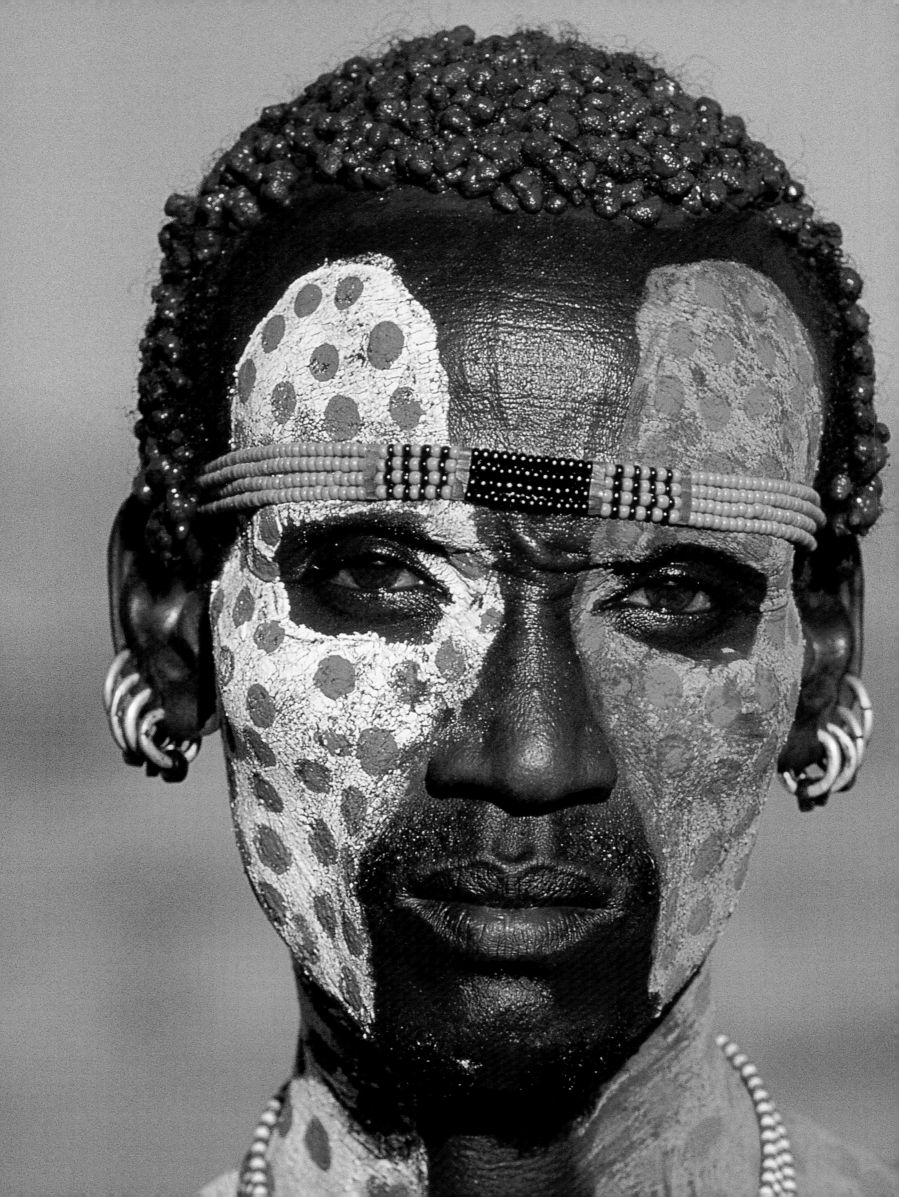

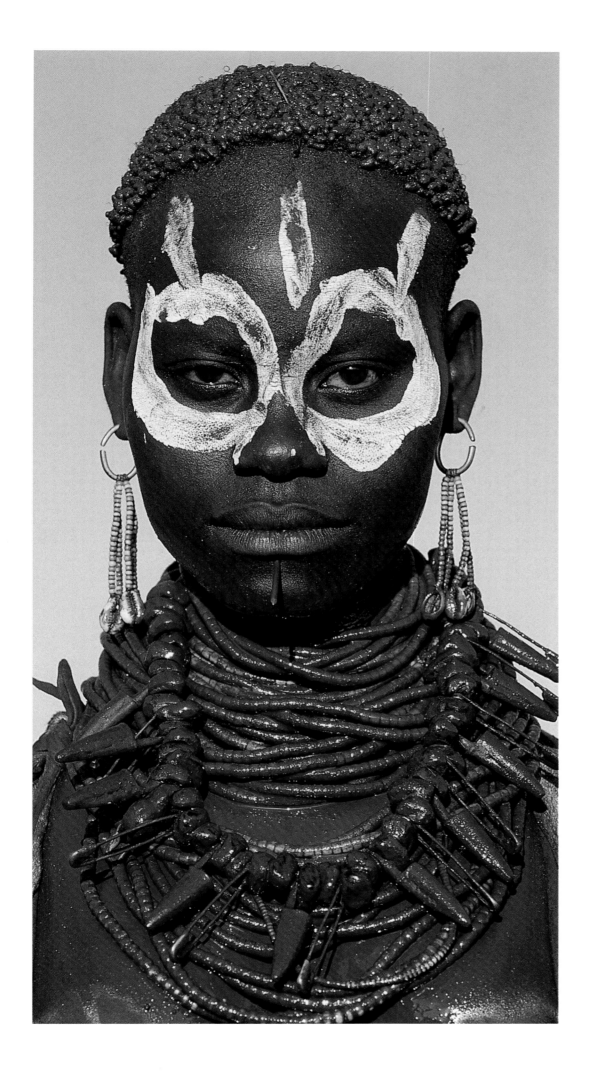

OPPOSITE: *Fierce face painting defines the ethnicity of this Karo man. The Karo live along Ethiopia's Omo River, and are one of Africa's smallest and most threatened peoples.*

LEFT: *This Karo woman's necklace is heavily coated in ochre, while her face is dramatically painted with a yellow mineral found in local rocks.*

the skin into a bas-relief effect, the cuts are rubbed with ash so that they become infected. When the wounds have healed, the skin is permanently raised.

The third group, the Bumi people, also practise scarification. Bumi men create raised designs that frame their eyes like eyeglasses. They also work the skin in rows of cuts above the eyes, in the middle of the forehead. The Surma, Karo and Bumi are sworn enemies, yet these patterns are not just a means of enhancing their physical appearance; they also establish their cultural identity, setting each group apart from their neighbours.

In a number of cultures, including the Maasai, chalk or clay is used during circumcision when boys are initiated into manhood. Chalk or clay is part of the distinctive apparel, grooming and demeanour of the initiate, indicating to onlookers that the boy is going through this crucial age-set ceremony. Once he has successfully completed the initiation process and become a *moran* (warrior), he transforms himself into a piece of living art. In addition to jewellery, the Maasai *moran* creates brilliant and imaginative patterns all over his legs. He applies a coating of ochre to his legs, and then, while the ochre mixture is still wet, draws patterns with his fingers to expose his skin. As the ochre dries, his legs acquire a coating of dust stirred

This cow is considered especially beautiful by its Maasai owner who has burned artistic designs onto the animal's hide.

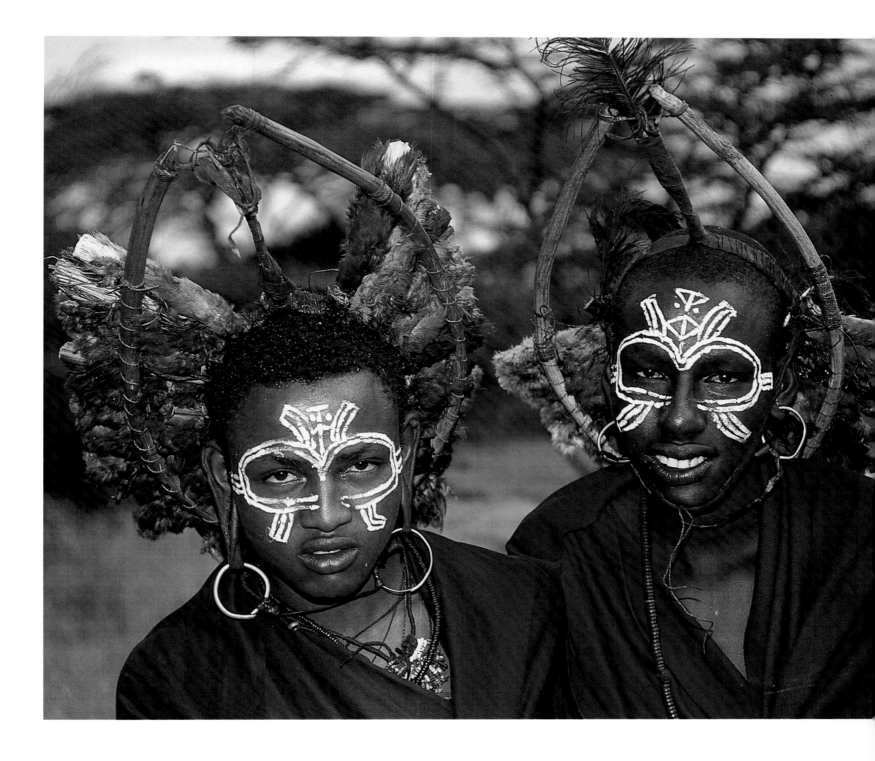

up as he moves about, and the pattern mutes into beige and rusty brown tones. The ochre, mixed with sheep fat, protects his skin from the sun and from insects.

In the past, when Maasai warriors engaged in hostilities with neighbouring peoples, the patterns were intended to make them appear fierce. Now that the Maasai have adopted a more peaceful lifestyle, the decorations are intended to make them as attractive as possible to young women. The Maasai also brand or draw patterns on their beloved cattle, especially their favourite animals, expressing their love of decoration in graphic designs against the beasts' white skin.

The Samburu use a much brighter, orange-hued ochre to decorate their faces for weddings, often drawing flower motifs, star shapes and geometric designs

The patterns painted on their faces indicate that these Maasai youths have been recently circumcised.

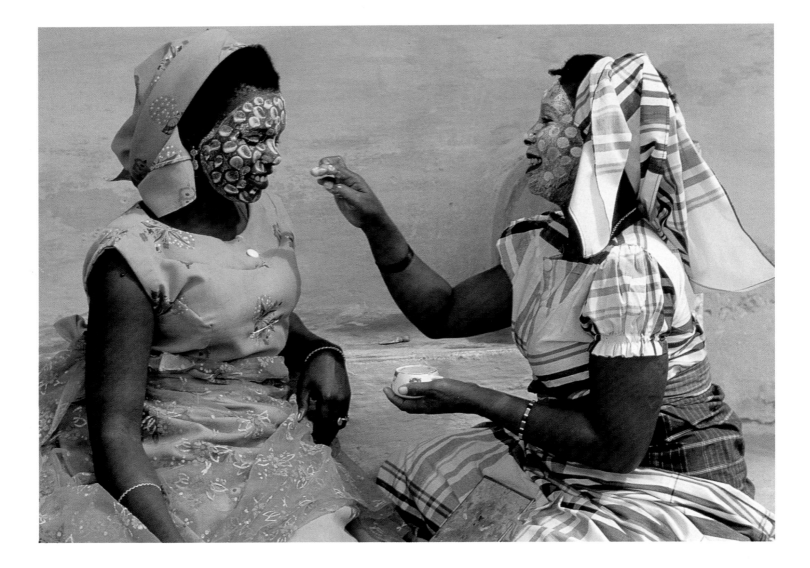

ABOVE: *Throughout Southern Africa, chalk, mixed with water to form a paste, is used as a skin astringent. It is being applied here by Macua women from Mozambique.*

OPPOSITE: *A young Wodaabe man of Niger competes in the Yakey, a male beauty contest. His face is painted to highlight his best features, especially the slender nose and lips.*

around the eyes, across the cheeks and on the brow. The men first apply a coat of ochre around the outside of the face, like a picture frame, before creating the designs. At wedding dances, girls decorate their faces with zigzag patterns that accentuate their cheekbones and draw attention to their eyes.

On Ilha de Moçambique, an island off the Mozambique mainland, the women apply a white paste to their faces. The paste, made from a ground-up root that grows wild in the forests of the mainland, acts as an astringent for the skin and enhances the beauty of the women. Although the white paste was originally used by rural women, it has been widely adopted by those in the cities. Many women in South Africa use similar preparations made from tree bark or white clay.

WODAABE

The Wodaabe are nomads who live scattered across West Africa, including parts of Niger. For most of the year, they see few people other than their own families. The search for fresh grazing for their livestock is a constant struggle in such an arid area; the fewer their numbers, the better their chance of surviving. The only time

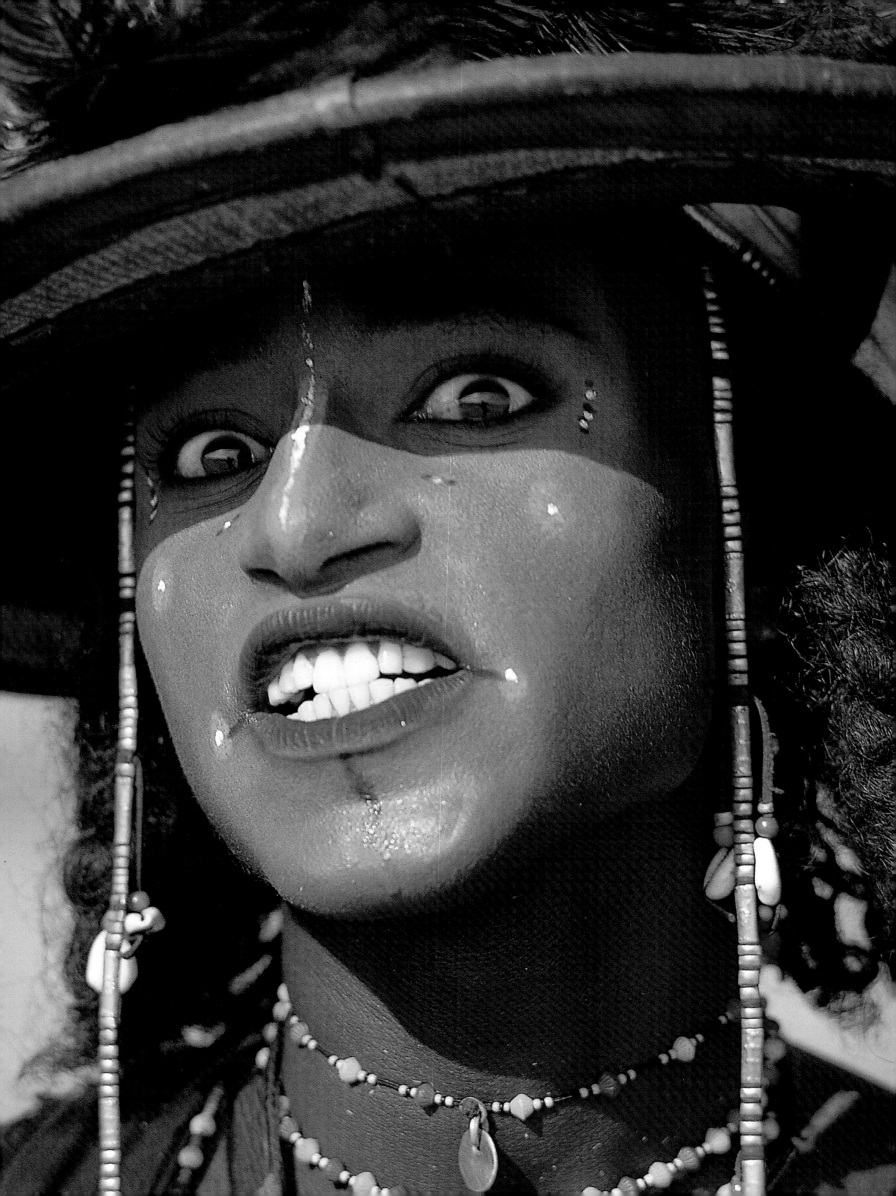

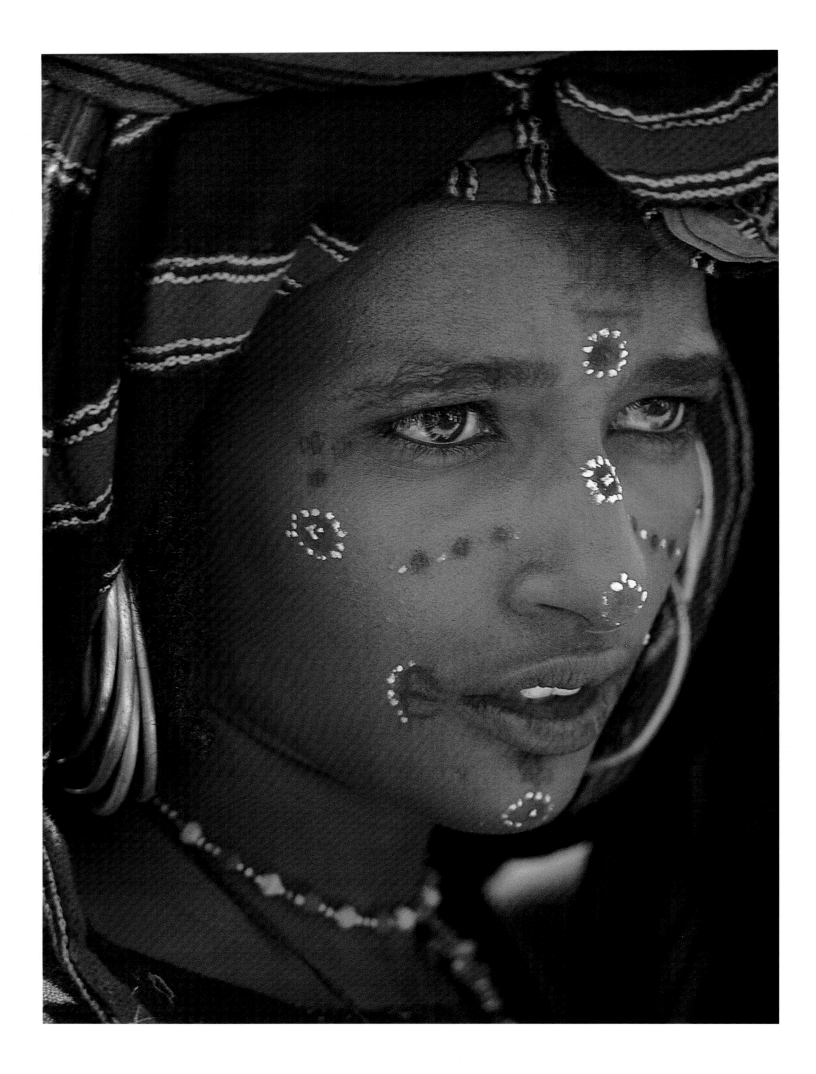

the Wodaabe come together in a group is during the annual Geerewol festival, a celebration of the bounty of grass that grows during the rainy season. This is the principal occasion for young men and women to meet and find partners. It is the ultimate expression of the Wodaabe belief that they are the most beautiful people on earth.

Artistic face painting is often associated with efforts to attract a mate, but few cultures go to the same lengths as the Wodaabe. Their face painting involves a wide variety of products very much like Western make-up, including preparations for the eyelids, the lips and the skin itself. The face painting alone would be enough to single out the Wodaabe as unique, but one aspect puts these people in a category all their own: it is the men who use make-up to attract the women. They spend hours preparing themselves, coordinating elements of their dress, including head ornaments, and making their faces up, before they begin to dance for an appreciative audience. The elders watch as well, but it is the young women for whom the men parade themselves. They are on display specifically for their beauty, and the standards of beauty among the Wodaabe are exacting.

The Wodaabe may fairly be said to be obsessed with appearance. Their lives revolve around the cultivation of beauty, and they pursue every art that enhances their natural attributes. The Geerewol is the time when men display their beauty in a kind of line dance called the Yakey that allows them to compete for the attention of the women. Because the men believe that the whites of the eyes are particularly attractive to women, they roll their eyes as they dance in order to display the greatest area of white, and cross them to emphasize the whiteness even more. Teeth represent another crucial element in their attractiveness, so Wodaabe men part their lips suggestively to expose their sparkling white teeth. To prepare their faces for the painted designs, and to brighten their skin colour, Wodaabe men apply a yellow paste to the skin, from the hairline to the chin. This forms the background for the designs, usually dots or circles of white, with which they paint their cheeks, chins and the area around the mouth. Their mouths and eyes are carefully outlined with kohl; this accentuates the whites of their eyes and contrasts with the whiteness of their teeth. No detail is neglected: Wodaabe men even shave their hairlines in order to have a neat 'canvas' on which to paint the designs and elongate the face. Equally painstaking attention is paid to headdress, ornament and clothing. The men wear brightly patterned, embroidered tunics that add to their colourful appearance, an overall impression whose effect is multiplied

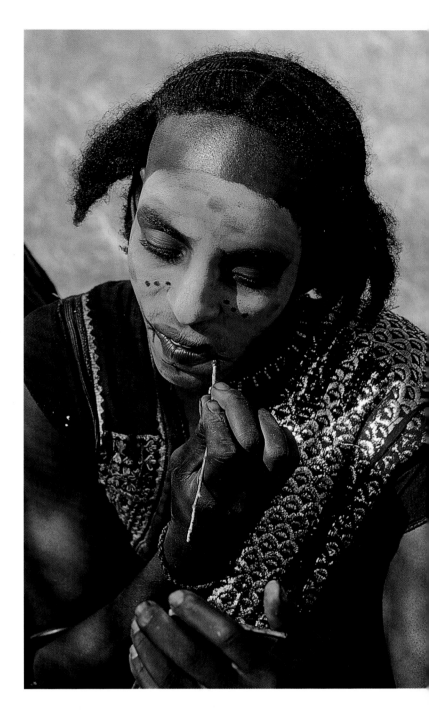

OPPOSITE: *When Wodaabe men perform the Yakey, women emulate the make-up and dress to catch the eye of the most handsome of the dancers.*

ABOVE: *Before the Yakey, Wodaabe men carefully highlight their eyes, cheeks and lips to accentuate their beauty.*

by their sheer numbers. Rows of safety pins create patterns on the cloth and catch the sunlight. The men dance side by side, as if they were a single unit, all the while competing for the attention of the women.

Although the Yakey is a traditional ceremony that demands a traditional style of dress, unusual objects are highly sought-after by Wodaabe men. They will attach any jewel or glittery object, such as small hand mirrors, that is likely to provide a reflective quality to their outfits. Cowrie shells, beaded ornaments and pieces of brass all combine to add to their brilliant display.

Wodaabe women are equally colourful, and choose their outfits with care. Although for the most part they leave the make-up to the men, the women traditionally tattoo their faces. They take great care with their ornaments and clothing, particularly the extensive embroidery on their waistcoats, blouses and skirts. Beautiful women are much admired and are permitted to wear particular brass ornaments in their hair. Young women covet the engraved brass leg ornaments called *jabo* that are attached below the knees (*see* page 136). They are worn in pairs, and force the girl to walk with a rolling gait, which is considered very seductive. All the elements of male and female dress have the same purpose: to appeal to the opposite sex. While the Wodaabe don their most extravagant make-up before marriage, they continue to make efforts to attract other partners, and the men may have up to four wives. Beauty is at the core of the Wodaabe existence and continues to occupy them after marriage.

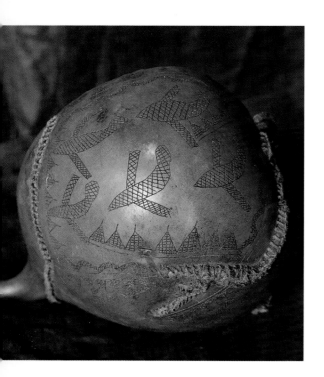

OPPOSITE: *A richly decorated Kamba gourd from Kenya features a powerful, engraved image of a buffalo. Another gourd (below) is adorned with motifs that resemble birds or aircraft.*

DECORATED GOURDS

Gourds or calabashes, a group of fruits that grow on vines, are used throughout East Africa. These natural containers grow in many shapes and sizes but they have in common a round body with a long neck, making them ideal for household use.

After the seeds are removed and the gourds dried, the hollowed gourds are smoked over an open fire to clean them out and to seal the inner surface. A leather top decorated with beads is used to close the gourd and keep liquids from spilling.

The Kamba people of Kenya renowned as master carvers (*see* page 42), and are also known for their beautifully decorated gourds. Their home territory, in the forests of Kenya, gives them ample material with which to work, and this proximity to material leads to experimentation. One of the recurring motifs of Kamba gourd design is Mount Kilimanjaro; many generations have passed since the Kamba people lived in the shadow of the mountain – their ancestral home – but the use of the motif persists.

Gourds are a form of status enhancer for the family, and are also used as bride wealth. Kamba gourds are used for beer and for honey. Gourds filled with honey beer are traditionally given as part of the marriage dowry, with both the container and the contents forming part of the gift.

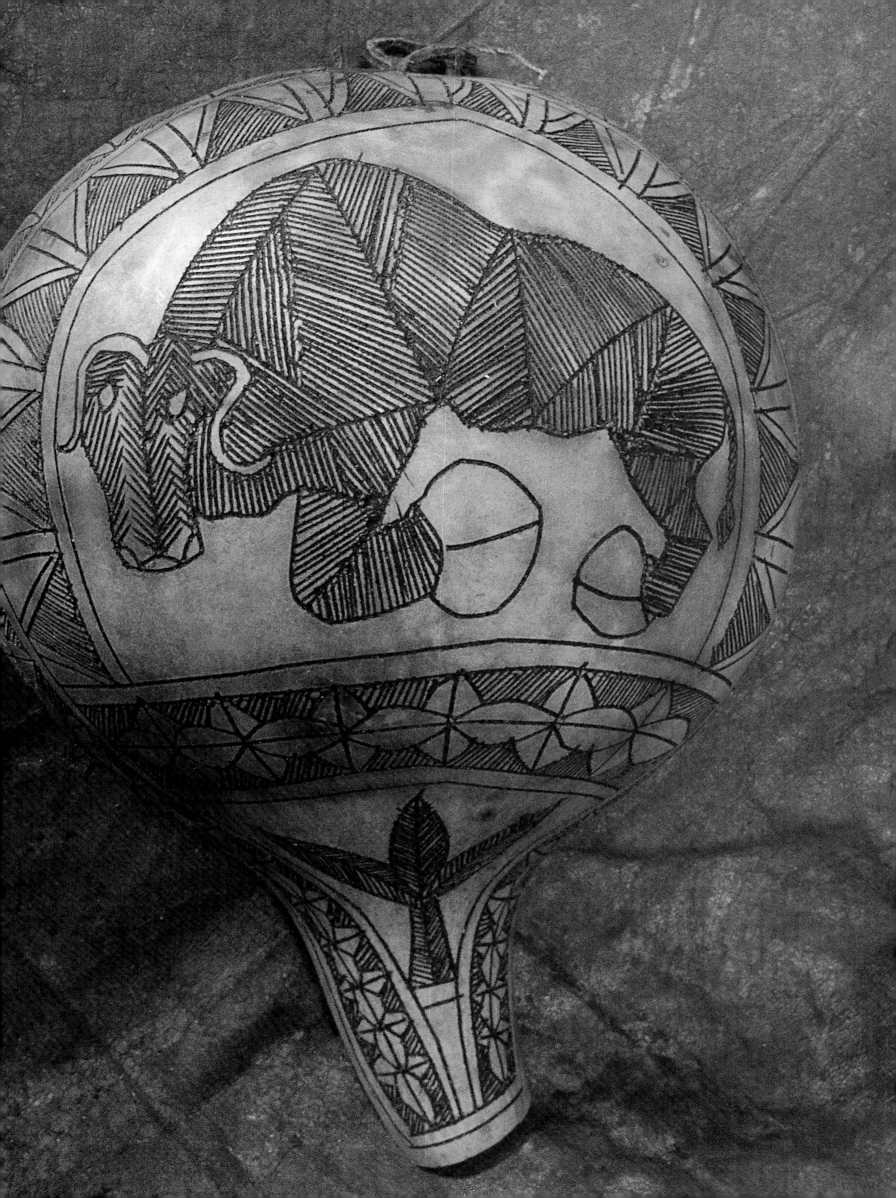

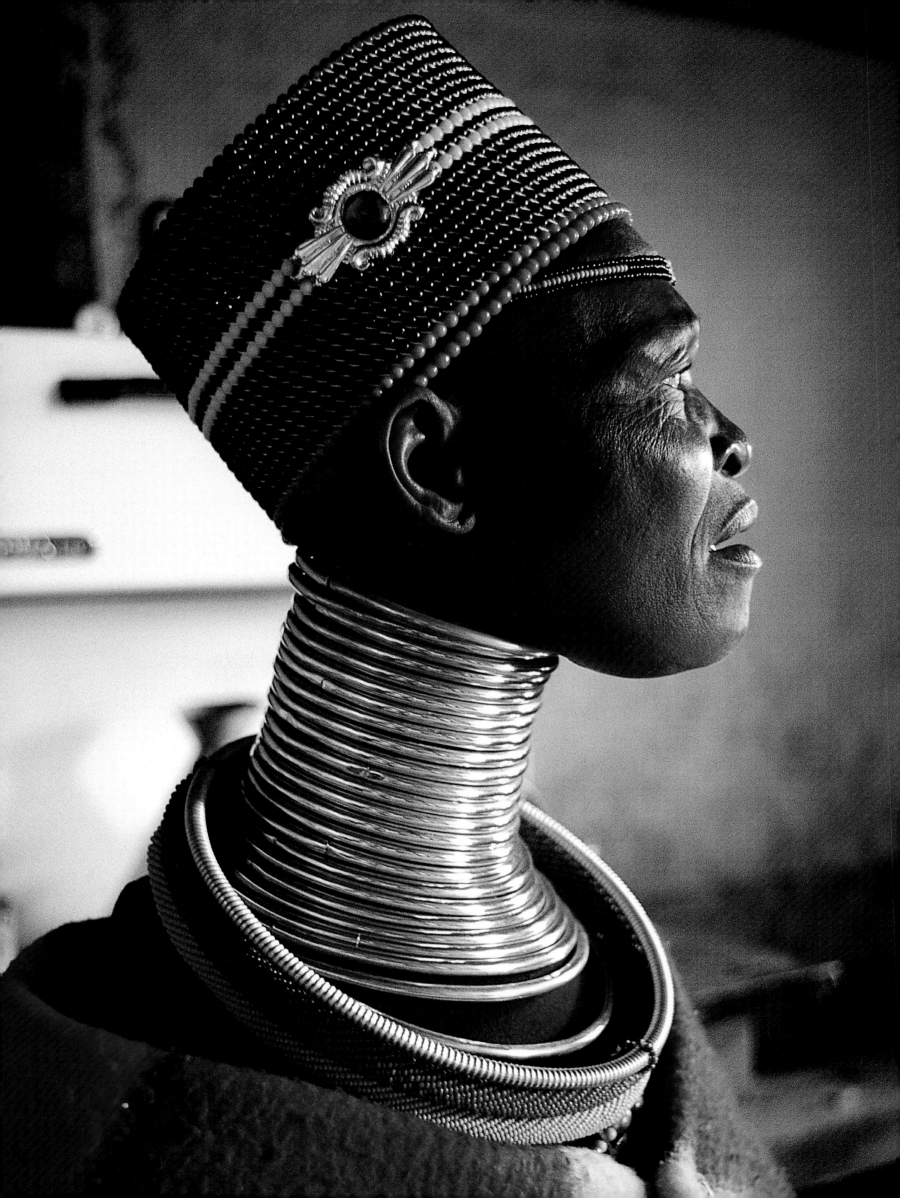

METALWORK

Gold has long been associated with Africa, even though most of the continent's traditional metalwork, including both jewellery and weaponry, has been fashioned from what are known as 'base' metals – brass, copper and iron. Iron was the most highly valued because it was the most useful. In the 18th century, iron bars were used as units of value – one bought objects, even slaves, with iron. Historically, gold was the preserve of royalty, and is identified almost exclusively with the Ashanti of Ghana and the Baoule people of the Ivory Coast. In spite of formidable gold reserves elsewhere in Africa, the goldworking tradition was scarcely evident in other regions. Where gold was mined, it was used in trade and as backing for currencies beyond Africa's boundaries.

The traditional brass dzilla *coiled around this Ndebele woman's neck create the elongated profile that these people find so desirable. In the past, the number of rings worn was indicative of wealth and status.*

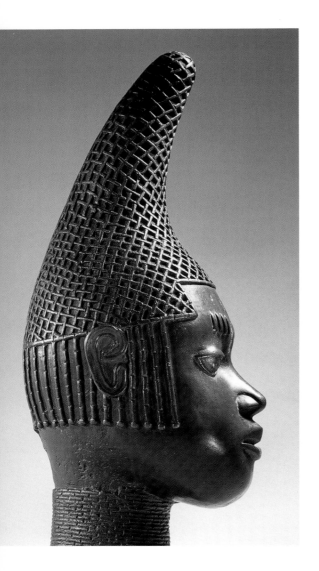

Creating objects from metal is quite different from all the other traditional crafts, as the work requires more complex methods. The craftsperson does not mould or shape the material directly by hand; generally, heat is required and often the shaping must be completed by teams. This sets metalsmithing apart even within the cultures where it is practised. In most cultures, including the Samburu of Kenya and the Yoruba of Nigeria, the blacksmith must be from another lineage, since those who are capable of forming metal through the use of fire are regarded with both awe and fear. The blacksmiths forged both swords and circumcision knives, as well as all the utilitarian metal objects needed in traditional life.

One of the most widely practised metalsmithing methods is lost wax casting. The process involves the creation of a wax model, which is surrounded by clay or similar material – plaster of Paris is used in modern commercial applications but the method is quite the same. When the model is heated in a kiln, the wax melts and runs out – or is 'lost' – and the resulting space is filled with gold or bronze. Once the metal has cooled and is set, the clay model is broken and the gold or bronze object is removed. It faithfully replicates every detail that was originally carved into the wax. The more precise and refined the wax model, the more beautiful and precise the metal replica will be. The lost-wax technique was employed in the West African kingdom of Benin as early as the 9th century. The famed Benin bronze heads depicting the *obas*, the Benin kings, have survived for centuries with every detail still beautifully rendered.

ABOVE: *This fine Benin bronze head, made early in the 16th century, depicts Idia, mother of Oba Esigie. The lattice-work pattern of coral beads portrays a specific hairdo of the period, and enables us to date the piece with reasonable accuracy.*

OPPOSITE: *The Benin metalsmiths created objects in brass as well as in bronze. This brass flask would have been carried by a Benin chief.*

GOLD

Gold has been mined in Africa for more than a millennium – the fabled mines of King Solomon were widely believed to be located in what is now Zimbabwe. That belief has a basis in reality: gold was mined in Zimbabwe well before 1000. But gold mining has had its greatest impact at two widely separated parts of Africa: in South Africa, gold fuels the economy but does not play a cultural role, whereas in Ghana gold is bound up with the history and culture of the Ashanti people. Although the country was known as the Gold Coast while under British rule, its modern name is taken from the ancient past. The empire of Ghana was well known to Arab travellers before 1000, who described the fabulous wealth of the king of Ghana as being built on gold, as indeed it was.

Ghana was the crossroads of West Africa, a place where caravans crossing the Sahara met and people shared ideas and goods. Gold was readily worked from streams, and panning techniques were used to separate the gold from the surrounding sediment. Traditionally, women panned for gold, while men excavated the pits from which the gold-bearing ore was extracted. The ready availability of the metal nurtured the goldsmithing techniques of the Ashanti, and, by the 17th century, the lost-wax technique was well known to them.

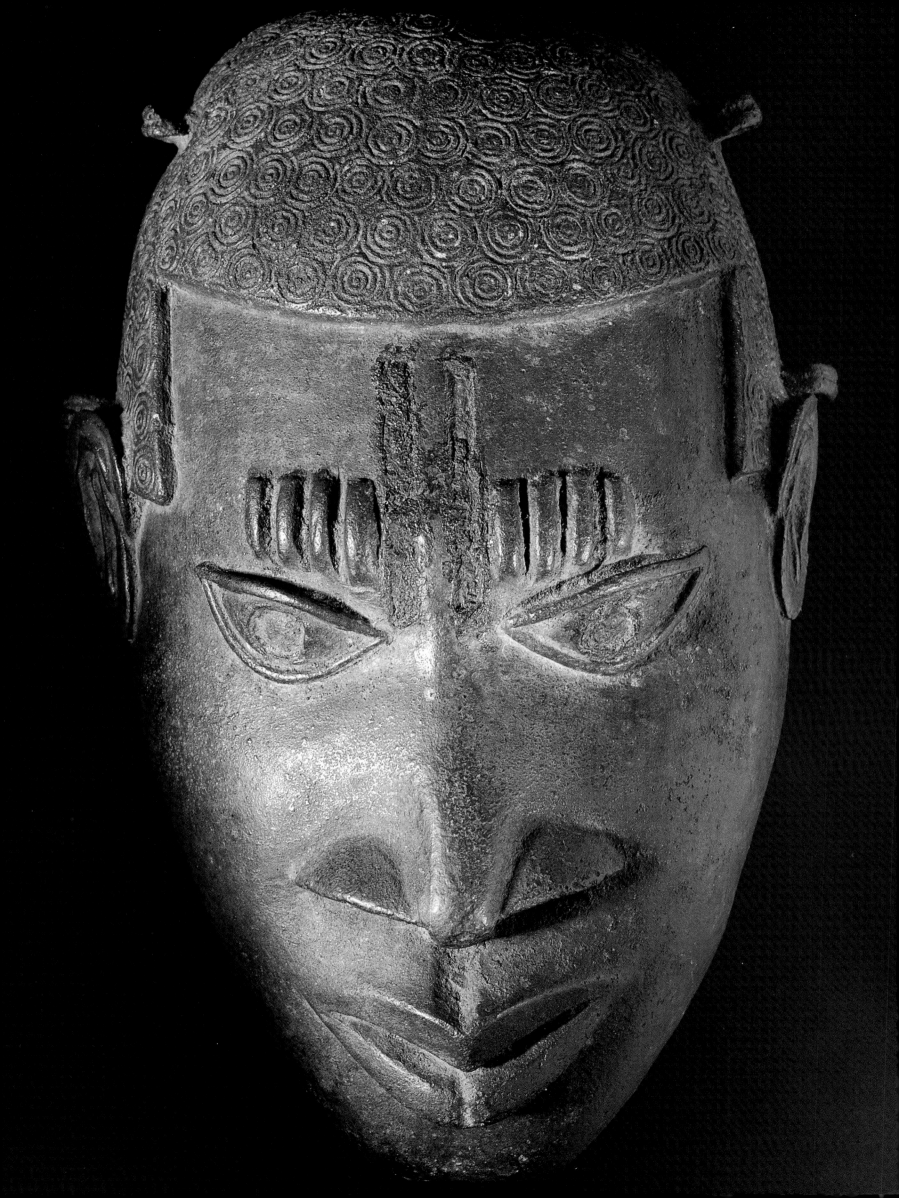

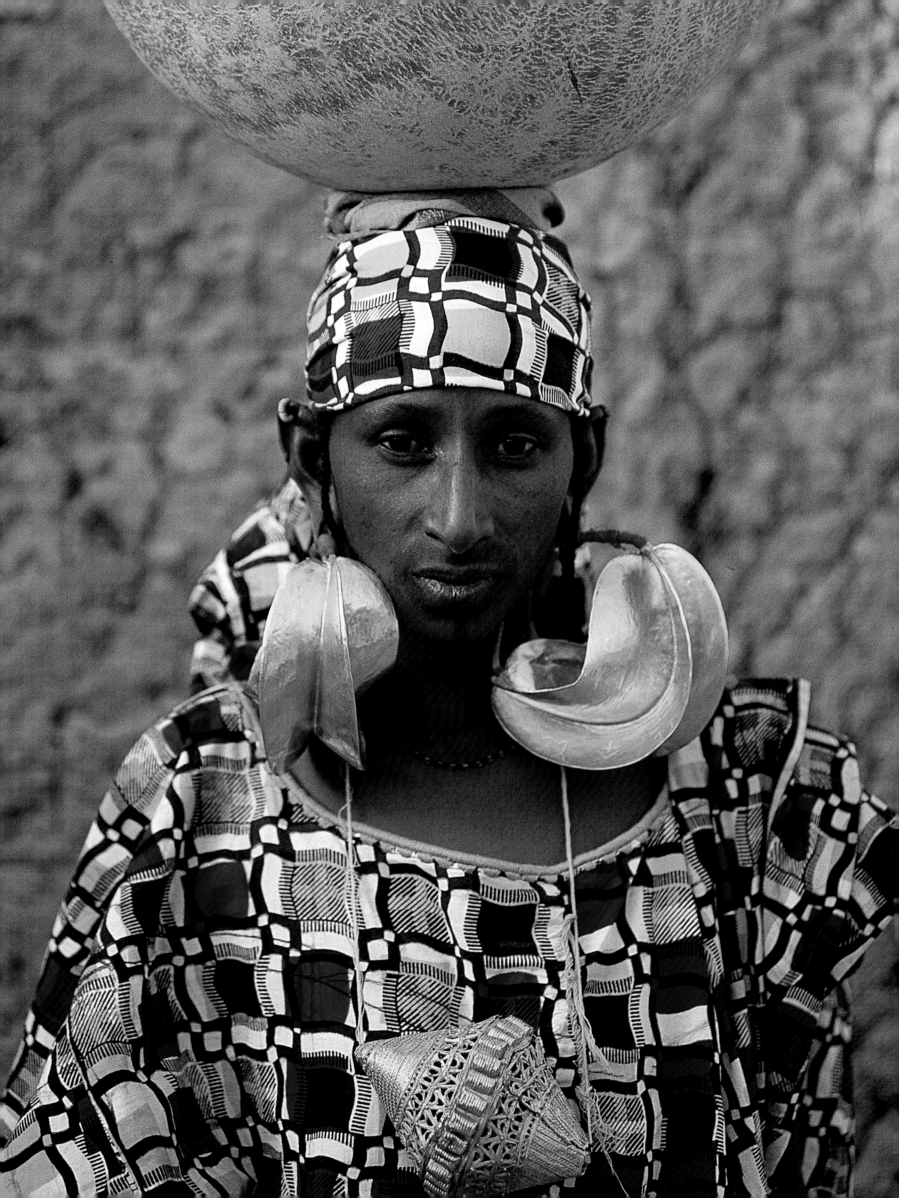

Gold is very malleable, and, unlike bronze, it can be worked with simple tools. In addition to the objects made by lost-wax casting, it can be beaten into very thin sheets, and it can be drawn into very fine wire. Patterns may be raised from below the surface or engraved on the surface.

This extraordinary flexibility, along with its availability, was at the basis of the extravagant use of gold in Ashanti culture. Ashanti metalsmiths created a staggering quantity of gold objects. Huge pieces of gold jewellery included chains, pendants and bracelets worn on both the upper and lower arms, as well as on the ankles. Necklaces also were made from numerous gold beads.

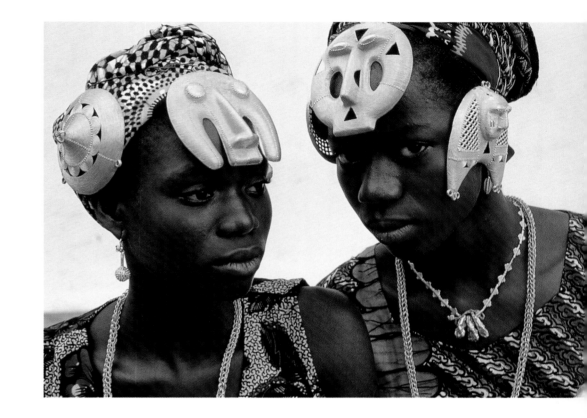

But gold was also used in the form of foil to cover entire thrones as well as ceremonial staffs. The wearing of gold objects was restricted to members of the Ashanti royal family – gold threads were embroidered onto the fabric used for the royal robes, and gold rings flashed from every finger of kings and paramount chiefs, providing a dazzling display on ceremonial occasions.

Gold was the basic element of trade in the region from the 16th century onward, and was exchanged for the European products that were in favour. Chief among these were the glass beads made in Venice, known as *millefiore* (thousand flowers). These beautiful beads were so highly prized that they even came to be traded for slaves. Thus, they became known as 'trading beads', and were accorded a value equal to their weight in gold.

Because gold figured so prominently in Ashanti trade, merchants created a system of standard weights. These took the form of small figures to be used on balance scales; each merchant had his own set. Gold weights were traditionally created in a set of twelve, were made of brass and were balanced against quantities of gold dust. The use of gold weights has been traced back many hundreds of years, but this system of measurement changed through the centuries as the civilizations involved in trade changed. As new trading partners were found, the weight system was adapted to accommodate their needs. Ultimately the troy ounce measuring system became the standard.

Gold weights feature a range of thousands of motifs, taken from the symbols that are used in other areas of life, and patterned after living creatures or mythical beings. Some represent everyday items such as the popular *wari* board game. Some

OPPOSITE: *Among the Peul of Mali, the upper lip is tattooed. This woman's earrings are made from pounded gold sheet, and her gold pendant is fashioned to emulate braidwork.*

ABOVE: *Gold is a mark of status in the Ivory Coast. These modern women, daughters of the Ebrie elite, wear large gold plaques sewn onto their turbans.*

show people going about their everyday tasks, while others faithfully represent birds and animals. The forms may also symbolize proverbs or morals from the Ashanti culture, although these may have been added along the way. The elegant knot design is a symbol of wisdom, and thus represents leadership and ultimately the king. The homely and familiar groundnut (peanut) is a basic foodstuff but also represents an object whose real nature is unknown until the outer surface has been removed. The porcupine, national emblem of the Ashanti people, is a popular form because the animal's formidable and numerous quills represent the strength of the Ashanti warriors. Over the years, foreign influence could be seen in weights that emulated Western objects such as ships, padlocks and guns.

Gold was also used in the Ashanti culture to make masks. Only a people with a profusion of gold could fashion such large objects from the precious metal. Unlike the gilding or foil used in ancient Egyptian objects, these pieces were made of high-carat gold, worked as a sheet of metal. Once again, the availability of a particular material may be seen to be crucial to the development of material culture.

The centre of the Ashanti kingdom, and its world of gold, is Kumasi, the seat of the *asantehene*, or king of the Ashanti people. His elevated status is shown in the gold that surrounds him on ceremonial occasions. Unlike the legendary King Midas, the *asantehene*, in the person of Otumfuo Opoku Ware II at time of writing, enjoys his gold and his life too. He wears masses of gold jewellery, so much that his arms and ankles become too heavy to lift.

BAOULE

The lost-wax technique (*see* page 124) was also used by the Baoule people of the Ivory Coast to create both gold and brass beads. These are known for their extremely fine detail and typically feature patterns of concentric lines. In order to achieve this effect, the Baoule use fine waxed threads in their models. The shapes are formed by casting these models to replicate the look of fine wires, and include circles, interwoven lines

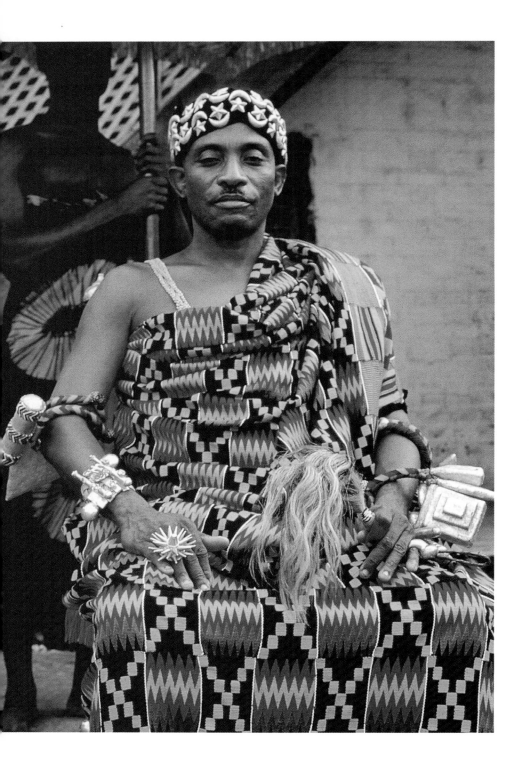

As befits his status within Ashanti society, paramount chief Nana Akyanfuo Akowuah Dateh II wears gold bracelets and a gold headpiece.

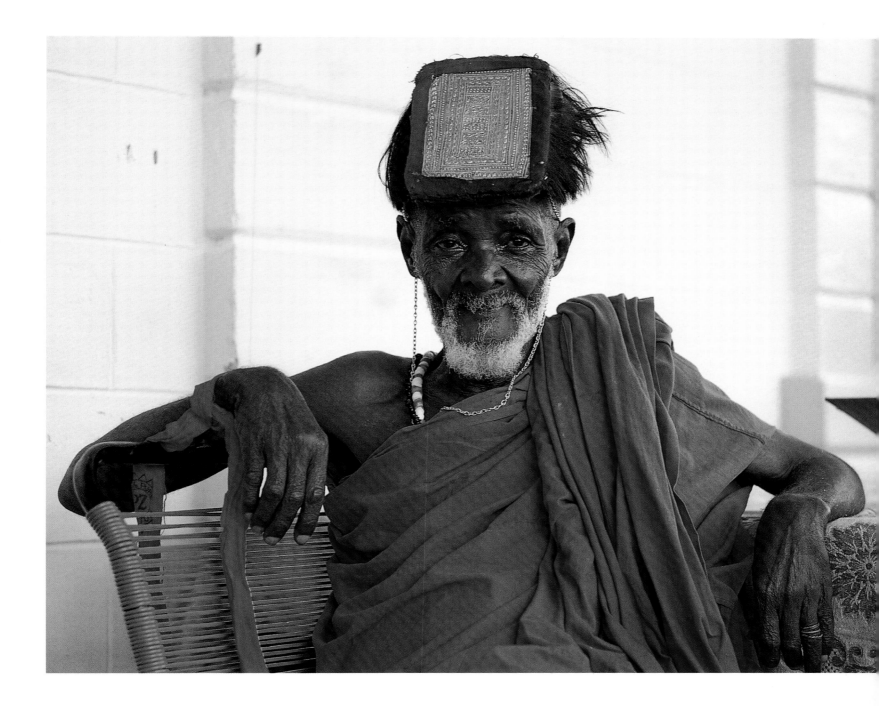

and zigzags. One of the best-known Baoule designs is a group of flat beads, each made in a different shape and pattern, but all featuring the same fine thread work. These would be hung in groups of thirty on the outside walls of wealthy members' homes during ceremonies. The Baoule even made knife grips covered with gold leaf – though not the blade itself, since gold is unsuitable for such a use.

The gold plaque on the headdress worn by this Ashanti elder is a traditional sign of power.

BASE METALS

Since the early years of the first millennium AD, African cultures have transformed base metals – iron, brass, copper and bronze – into weapons and other useful implements. Blacksmiths forged all the tools that were needed for hunting and daily life, such as wrought-iron daggers, spears and axes. Iron thumb knives, which

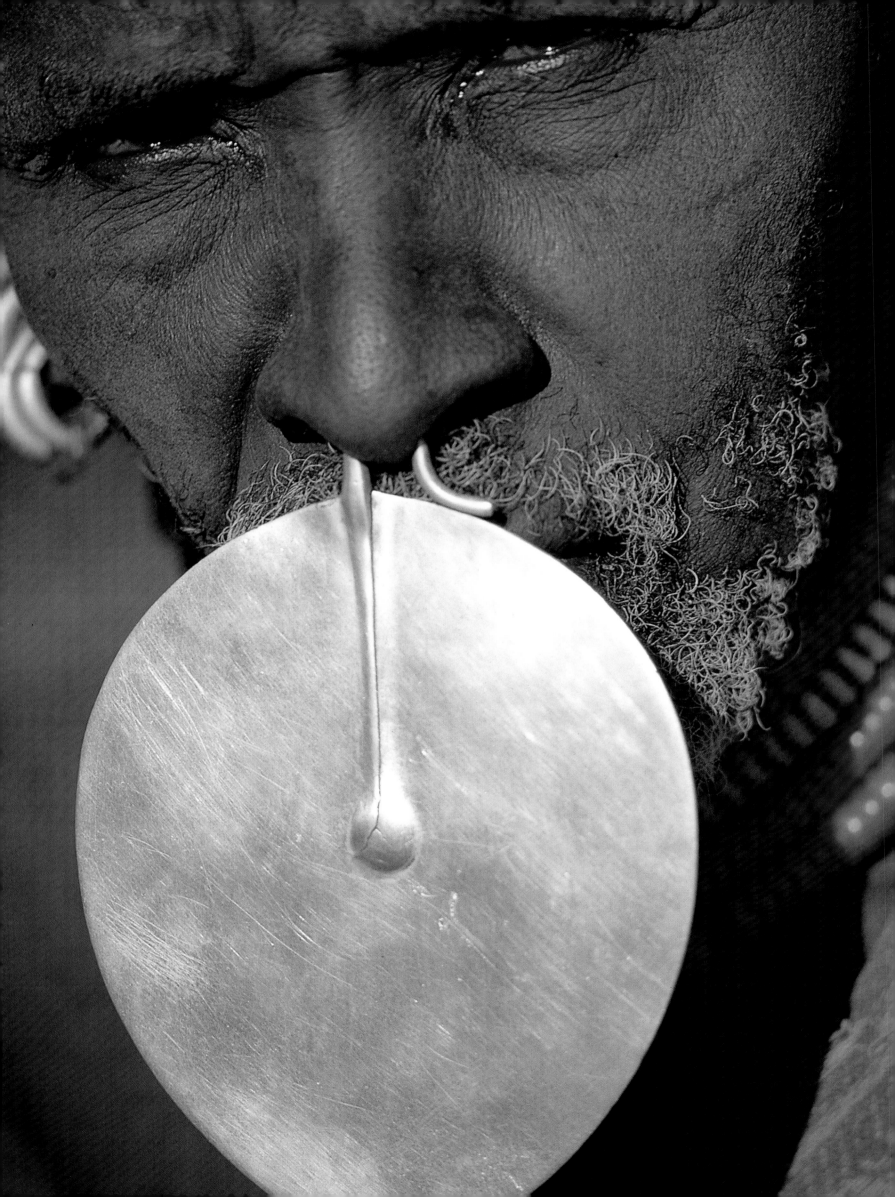

were fitted around the thumb, were used by the Turkana, while the throwing knives made in what is now the Central African Republic and Cameroon were fierce instruments with numerous points and cutting edges. Although deadly, these weapons were also beautiful, and were shaped into sinuous curves. Iron blades were used as currency in the Congo, and their fantastic shapes echoed those of both the panga and the scythe – familiar forms to the local blacksmiths. Knives and weapons acquired a high value because they were the most useful, and therefore the most valuable, objects an individual could own. Unlike coins, which are merely symbolic, weapons have an intrinsic value.

Arrows are still an essential tool for the nomadic peoples who bleed their cattle on a regular basis. The Samburu and Maasai, whose diet consists largely of the milk of their cattle, periodically bleed an animal to mix the blood into the milk for added strength. While two men hold the animal steady, another man carefully aims his bow and arrow at its jugular vein. The arrow is designed to pierce the skin and start the blood flowing. After a couple of pints of blood have been drawn, the wound is rubbed with dung. No animal is bled more than once a month, and the Samburu and other peoples are careful to keep track of which animal has been bled. In hard times, when they are forced to sell their cattle, they may rely on smaller livestock.

JEWELLERY

In most African cultures, base metals, including brass and iron, were often used to produce jewellery. In some instances, aluminium replaced these heavier metals when it became available early in the 20th century.

Brass coils wound around the upper and lower arms are found in many East African cultures, including the Maasai and Turkana. The Maasai *surutia*, worn only by a woman who has a circumcised son, and by her son who borrows the

OPPOSITE: *The large nose pendant worn by this Turkana elder is in the traditional form of a leaf.*

BELOW: *A brass and copper wire etepesi (chin plug), normally worn by Turkana women, adorns this Turkana man. Men wore ivory versions of this ornament until the 1970s, when the use of ivory was banned in Kenya.*

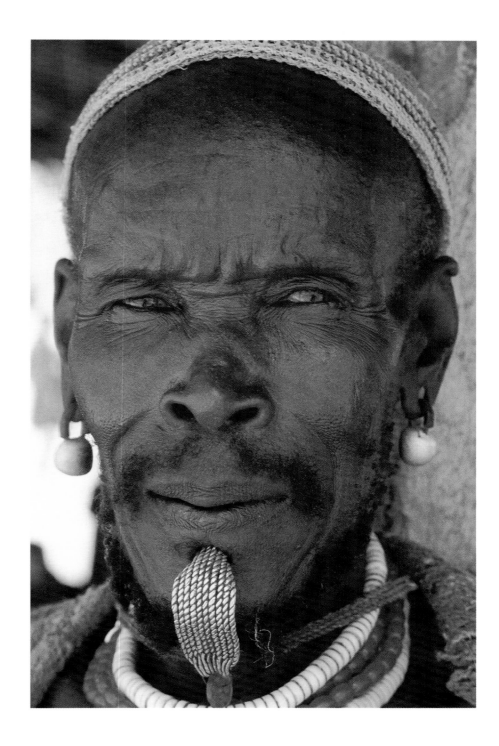

131

OPPOSITE: *For the Himba, who inhabit Namibia's Kaokoland region, the use of metal is highly ritualized. Copper coils reach from wrist to elbow while metal studs made from wire are pounded onto leather backings.*

surutia to wear before his circumcision, has become one of the most imitated designs. The simple continuous coil, worn by the Maasai on a leather thong, is borrowed by the son for his initiation ceremony and then returned to his mother.

Rendille women of Kenya wear brass or iron wire coiled around their lower arms at marriage. After a woman's first son has been circumcised, a coil is added to her upper arm. These ornaments can interfere with the body's normal circulation and may cause the arms to swell above and below the coils. The *dzilla*, or brass neck coils, worn by Ndebele women (*see* page 122) to elongate the neck have a similar effect. When the coils are taken off, a woman's ability to hold up her head may be severely compromised.

Because it is lightweight and does not tarnish, aluminium is ideal for making jewellery. The frugal Gabbra of northern Kenya take discarded aluminium cooking pots and work the metal into square beads that are chiselled and incised with designs. Before aluminium was available, the Gabbra smelted iron ore, found near Lake Turkana, to produce iron. Aluminium is also worked into nose pendants by the Pokot and other peoples of Kenya. The Turkana use discarded pots to make earrings, formed in a clay mould, with designs incised using a hot nail.

HIMBA

The Himba of northern Namibia are one of the last peoples to pursue a way of life that is little changed from that of their great-grandparents. The Himba are thought to have migrated into the region from the north-east about four hundred years ago. Prevented from moving into areas with more rainfall by the Ovambo, they instead found a way to survive in the stark and forbidding region known as Kaokoland. Like many nomadic people, they depend on their livestock.

Although the Himba live in the desert, where the midday sun is fiercely hot, the nights can be bitterly cold since there is no ground cover, and the heat of the day is lost quickly once the sun has gone down. In spite of the harsh conditions in which they live, both men and women are richly ornamented. The women are fastidious in arranging their hair, dressing it in styles that indicate their marital status. They coat themselves with a mixture of butter fat coloured with a red ore derived from crushing certain rocks found in the region. The colour attaches itself to the skins draped around their hips – the only clothing worn by the Himba. The tinted fat is used by men and women, and helps to protect them from both heat and cold. The coloured paste is also mixed with the pounded leaves and stems of aromatic plants to give off a pleasant scent.

Most of their attire takes the form of jewellery: necklaces, belts and straps. Himba women's coiled copper armlets are worn somewhat loosely and do not constrict their movements. Each woman wears virtually identical jewellery, including a leather, shield-shaped ornament studded with metal. The ornament derives its stiff

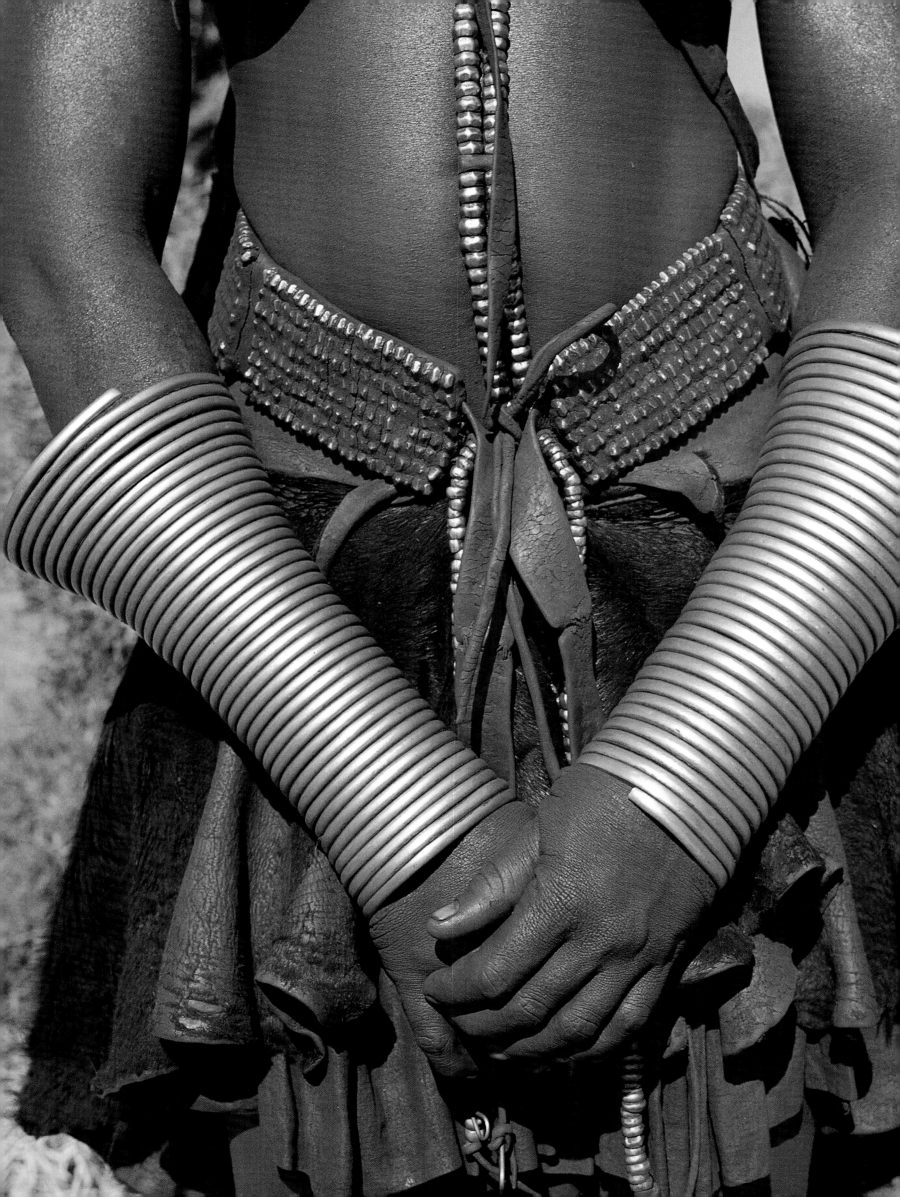

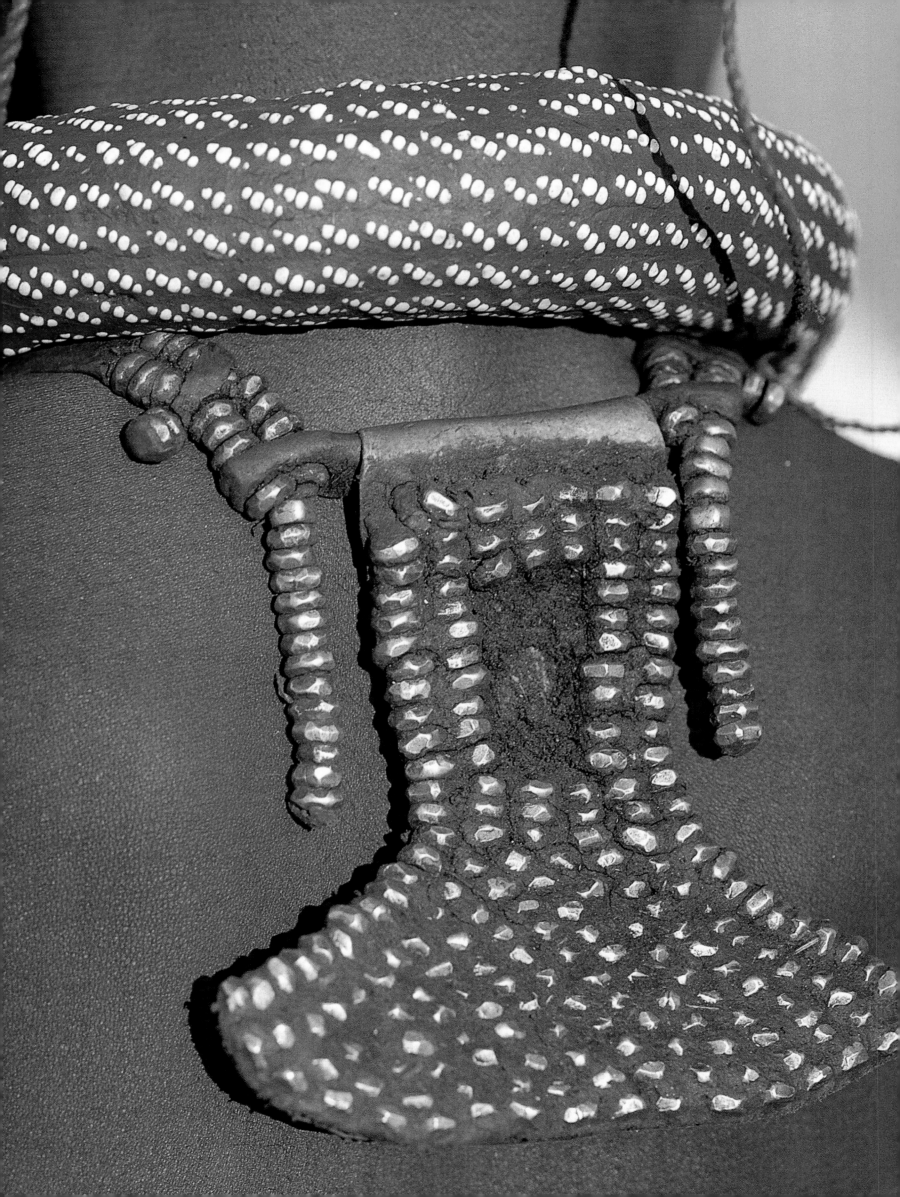

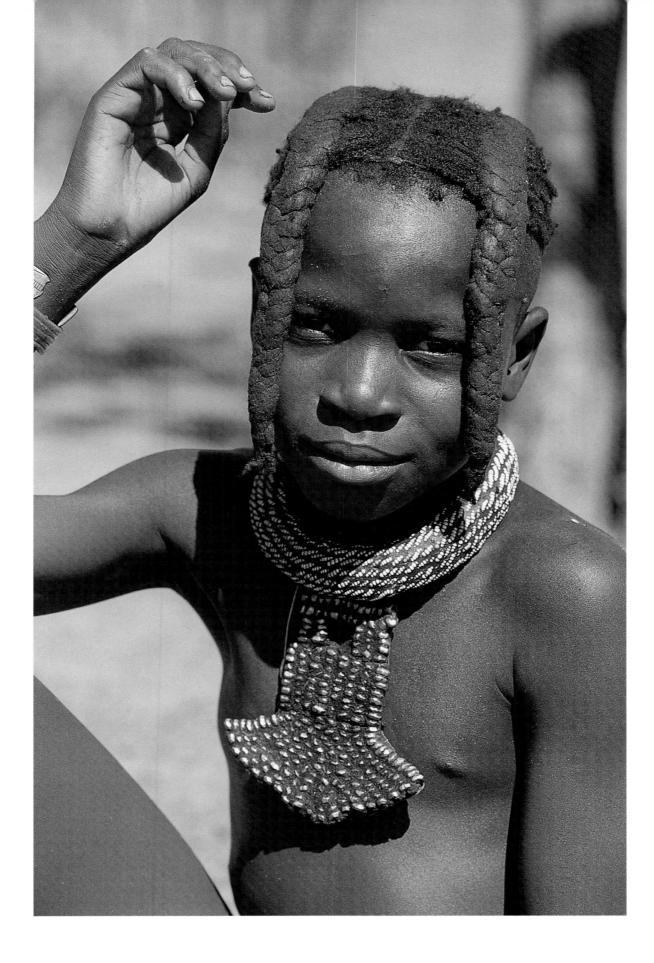

OPPOSITE: *The extraordinary appearance of Himba jewellery is achieved through the use of small metal beads on a leather backing. The beads are made by pounding wire and cutting it to size, and then pressing the pieces into the backing. Each Himba woman wears one of these metal-studded ornaments (above). The remote area of Namibia where the Himba live has enabled them to maintain their distinctive traditions.*

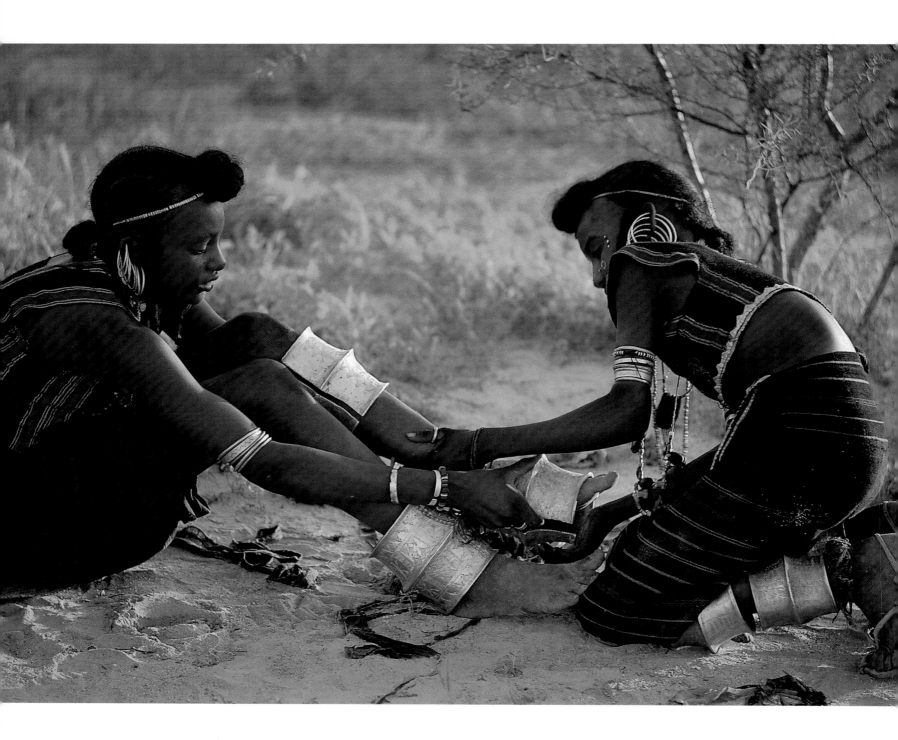

Above: *Wodaabe women of Niger adorn themselves with brass leg ornaments that restrict their gait (see also page 120). Here, a Wodaabe woman helps her friend remove her jabo for cleaning with water and sand.*

Opposite: *Each Wodaabe woman will wear her jabo until the birth of her second child.*

shape from a piece of white PVC (polyvinyl chloride) tubing. This very modern material makes just the right base and allows the ornament to hold its shape. The original colour of the Himba's coiled necklaces, headdresses and other parts of their apparel are all muted through constant and liberal application of body colour combined with the area's natural dust.

Although the Himba have withstood all modern intrusions and managed to maintain their traditional way of life, a plan to dam the Cunene River at Epupa Falls and, in the process, to flood their ancestral lands, will end all question about their survival as a culture. Resettlement schemes are all based on a complete change of life patterns. The plight of the Himba is one of the most dramatic examples of the changes enforced from the outside that have an impact on material cultures.

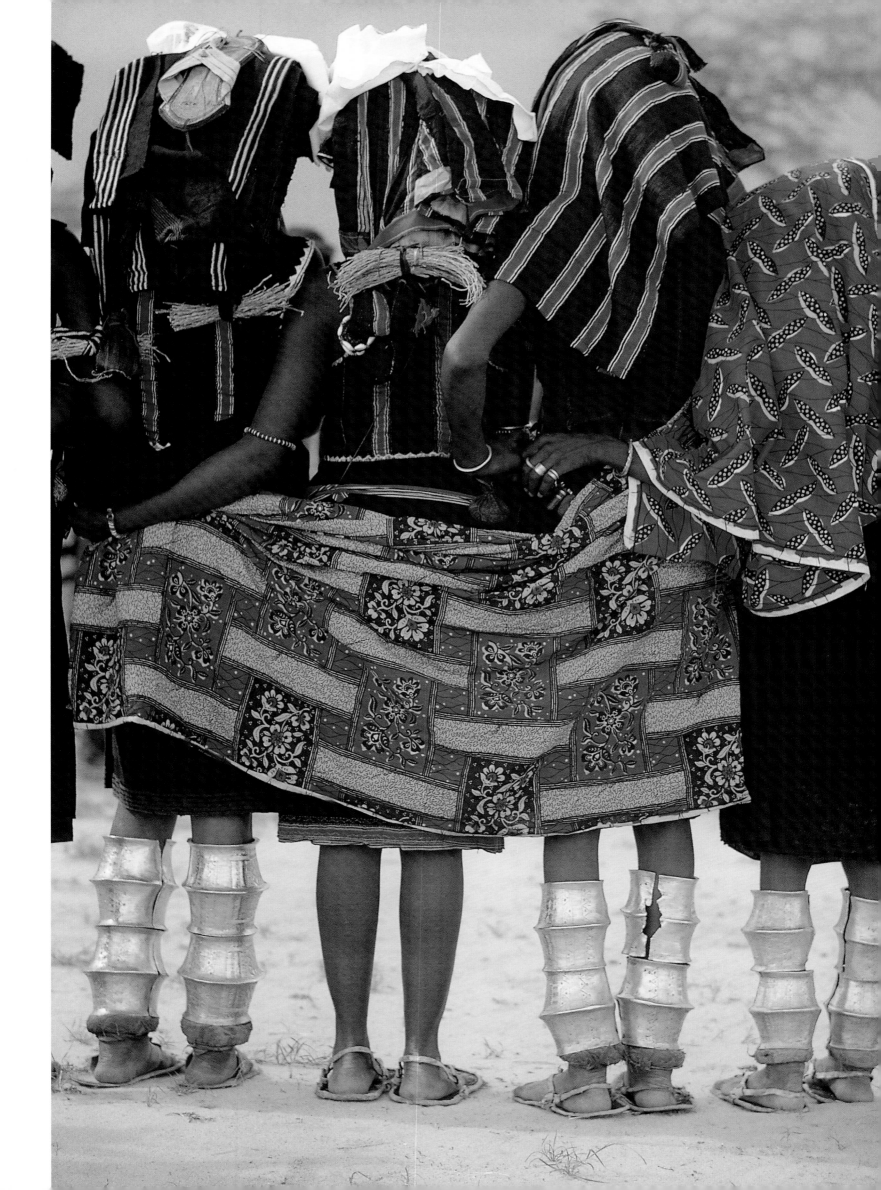

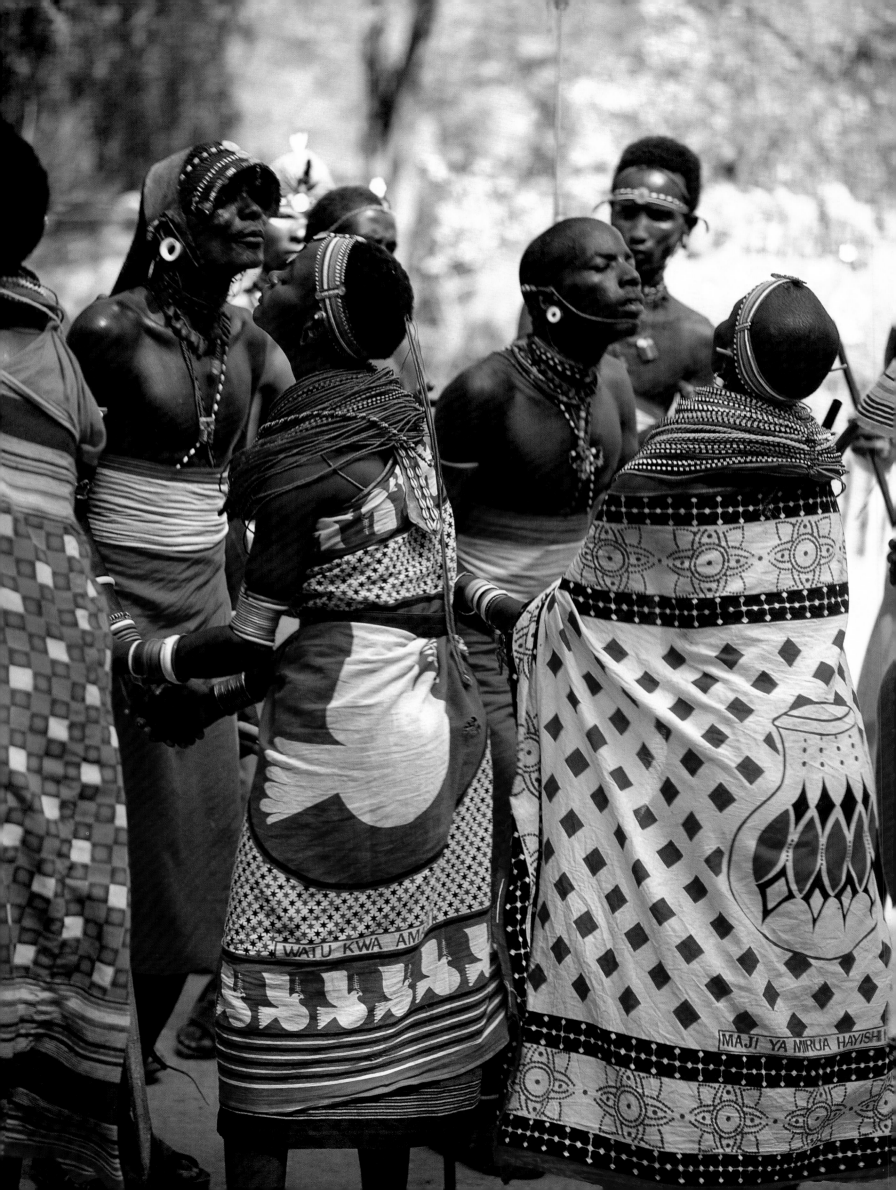

WEAVING

From the simple cotton kanga of the East African peoples to the voluminous trousers of the Senegalese, African dress is highly differentiated. The fabrics may be locally made and restricted to royal or elite use, or they may be imported from Europe and printed with designs that appeal to African tastes. The flamboyant use of brightly printed fabric among the Yoruba of Nigeria suits the local climate as well as the body type of the wearer. The closely wrapped sarongs of the Maasai and Samburu warriors suit an age set as well as a body type. Even when African styles are influenced by European ideas, they depart from the original idea with verve and elegance and, in the process, become uniquely African.

Among the Samburu of northern Kenya, printed cotton kangas are wrapped around the body by both men and women. Like their Maasai cousins, the Samburu prefer red fabrics.

Long before there were woven fabrics, people used the inner bark of trees to make a kind of cloth. The bark was slit and peeled off the tree in one piece, and then beaten until it became supple and suitable for use as fabric. Bark cloth was utilized throughout sub-Saharan Africa, wherever there was bark to harvest. It is believed that the first people to actually make clothing from bark cloth were the Kuba of what is now the Democratic Republic of Congo, under their king Mucu Mushanga.

Bark cloth was still widely used by the Buganda of Uganda through the 1950s. Loose-fitting bark robes, wrapped and draped around the body, were worn by elders at traditional gatherings. The cloth was made from the bark of the ficus tree, with designs sometimes painted or stamped on the cloth. In the Congo, the Kuba created patterns by using different-coloured bark in geometric designs (*see* page 153). The colours were placed side by side, with rows of contrasting colours forming the patterns.

As various cultures began to herd livestock, they started turning animal hide into clothing. Many others, however, began to use woven cloth for their garments.

WOVEN FABRICS

Woven fabrics have been known around the world for five thousand years; looms for weaving are at least that old. The technique of weaving probably originated with basket-making. But, whether the material employed is raffia, cotton, silk or wool, weaving is common to nearly all cultures that have access to materials supple enough to manipulate.

In Africa, where both men and women weave, each sex uses a different loom, with each loom producing a specific type of cloth. In West Africa, women sit in front of a fairly wide loom that is fixed in one place. The woven pieces made by women are wide enough to be used just as they come off the loom, and may also be sewn together to form a larger fabric. By tradition, men work on a narrow, portable band loom

RIGHT: Brightly coloured striped mats woven by women find myriad uses in the households of Africa. These mats were made in the Palma district of northern Mozambique.

that produces long strips of cloth measuring ten centimetres (four inches) in width. Many such strips must be combined in one piece of fabric large enough to make clothing. Although the strip loom may appear to place great limitations on the weaver, in fact he can produce quite varied effects by planning the finished cloth and incorporating different elements along each strip. The total effect is only achieved when the strips are sewn together.

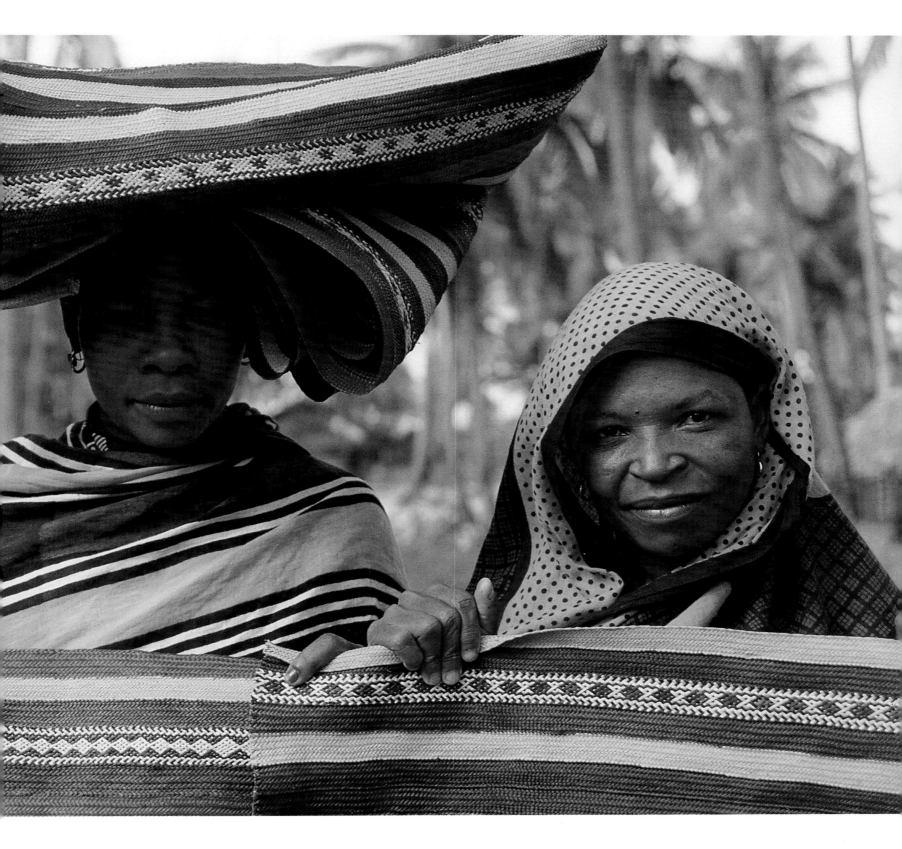

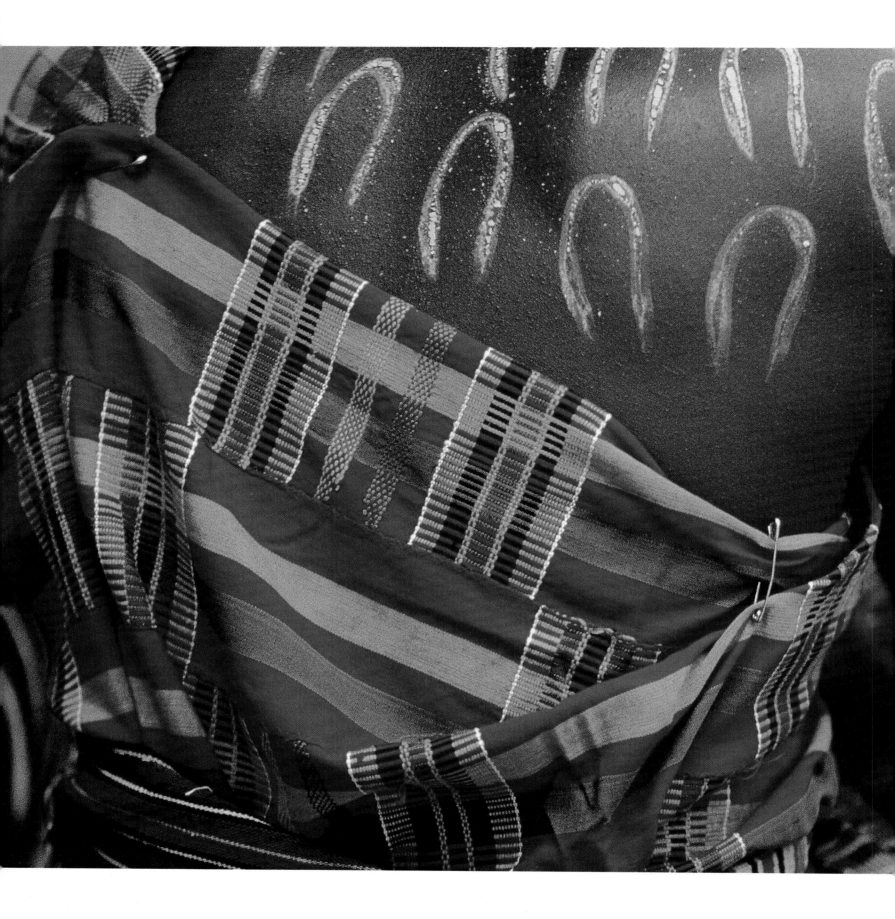

Because they must look after the house and children while they work, women find it convenient to use the stationary loom. Men, on the other hand, have no such obligations and are free to take their looms to an area where they may join their friends and weave in a companionable way. Women often cover their looms

when they are not in use and hang charms or talismans over them to prevent competitors from stealing their designs.

KENTE CLOTH

The most renowned African woven fabrics are Kente cloth from Ghana and *bogoloanfini*, or mud cloth, from Mali. Originally, Kente cloth was made exclusively for members of the Ashanti royal family. Not only was the cloth restricted to the ruling elite, but each pattern was woven especially for a particular king. Even today, because the cloth is so densely woven and takes such a long time to produce, a generous display of Kente-cloth fabric indicates not only a person of royal status but also someone of wealth.

The name 'Kente' is derived from the word *kenten*, meaning 'a basket'. The patterns, which were originally woven from raffia fibres, resulted in cloth that looked like a basket – what we would call a 'basket weave'. The weavers themselves call the cloth by its Asante name, *nsaduaso*, which describes the process, meaning 'a cloth hand-woven on a loom'.

Kente cloth dates to the 17th century, but is believed to be based on an older tradition of strip weaving that had been practised since the 11th century. Kente cloth had its origins in the Ghanaian village of Bonwire (also spelled Bonwuire). The threads used to weave the original cloths were often made from imported silk. The silks were taken apart by the weavers, who re-wove them on strip looms in the patterns that suited their royal clients.

LEFT: *The combination of Kente cloth and gold body paint worn by this Ivory Coast man conveys an overwhelming impression of high status and wealth. In the past, Kente cloth could be worn only by members of the Ashanti royal family.*

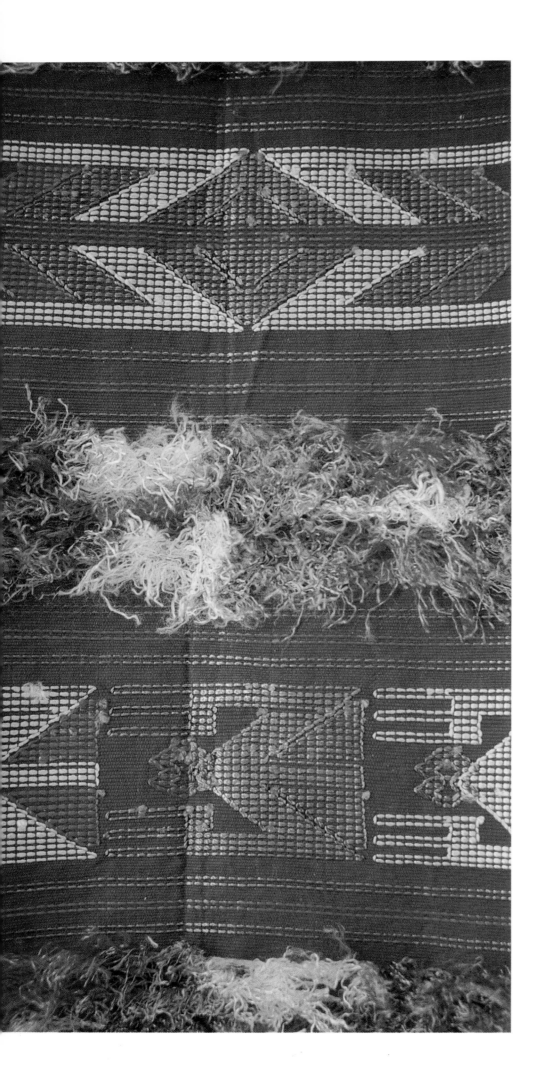

Kente cloth is one of the world's most labour-intensive and complicated weaves. Like all woven fabric, it is built upon the simple crossing of woof (or weft) yarns over and under the warp. The warp threads, which usually number about 240, run the length of the loom while the woof threads are woven across them. The restrictions imposed by this rectangular, grid form are obvious, and yet the variety of patterns produced by the weavers shows that even the most rigid format can inspire immense creativity. It is possible to create illusions within this grid that seem to leap over these built-in obstacles like a stone skipping over water.

The weaver who creates a new pattern is recognized as someone of great talent. Each pattern is given a name, usually in reference to events that took place during the reign of an Ashanti king, or to commemorate a particularly significant event. These specific patterns represent such desirable qualities as strength, bravery, beauty, valour and leadership. Instead of painting a portrait of a brave warrior or a heroic king, the weaver creates a cloth that embodies those qualities. Brilliant colours — with yellow, orange, blue and red predominating — are mingled in intricate patterns that are repeated along the narrow strip.

New patterns mark turning points in the life of the Ashanti people. Patterns become well-known in the communities where they are made and come to represent the actual history and values of the people. The shared beliefs that the cloth communicates may be 'read' by an informed observer. This remarkable belief system may be the reason for the explosive growth in the use of machine-made, Kente-style designs today. The distinctive patterns immediately identify the wearer as one who honours African culture.

Among the important patterns are *Emaa da*, which means 'it has not happened before'. The Ashanti king who first saw the pattern was struck by its originality and gave it that name. *Kyeretwie*, which signifies 'lion catcher', was designed to commemorate the skills of the warriors. The cloth named *Akyempem*, or 'thousands of shields', celebrates the unity of the men and women who defended the Ashanti kingdom. By placing the square symbols in stepped rows, the weaver brilliantly conveys the impression of a line of warriors with their shields at the ready. The design called *Sika Futuro* may be translated as 'gold dust' and refers to the widespread use of gold as a medium of exchange in West Africa before the advent of coins and paper money. The fabric is a symbol of wealth, created in rich yellow, orange and wine-red threads.

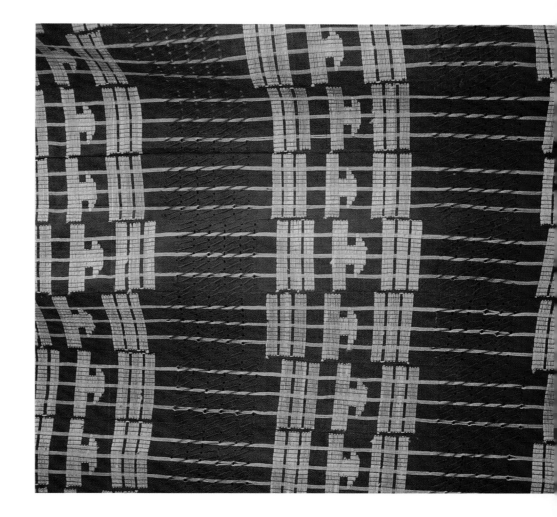

The Ewe people of eastern Ghana (and the adjacent areas of Togo), weave a variation on Kente cloth. The cloth produced by the Ewe weavers is distinguished by its resemblance to tweed, an effect that is created when various coloured threads are twined together to form the warp threads on the loom.

ASOKE CLOTH

Asoke cloth, made by Yoruba men of western Nigeria, is produced in a similar way to Kente cloth, with narrow strips woven in striped patterns. Asoke cloth was generally used for funerals and other important events. Occasionally, the weaver would include a contrasting strip against the striped background. Both Asoke and Kente cloth are woven from yarn that has already been dyed; the complicated interweaving of colours in the finished fabric comes from the interweaving of these dyed strands. But other patterned cloths are also made from solid-colour fabric, onto which the pattern is applied.

The more complicated Asoke weaves are known as 'prestige cloth', some of which have lace-like openings. The Yoruba once imported quantities of lace, and admired and appreciated the complexity of its creation. When they were unable to get lace, they began to weave patterns that emulated it. 'Prestige' refers both to the weaver as well as to the wearer, and such cloth is very expensive.

OPPOSITE: *The richly coloured weave known as* Iyage, *woven for the Yoruba people of Nigeria, features a distinctive pattern of threads pulled up from the surface to form a raised section.*

ABOVE: *The Asoke pattern known as* Olomoyoyo ongawa *is woven for Yoruba women.*

While the whole pattern of a Kente cloth is created to communicate a message, Adinkra cloth is built upon a wide vocabulary of symbols. More than eighty symbols are in use, symbols that are read just like the characters of Chinese calligraphy. These symbols are used as design elements on a variety of goods made by the Ashanti and so are universally understood. They form a virtual alphabet but go far beyond mere symbolism. Visually, Adinkra symbols represent the thinking, the history, the beliefs of the Ashanti people. The word Adinkra means 'farewell' and was originally associated with funerals and other rites of passage. According to the widely accepted myth of origin, Adinkera (or Adinkra), a king of the territory known as Ivory Coast, tried to copy the Ashanti's revered Golden Stool. In a war over this claim, Adinkera himself was slain. The cloth he wore when he was killed featured the stamping technique – or so it is believed.

The vocabulary of Adinkra symbols is based on Ashanti proverbs that describe the events of everyday life. They are sometimes patterned after forms found in nature as well as those that are created by the people. Some patterns capture the behaviour of people as well as the animals in the region. All of these show a keen eye for observation and the artistic ability to synthesize ideas into symbols. Adinkra symbols encapsulate the wisdom and beliefs of the people in succinct and beautiful motifs. The graphic shapes have been in use for more than a century.

The patterning process begins with a light-tone, solid-colour cloth. Designs are carved into a stamping die made from a calabash (a hard-skinned gourd that grows on a vine). The natural colours used with the calabash stamp are made by boiling the bark of the badia tree and then mixing it with iron slag.

The designer blocks out sections of the fabric, dividing them up into squares. Then the symbols are stamped repeatedly to create dense rows of patterns. Each square is stamped with a different symbol. Although the symbols are repeated within the square, the many different symbols used over the entire cloth give the finished product a lively visual appeal. A comb is used to create

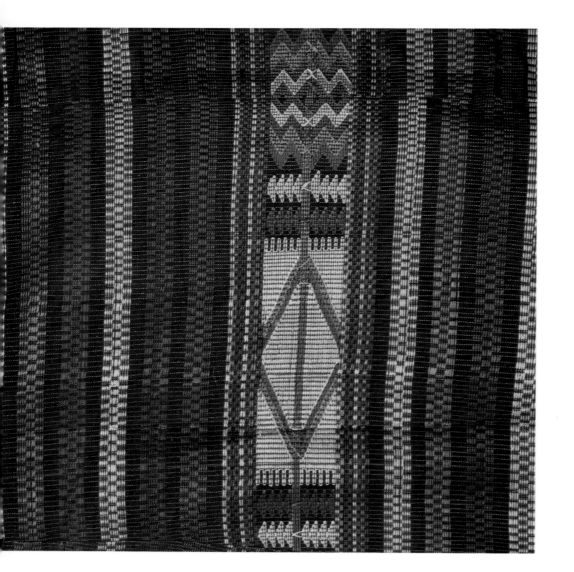

Akwete, a women's weave made by the Ibo people of Nigeria, uses skilful weaving techniques to create a vivid mix of patterns and colours. The rich fabric is produced on the broad loom that is used by women.

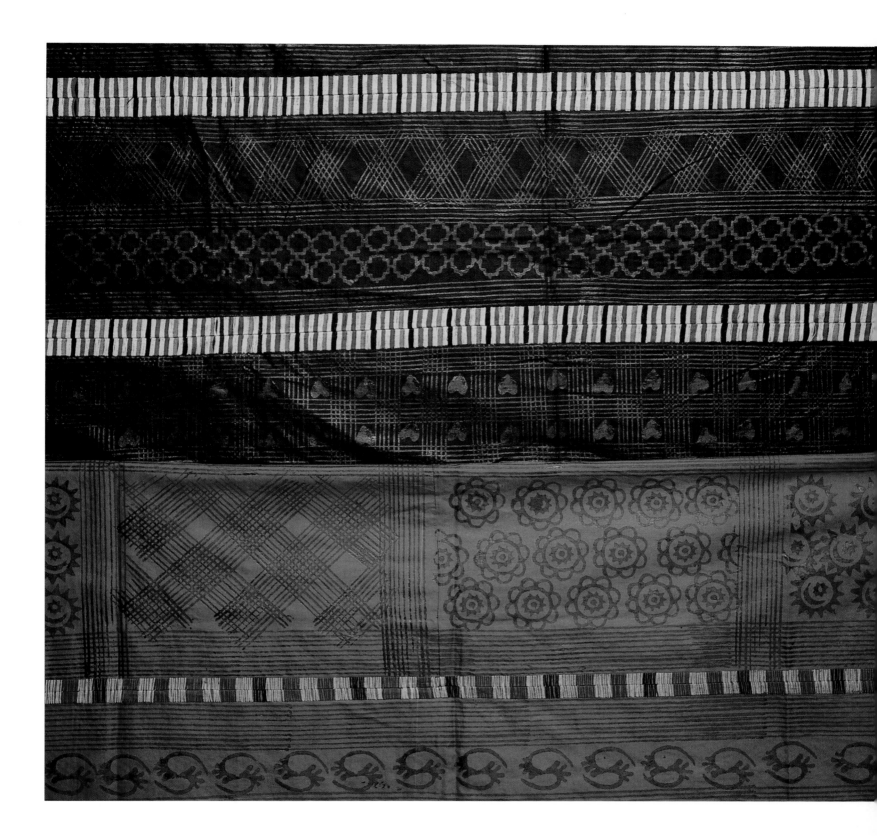

lines on the cloth, and these help to delineate the squares of stamped patterns. This reduction of complex ideas to elegant symbols is one of the most remarkable examples of a printed language that is not based on an alphabet.

Some of the symbols begin with simple, universally recognized shapes such as *Akoma*, the heart. In addition to the Western symbolic meaning of love, in Adinkra terminology the heart also implies patience, faithfulness and endurance. But, when the heart is embellished so that the lines are extended into curlicues both inside

Adinkra cloth, one of the numerous original textiles from Ghana and the Ivory Coast. The stamped symbols have specific meanings, and often express proverbs or historical events.

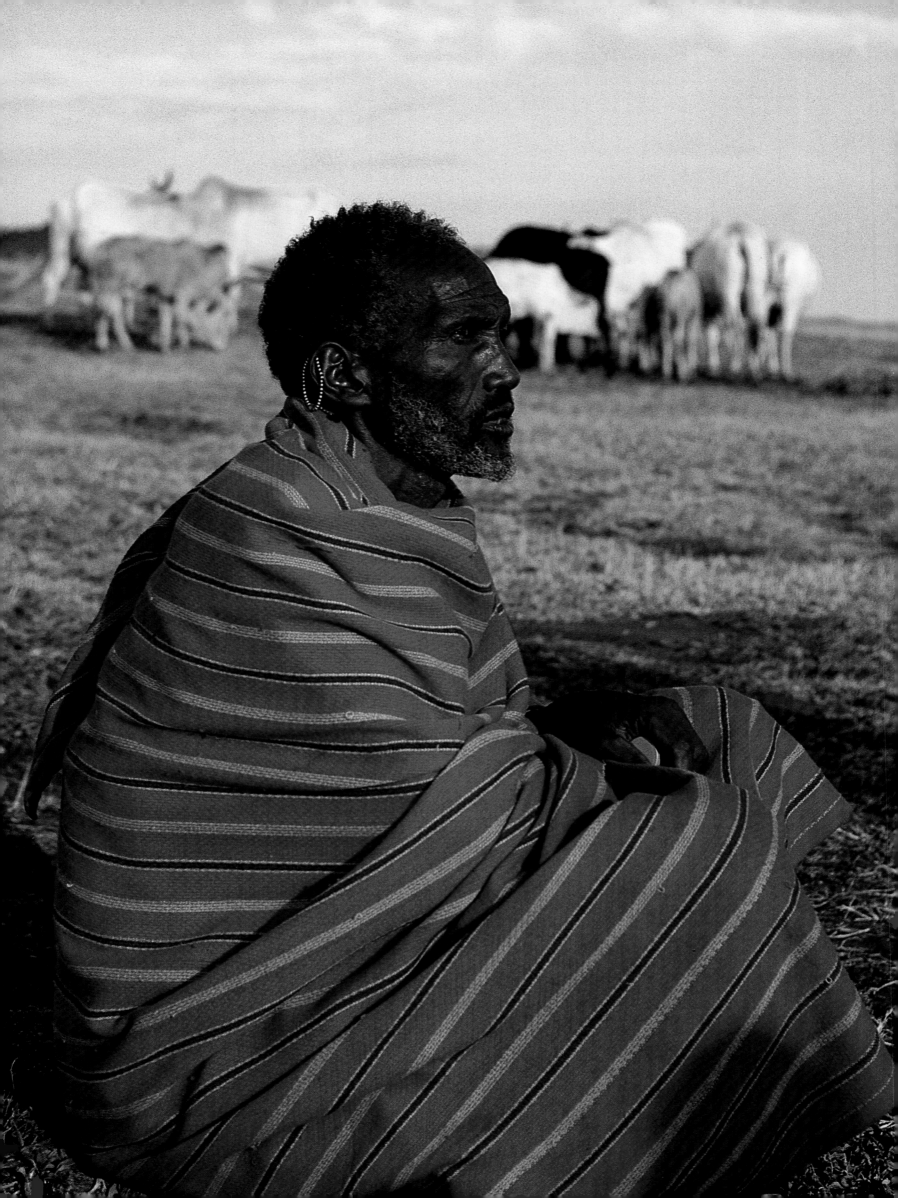

and out, it takes on other meanings. One such is *Sankofa*, or 'go back to fetch it'. It has been interpreted as showing the wisdom to be derived from the learning of the past. By retrieving the past, you can create a better future.

Several symbols relate to infinity and are built on designs that repeat in an end-less circle. These are often used to nurture unity and to advise people to avoid con-flicts. The free-flowing symbol *Bi-nka-bi,* or 'do not bite one another', is a direct symbol of unity, and suggests that people should refrain from fighting. The impor-tance of the king is described by a circular symbol with many arms, each ending in a circle. Known as *Ohene niwa*, or 'in the king's eye', it conveys the power of the king by suggesting that he sees all, and so nothing can be hidden from him.

MALI CLOTH

Also known as mud cloth, Mali cloth is a rich fabric dyed with the mud taken from the rivers that run through the West African country of Mali. Rivers are seasonal in many parts of Africa, flowing strongly during the rainy season, then slowing to a trickle in the dry season. Among the Bamana people of Mali, who make the mud cloth, the fabric is known as *bogoloanfini* which combines the words *bogolan* – something made with mud – and *fini*, which means cloth.

Mali cloth is readily recognized by its deep brown or black-brown geometric patterns placed against a beige or off-white background. Bands and borders of zigzags, diamonds and other symbols are placed within blocks to create dazzling designs. Although the elements of the designs are quite simple, the placement of repeating motifs and their juxtaposition on the cloth are rich with meaning for the informed observer. Some of the symbolism relates to the specific use of the cloth, for example in initiation ceremonies. Others refer to items that symbolize warriors and therefore strength and bravery. A pattern called *Cele ju*, or 'bottom of the net', evokes a type of net basket used either for fishing or as a bag for carrying per-sonal belongings. *Kumi Jose kan* cloth was made to commemorate a leader, Kumi Jose, who ruled until 1915. He had an unusually long neck, and the elongated shape in the design refers to this feature. Symbolic crocodiles feature prominently in the designs although they are so stylized that they are unrecognizable as such.

For outsiders who cannot read the symbols, they still offer a compelling visual experience. There is some question as to how widely legible the symbols are even within Bamana culture. Unlike Adinkra cloth, these meanings are not univer-sally shared. In addition, new patterns continue to be created by contemporary cloth makers. Their messages may be as personal as those of any other artist.

Using heavy or rough cotton, the men weave narrow strips of cloth, which are then sewn together to form a larger cloth. The intricate decoration is executed by the women. The process of colouring the cloth is extremely time-consuming, making the finished product highly desirable.

OPPOSITE: *A Kenyan herdsman wraps up against the cold morning air in a long length of striped cloth. In East Africa, fabrics can be wrapped in a hundred different ways.*

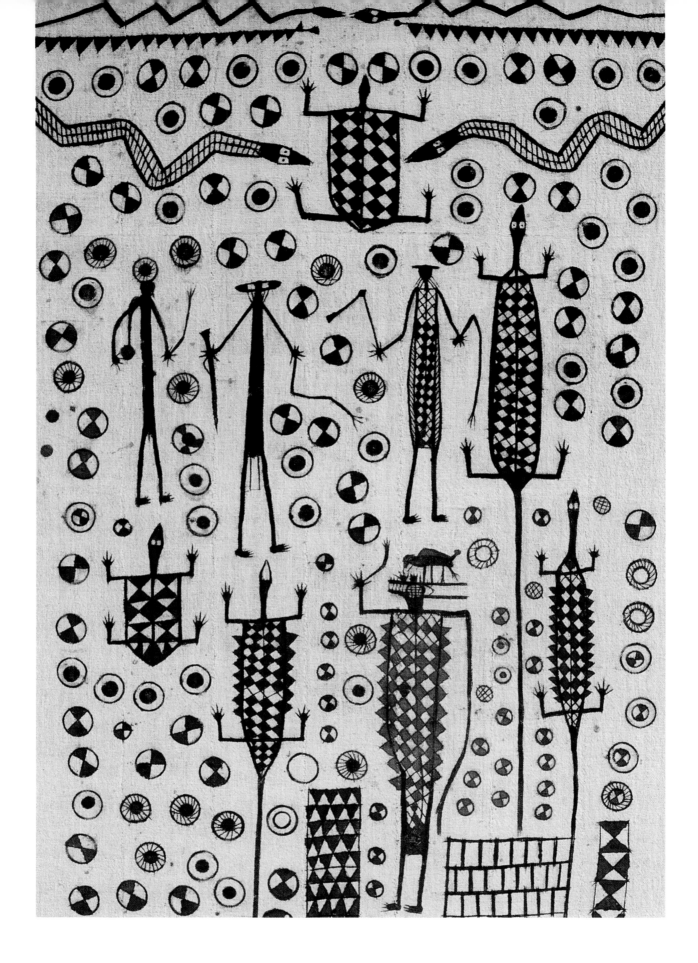

ABOVE: *In the northern part of the Ivory Coast, narrow strip cloth is woven locally. The lively Senufo Poro society masquerader designs are painted onto the cloth with a green paint made from boiled leaves. A resist method is used to produce Mali cloth, also known as mud cloth (opposite). Mali cloth is created in patterns that carry messages for the informed observer. Some cloths are made to honour leaders, others are designed for initiation ceremonies.*

To colour the cloth, the women first prepare it in a dye bath, using leaves that contain the chemical tannin. Then they gather river mud and allow it to ferment in clay jars. When the mud reaches the right consistency, it is applied to the cloth as a frame around the pattern envisioned. The tannin that has soaked into the cloth reacts with the mud to create the pattern. After the mud has been washed off, the background colour is bleached to emphasize the design. To describe the colour combination is a bit like considering the stripes on a zebra: is it a brown pattern on a beige background or a beige pattern on a brown background?

In Bamana society, the cloth is worn to mark important stages in life, ceremonies that celebrate the rites of passage. These include circumcision and continue through to death, when the cloth serves as a shroud. Except for its use by hunters, the fabric is worn exclusively by women on these ceremonial occasions.

The enormous popularity of Mali cloth has led to a variety of adaptations, some utilizing lighter-weight cloth that is more suitable for such products as sheets and tablecloths. While some of these adaptations retain elements of Mali cloth design, some stray very far from the appeal of the original. The designs are stencilled on in unvarying repetitions that show virtually none of the design imagination of the original work. Typical of this is fabric that is stencilled with images of Dogon dancers – not at all traditional but in some ways perhaps more appealing to the tourist market. The commercial products, unlike the original cloth, are usually made by men. While these cloths still have a handmade element, Mali cloth designs have also been adopted for large-scale commercial products that are sold in upmarket shops around the world.

KUBA CLOTH

Kuba cloth, a tufted or velvet pile raffia fabric, is also known as Kasai velvet, and is named for the Kasai region of what is now the Democratic Republic of Congo. The origins of the cloth date to the 17th century and are often credited to King Shamba Bolongongo. The patterns of this cut or tufted pile fabric are based on 'broken' geometric forms, with the elements fitting together to form designs. Geometric shapes, with their built-in symmetry, are used to create eye-catching patterns. Some involve a running design in which one element crosses under and over another, all of it an illusion created by the skilful placement of colour.

These complicated and labour-intensive cloths are created using the combined efforts of men and women. The basic fabric is actually a mat woven of raffia; the raffia is prepared from palm-leaf fibres by the men, who then weave the mats on looms. The woven mat may be softened by immersing it in a mortar filled with cold water and beating it with a pestle. At this point, the raffia mat passes to the women, who use it as the background for patterns worked with palm thread. The pile is created by clipping the tufts. Amazingly, the patterns are not marked on the

Opposite: Kuba cloth, produced in the Kasai region of the Democratic Republic of Congo (formerly Zaïre), is created from banana tree fibres and features geometric designs that create a trompe l'oeil *effect.*

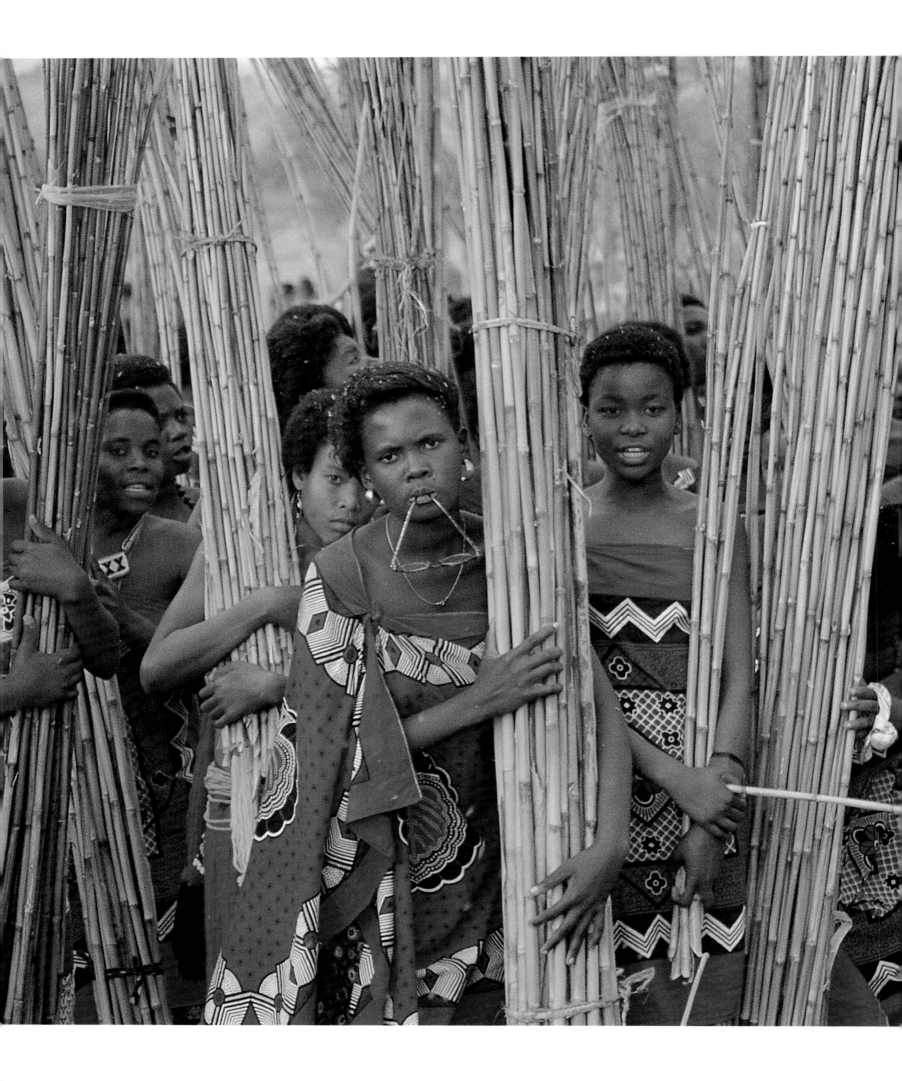

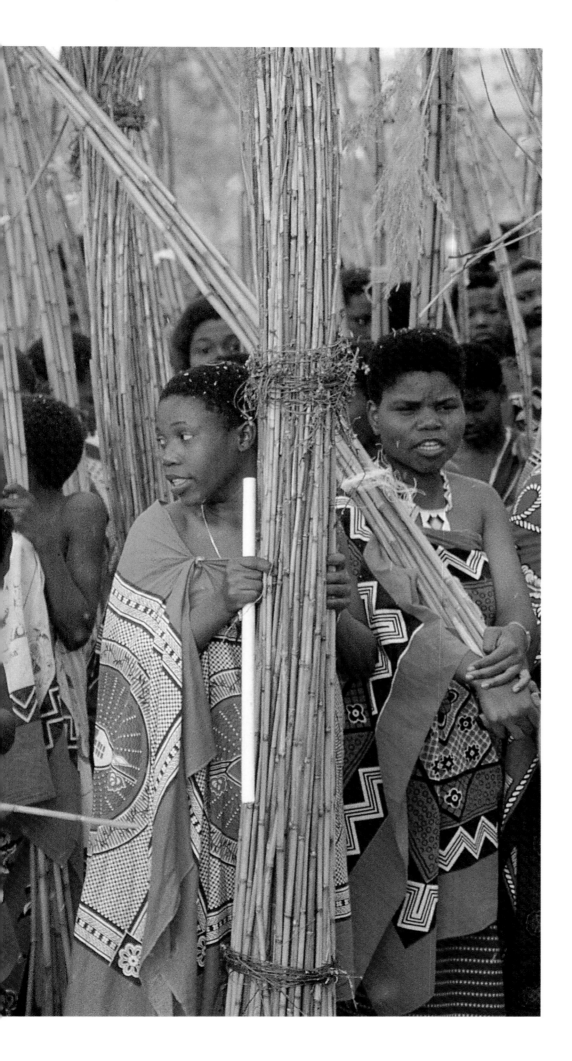

Each year, the young women of Swaziland gather at the Queen Mother's homestead to weave a new fence. They wear commercially made woven cloth wraps featuring the shield of Swaziland.

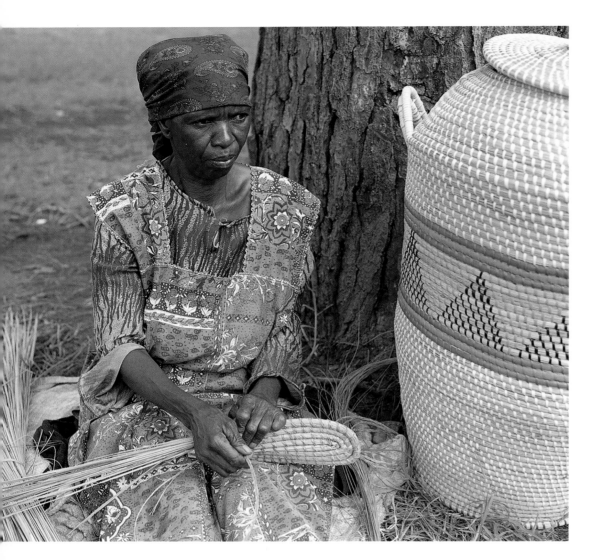

mats; instead, the women keep the designs in their minds as they work, brilliantly anticipating the placement of the coloured threads that are needed to complete the design. Finished Kuba cloths are sometimes sewn together.

In addition to weaving, women often embroider the fabric, and may also attach shells or small pieces of leopard skin – the symbol of royalty. Kuba cloths were so highly valued that they were used for royalty, and sometimes buried with members of the royal family. Fabric made for the wives of the king boasts particularly complicated embroidery, befitting their royal status.

BASKETRY

Among many cultures, weaving is also used to fashion household objects, and may even constitute the method of construction for the house itself. Gourds, widely used as containers for liquids (*see* page 120), including milk, require a balancing support when they are carried on the head or placed on the ground. The solution is a circlet woven of banana fibre or other natural fibres such as papyrus or grass, into which the gourd is placed. Among the Zulu of KwaZulu-Natal, this woven circle is called *inkatha*. In the dry regions of Kenya where the Samburu live, wild sisal fibres are loosely woven to make mats for the roofs of houses. These mats are placed over a framework of wood, itself a lattice form of weaving.

Basket-making is widely practised in sub-Saharan Africa, using all kinds of locally available natural ingredients, including vines, grasses, reeds, sorghum, papyrus and palm fronds. By combining different colours and weaving techniques, the basket-maker can create a variety of intricate patterns. Varying the placement of the upright fibres (the warp) with the crosswise ones (the woof) permits an almost infinite number of different weaves. Natural dyes made from roots and bark are applied to impart muted, earthy tones. The fibres may be wrapped around one another, coiled, interlaced, formed into checks, herringbones and braids. Baskets may be woven loosely, to sift grain, or tightly, so they can hold liquids. In virtually

ABOVE: *Using reeds, women weave baskets as well as mats and other objects. The baskets made by Zulu women in the Drakensberg region of KwaZulu-Natal fill a wide variety of uses. Many have tightly fitting lids.*

OPPOSITE: *Himba girls from the Kaokoland region of Namibia use their open-topped baskets to carry home fruits gathered in the bush.*

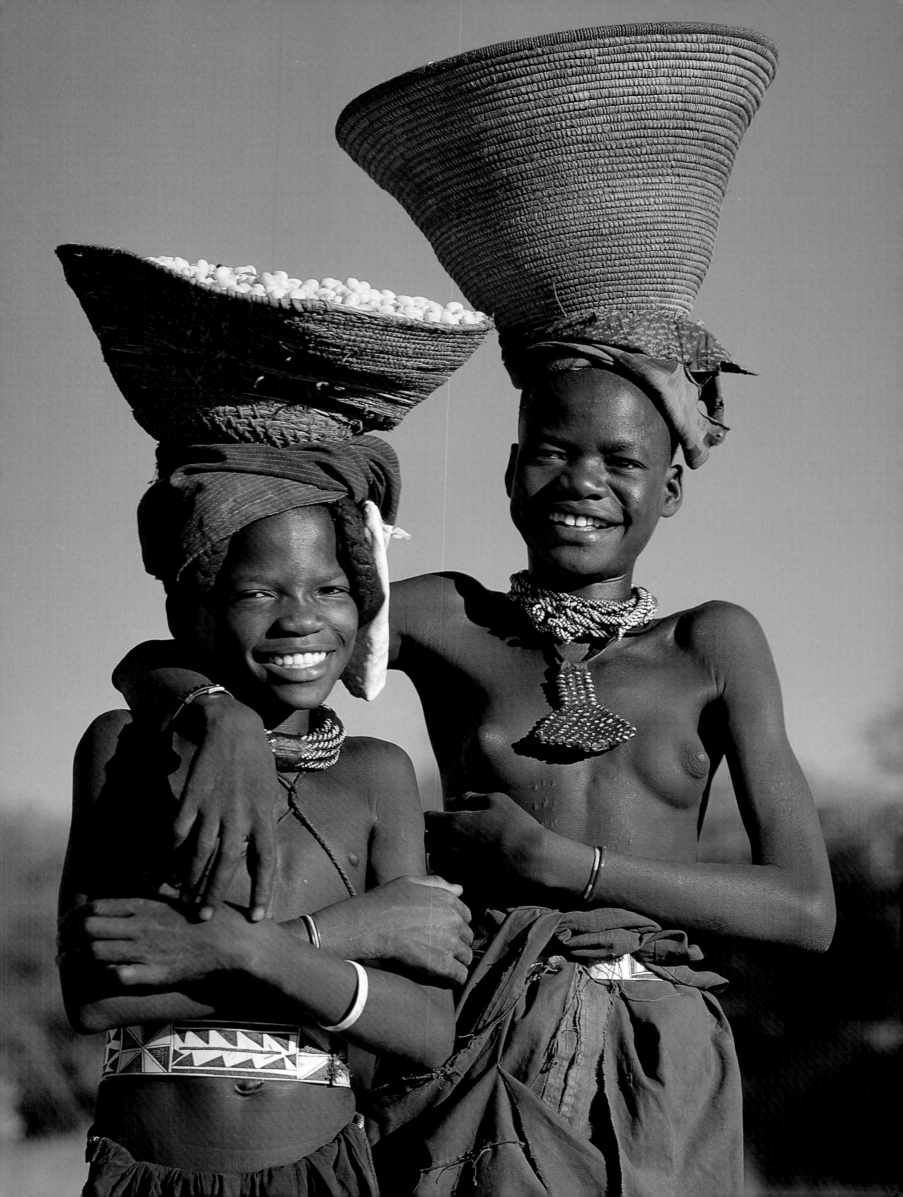

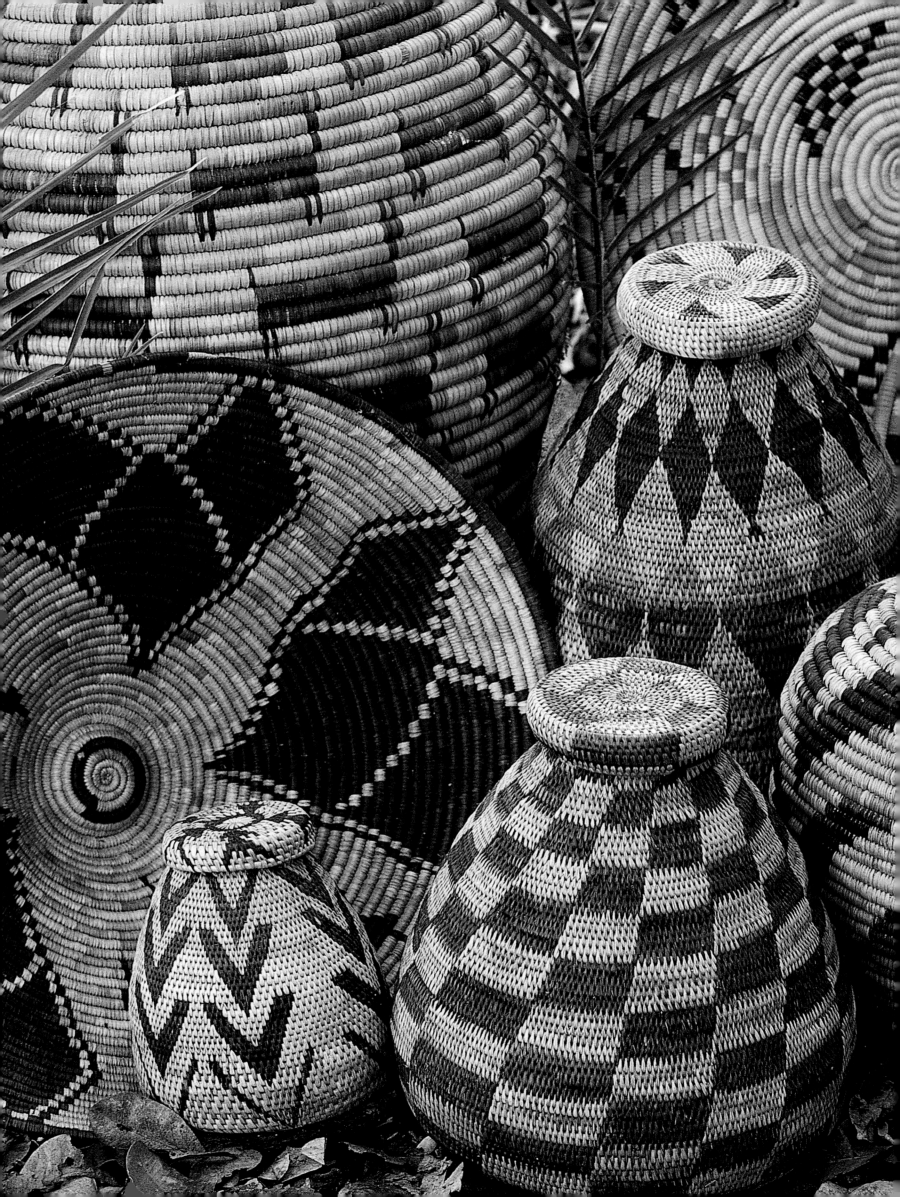

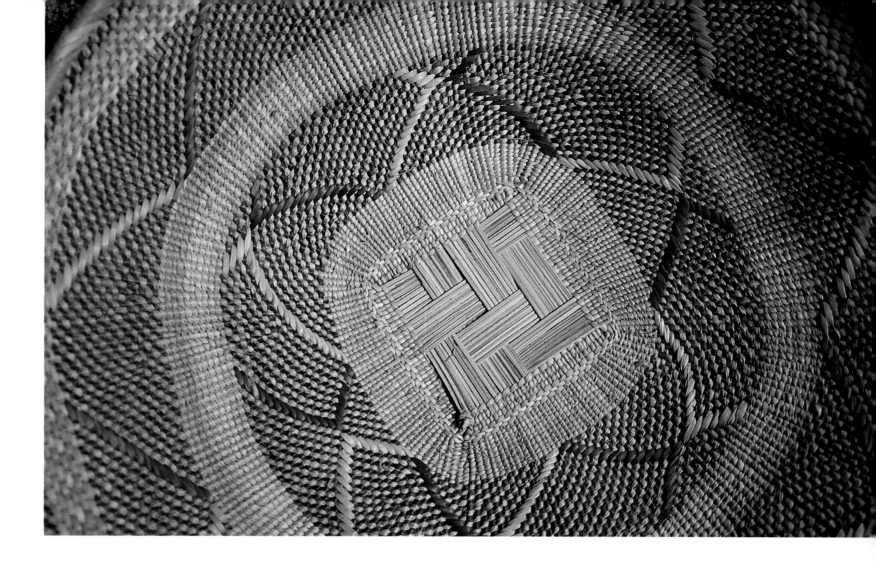

every culture, materials are readily available that can be utilized to make baskets. The materials determine the fineness of the weave but the ingenuity of the basket-maker determines the ultimate artistry of the work.

The weaving technique is also employed to make baskets of varying size, from tiny snuff and herb containers to enormous grain baskets. Some baskets have fitted lids that look like hats. The distinctive rounded Zulu baskets are among the most beautiful still being made. In Botswana, doum palm fronds are woven into flat and round forms in dozens of distinctive patterns, with the finished products ideal for holding grain and seeds. Trays are made according to the same technique. The woven patterns actually tell a story to those who know the symbols they represent. When the baskets are wetted, the coils swell and the basket becomes watertight. In Angola, river reeds are dyed and woven into beautiful trays called *kambalas*. Traditional baskets from the Congo are made in square shapes, while those from the Sudan have sharply peaked lids. Serving trays sometimes have matching lids to protect food from insects. In the Nubian communities of East Africa, weavers often use bright commercial dyes such as green, gold and red.

Although weaving is almost universally practised, African peoples have turned this practical craft into a lively expression of personality and culture. Fabrics such as Kente cloth and Mali cloth, as well as Zulu and Botswana baskets, have become highly prized far beyond the traditional settings where they are made and used.

OPPOSITE: *Botswana basket makers skilfully weave palm fibres to create a multiplicity of forms and patterns. Some lid-topped baskets are so tightly woven that they can hold liquids. Trays are used for sifting grains.*

ABOVE: *A detail of a Tonga basket, from the border region between Zambia and Zimbabwe, shows the superb weaving technique of these people. The natural beige and brown colours of the fibres are used to create intricate patterns.*

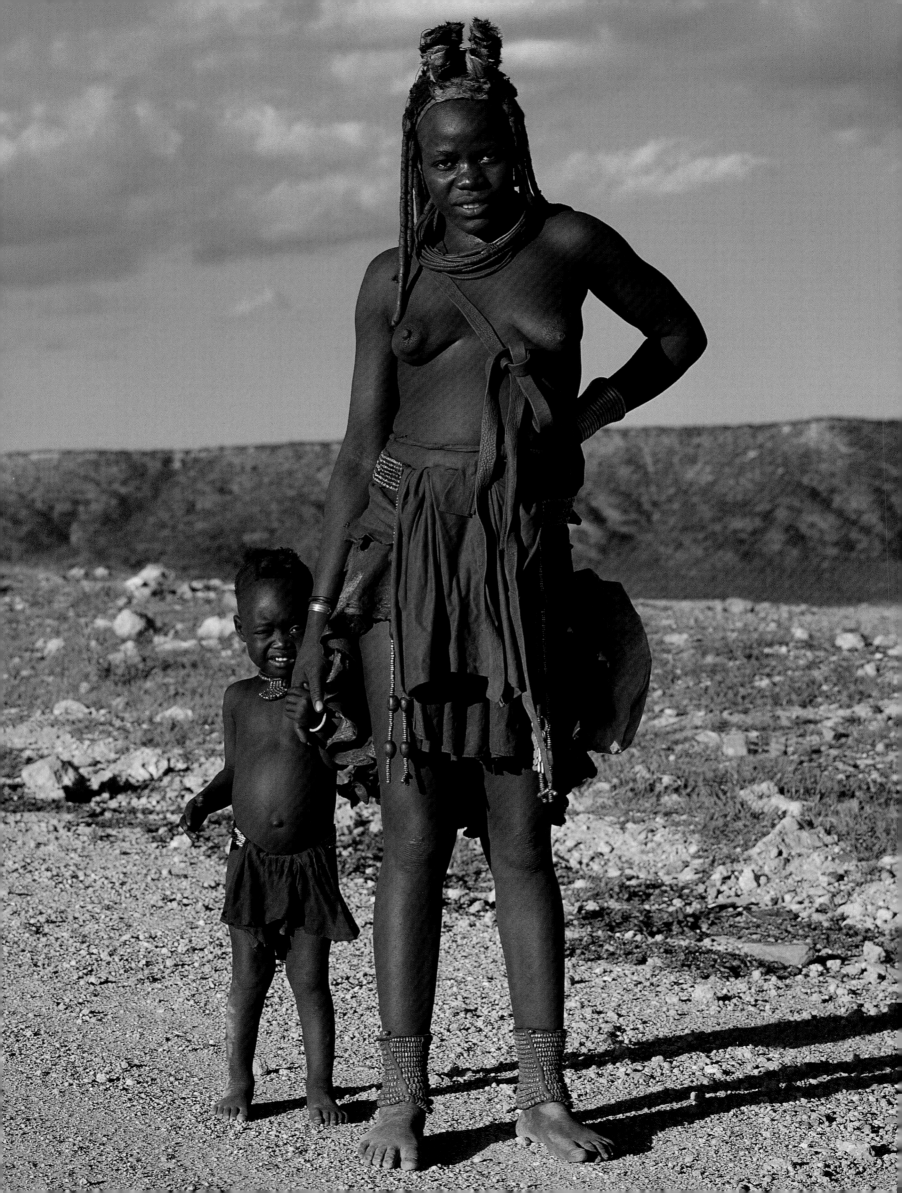

LEATHER

The hides or skins of domesticated animals are one of the most basic materials used by African cultures. Wherever livestock – cattle, goats, sheep, camels – are part of everyday life, hides furnish a myriad products for everyday use. Livestock are also at the heart of a family's wealth and status within a culture. When the link between a people and its livestock is broken – because of drought, warfare, urbanization or disease – the culture itself is placed at risk. In many cultures, livestock are prized and cared for with the same attention paid to human members of the family.

In the remote Kaokoland region of Namibia, a Himba woman wears a soft skirt
made of calfskin. Her headdress and her child's loincloth are also of calfskin.

RIGHT: *A Herero girl of northern Namibia wears a leather modesty apron ornamented with brass tassels.*

OPPOSITE: *Wrapped in a sheepskin, a Wodaabe boy in Niger tends the family livestock. These nomadic people rely heavily on their animals.*

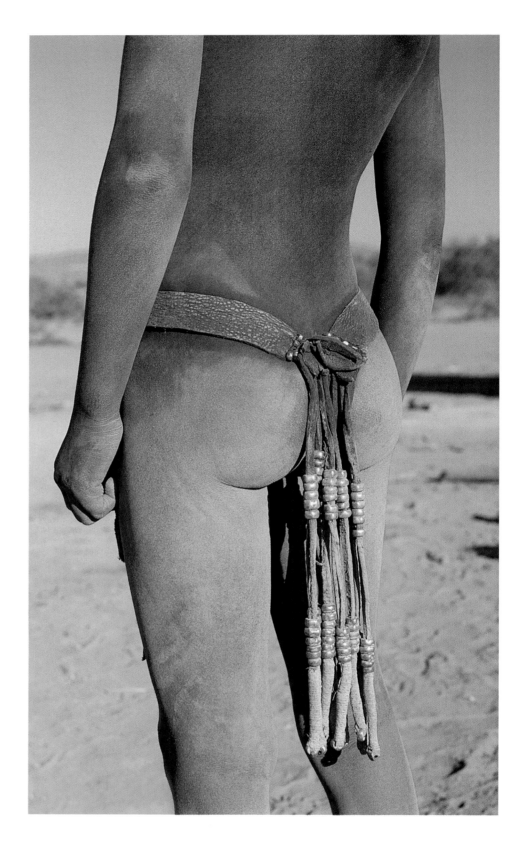

Skins have long been the traditional dress of many African peoples. The hides were scraped clean, beaten until they were soft and supple, then tanned and treated with ochre and fat. Skins could be stitched together and decorated with beading. In remote rural villages of the Pokot, Maasai and Samburu in Kenya, older people still use skins for clothing. In the most isolated areas, some younger people wear skins as well. As traditions fade, the wearing of skins will become even more rare.

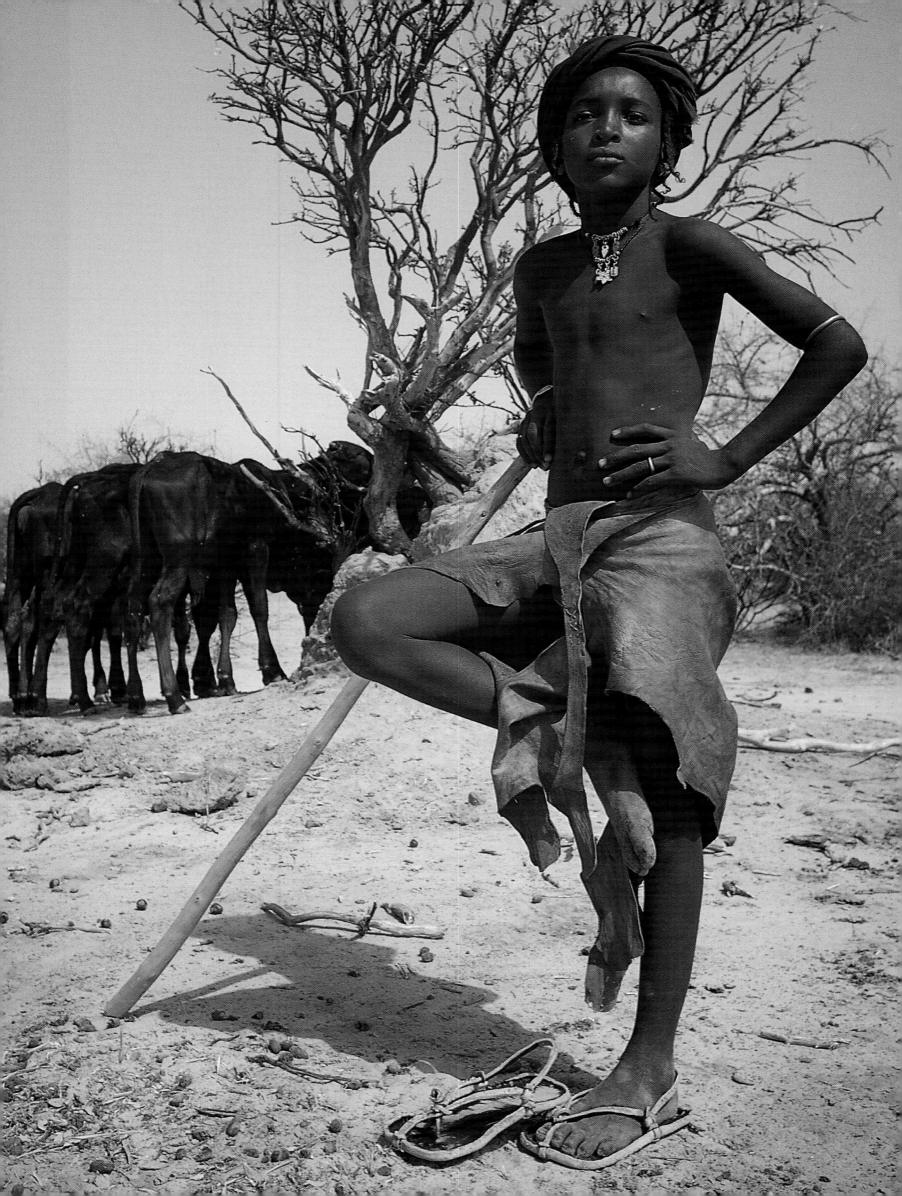

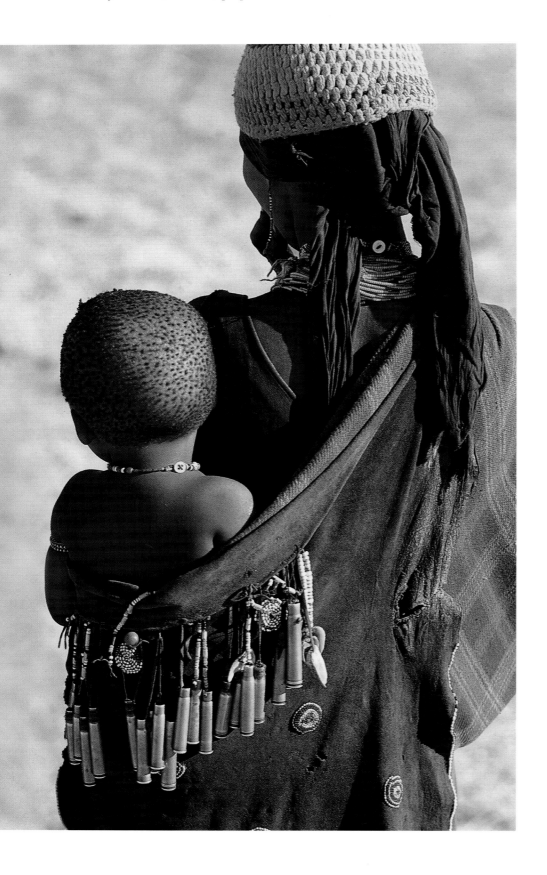

A !Kung woman living in the Kalahari Desert of Namibia carries her baby in a caross made of skin. Cartridge cases found on the ground have been added for decoration. The !Kung are members of the San (Bushmen) people.

SAN (BUSHMEN)

One of the last groups of people to wear skins are the San (Bushmen) of Southern Africa, who have lived continuously in the region for longer than any other culture. Using small bows and arrows tipped with poison, these hunter-gatherers stalk wild game in the bush, shoot at close range and then chase the animal until the poison takes effect and it succumbs. Game is hunted only when it is needed, and then the carcass – the meat, the hide, even the sinews – is used in its entirety. For the San (Bushmen), every bit of the animal has a purpose: hides are used to make slings to carry babies, the modesty aprons worn by women and mats to cover the ground. Arrows are carried in quivers made of skin.

The number of San (Bushmen) still living traditionally in the dry interior of Southern Africa is now thought to be no more than a few thousand. The ability to roam freely, making use of only a limited number of wildlife in order to sustain a traditional, nomadic life, has been greatly reduced by the fencing of land for game parks and the use of even marginal lands for farm crops and commercial livestock rearing. But those groups that maintain their own herds are able to continue making household and other goods from the skins of their animals.

HIMBA

As mentioned in the chapter on metal (*see* page 132), the Himba, who live in the forbidding Kaokoland region of north-western Namibia, have managed to maintain their traditional way of life. Their homeland is desolate in the extreme, an area of mountains and bone-dry plains. The Himba had virtually no contact with Europeans until after 1850. Explorers had been thwarted by the fierce geography and climate of the region, the utterly bleak

Atlantic Ocean shore – known for good reason as the Skeleton Coast – and the harsh Namib Desert. Even missionaries left the Himba alone, and it was not until 1954 that a mission with a school and hospital was built.

Although the Himba found ways to survive under these demanding conditions, even they were defeated by a severe drought in the early 1980s which wiped out more than eighty percent of their cattle – perhaps one hundred and thirty thousand head – as well as tens of thousands of sheep and goats. When the drought ended, only a few thousand Himba resumed their semi-nomadic way of life. The land, with its sparse waterholes, requires that people keep on the move, constantly on the lookout for feed and water for their livestock.

Only with a viable herd of livestock can a Himba family hope to pursue their traditional culture. Unlike most other traditional cultures, such as the Maasai and Samburu, the Himba still dress in skins. The women as well as the children wear skirts and aprons made of calfskin that has been softened through extensive preparation. Even small children wear tiny aprons made of hide. The women sometimes wear leather belts with a variety of metal pieces attached in neat, geometric rows. In spite of their totally traditional way of dress, the metal pieces often consist of discarded rifle cartridges and even pins from hand grenades. Divorced from their original uses, the metal bits glint in the sun and lend sparkle to the otherwise monochromatic look. Over their skirts they may wear ornaments of leather onto which they sew cowrie shells and strips of metal.

Everything the Himba wear is heavily coated with ochre; combined with the natural colour of the hide, their own skin colour and the reddish colour of the earth in the Kaokoland region, this results in a single colour from head to toe. The men also dress in skins coated with ochre. Although Himba dress is all one tone, the overall effect is nothing short of spectacular. Even when they travel to Windhoek, the capital of Namibia, they seem perfectly comfortable and at ease in their ochre-soaked skins and leather ornaments.

In spite of the rebirth of traditional Himba life – with a cattle herd that now numbers more than fifty-five thousand head – the current generation of Himba know they are likely to be the last to pursue their nomadic way of life. Their children, who spent their formative years in refugee camps, have been to school and have learned to wear Western-style clothing and to listen to radios. They have little interest in following the traditional Himba way of life.

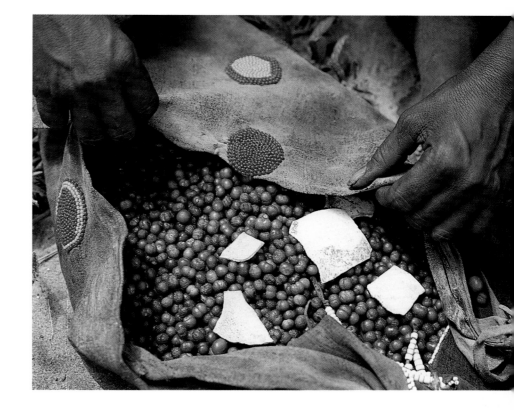

ABOVE: *The resourceful San (Bushmen) of Namibia live off the land. This beaded leather pouch is filled with fruit gathered by its wearer.*

OVERLEAF: *Two examples of the use of leather by the Himba. Page 166 shows a leather dress richly ornamented with cowrie shells – highly prized and used as currency in the past. The metal beads are made by pounding wire and cutting it to size. The pieces are then pressed into the leather backing. Page 167 shows a woman's leather belt enhanced with a storehouse of found objects, including rifle cartridges, hand grenade pins and a nail clipper. The leather has been softened and treated with ochre and fat.*

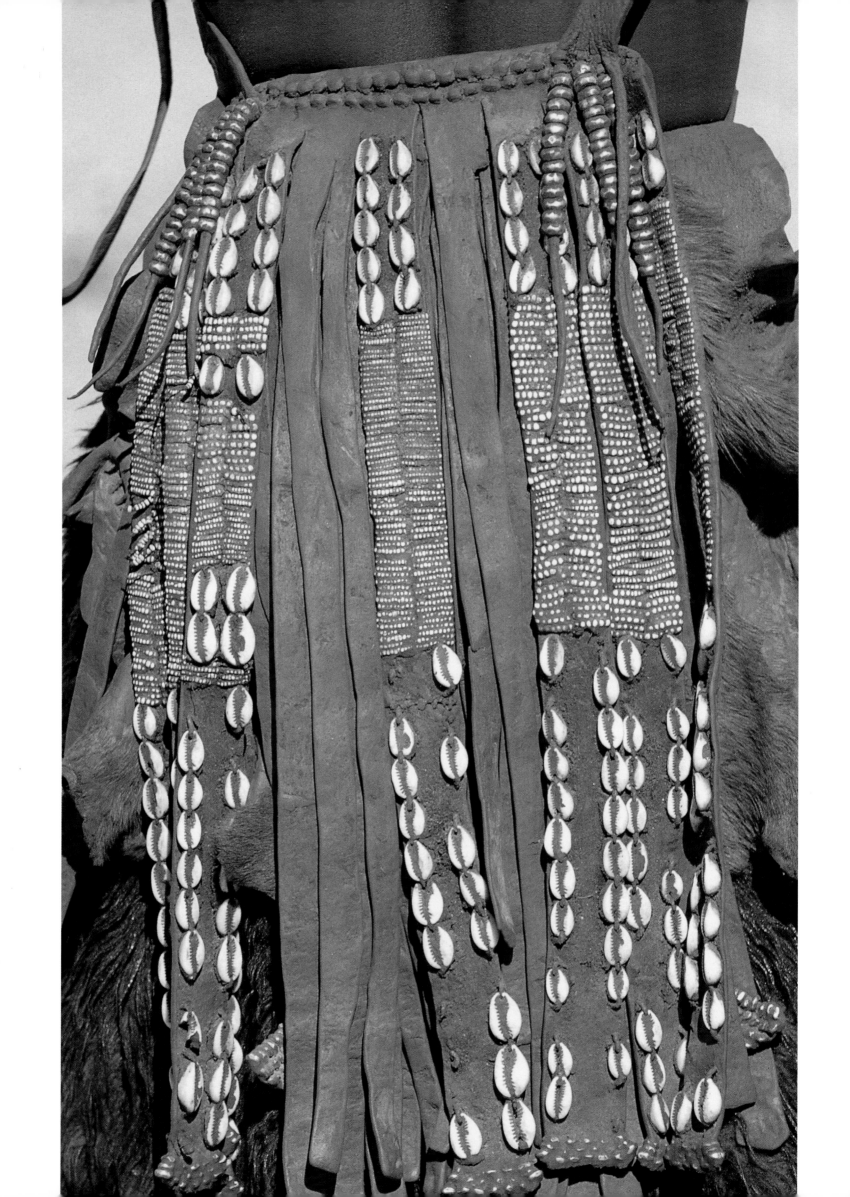

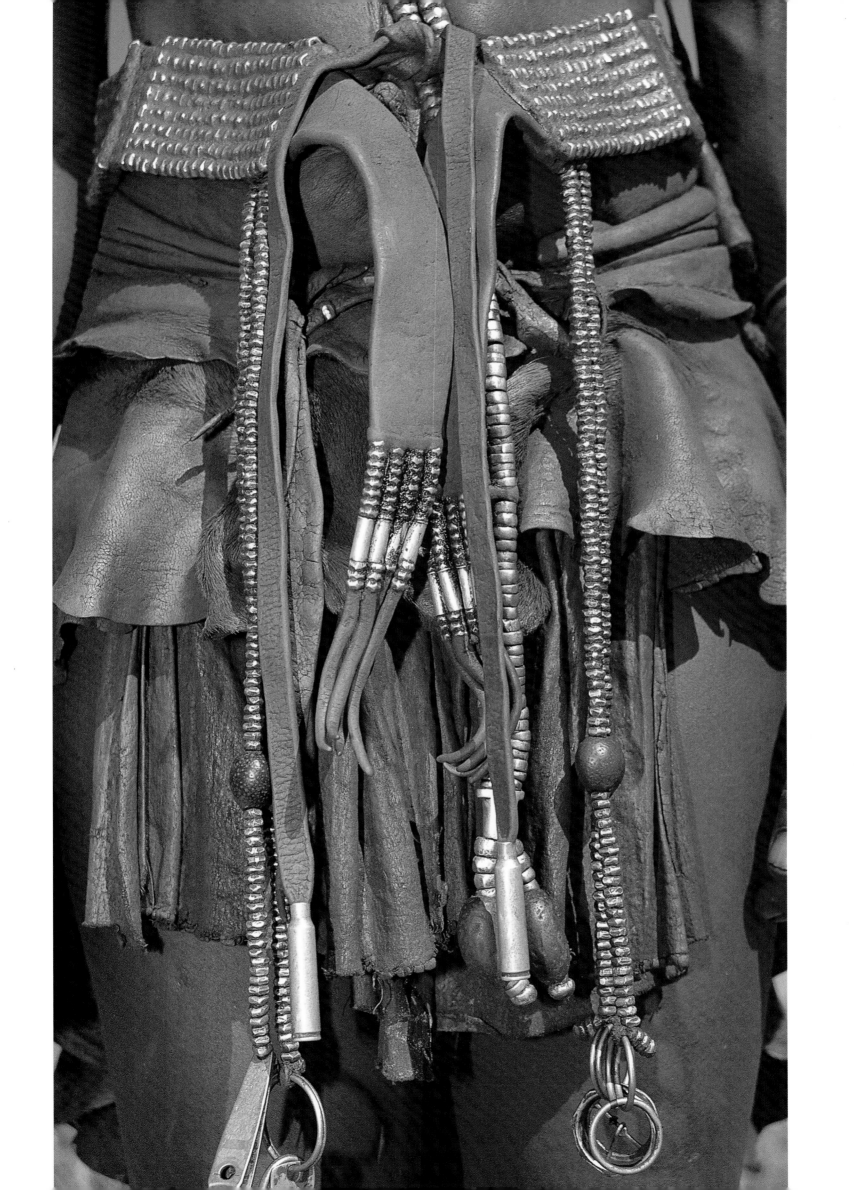

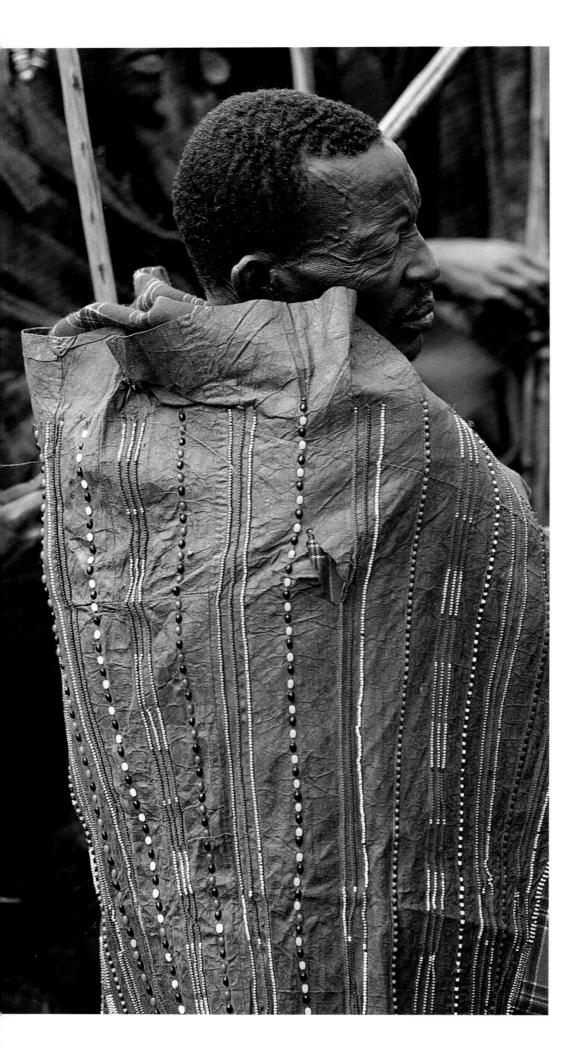

LOVE OF CATTLE

The relationship between cultures and their cattle is best expressed by the Maasai of Kenya and Tanzania and the Samburu of Kenya. Traditional Maasai life is inextricably tied to livestock. Their herds include goats and sheep, but it is cattle that give a man status. In 1980, it was estimated that there were three million head of cattle in Maasailand. The ancestry of the Maasai lineages is tied to their cattle and each lineage brands its cattle with a distinctive and recognizable mark. When their cattle breed, the Maasai keep the most beautiful animals for their herds; especially prized are those animals with elegantly curved horns. Others may be sold for money or used as meat. The Maasai, who sing to their cattle, praise their virtues as they watch over them in the areas where they graze.

When a Samburu girl marries, her wedding dress is made from three goatskins. An older woman prepares the skins by first stretching them out and drying them in the sun. Then she scrapes away all the dead matter that was left when the goat was skinned. The skin is treated to make it supple, and then heavily oiled and coated with ochre. For the wedding, a cape is made for the bride's mother from a specially chosen goatskin. When the skin is prepared, one central strip of natural goat hair is left in place, to form a dramatic stripe down the back of the cape. The cape is used only for this one occasion.

In many parts of Africa, cattle are crucial for the payment of *lobola* (bride wealth). Specific numbers of cattle are

paid – among the Samburu the number is usually seven – and included among them should be one ready to deliver a calf, promising even more wealth. Among the Zulu of South Africa, *lobola* is usually ten or eleven head, with the eleventh being the traditional sign of the bride's virginity. More cattle are asked for a chief's daughter; if a girl has been to university, a higher price is also demanded.

During a Samburu circumcision ceremony, animal skins play prescribed roles in the ritual. During the days leading up to the circumcision itself, the boys dress in a single wrap made of goatskin that has been blackened with charcoal. Their mothers rub animal fat into the cloaks before the boys begin a long journey into the bush to gather the sticks and other

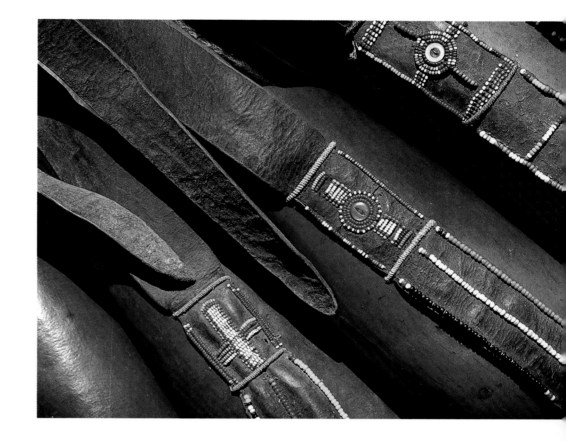

materials that they will use to make weapons for hunting. For the circumcision, each boy is seated on a specially prepared ox hide covered with a sheepskin from a newly slaughtered animal. As soon as the circumcision has been completed, the boy is carried into a house built just for this ceremony where he is laid out on the ox hide. He and his mother will live in this house for one to two months, throughout the healing period and during the time he begins to roam the countryside, learning the ways of the *moran*, or warrior. Pieces of the same hide are cut to make a new pair of sandals to be worn only during this period. Slaughtering an ox for this ceremony represents a considerable financial burden, and reflects the importance of this ceremony in the life of the boy, his family and his entire community.

OPPOSITE: *A Maasai elder wraps himself in a skin decorated with beads.*

ABOVE: *For their daily diet of milk and blood, Maasai women fashion containers from gourds. Beaded leather straps are affixed to the gourds so they may be easily carried.*

HUNTING

When the Maasai warriors roamed the East African plains, raiding for cattle, they carried shields made of hide. The ornamental patterns created by the natural coloration of the hide indicate the warrior's age set, as well as the bravery he has shown. Today, with opportunities for displaying bravery greatly reduced, such shields are more symbolic than defensive in function and the patterns may be designed with tourists in mind.

Before circumcision, young boys always made headdresses from the feathers of lovebirds, sunbirds or other species prevalent in the region, and wore their mother's earrings (*surutia*) during this time. Black and white ostrich feathers, which

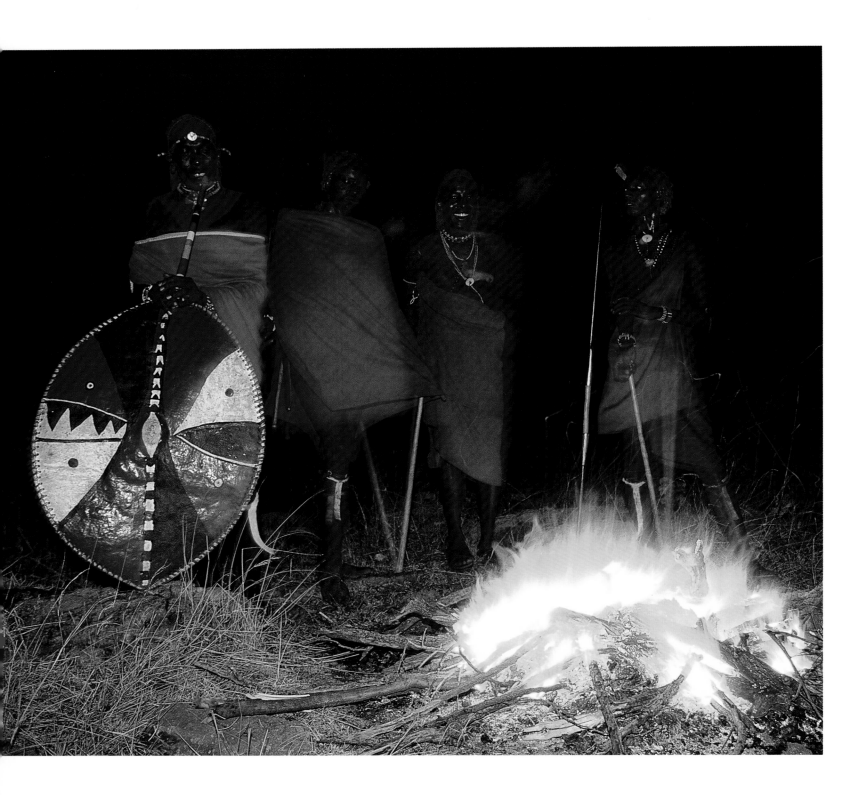

ABOVE: *Maasai warriors gather at a fire. Traditionally, shields were made from buffalo hide, although cowhide is more likely to be used today.*

OPPOSITE: *This Maasai moran is framed in an ostrich feather headdress mounted on a beaded leather frame.*

are taken only from the male bird, are worn only by a warrior who has proven his bravery in the lion hunt. The feathers are attached to a leather band framing the face, and make beautiful and dramatic headdresses.

Historically, Maasai proved their bravery by killing a lion. Boys would hunt as a group, and one boy would be designated to plunge his spear into the lion while another one held the tail. The boy who accomplished the extraordinary feat was entitled to wear the animal's mane as his headdress. When lion hunting was outlawed, boys began to hunt smaller animals, especially monkeys, and to shoot birds with arrows; the feathers were made into headdresses before their circumcision.

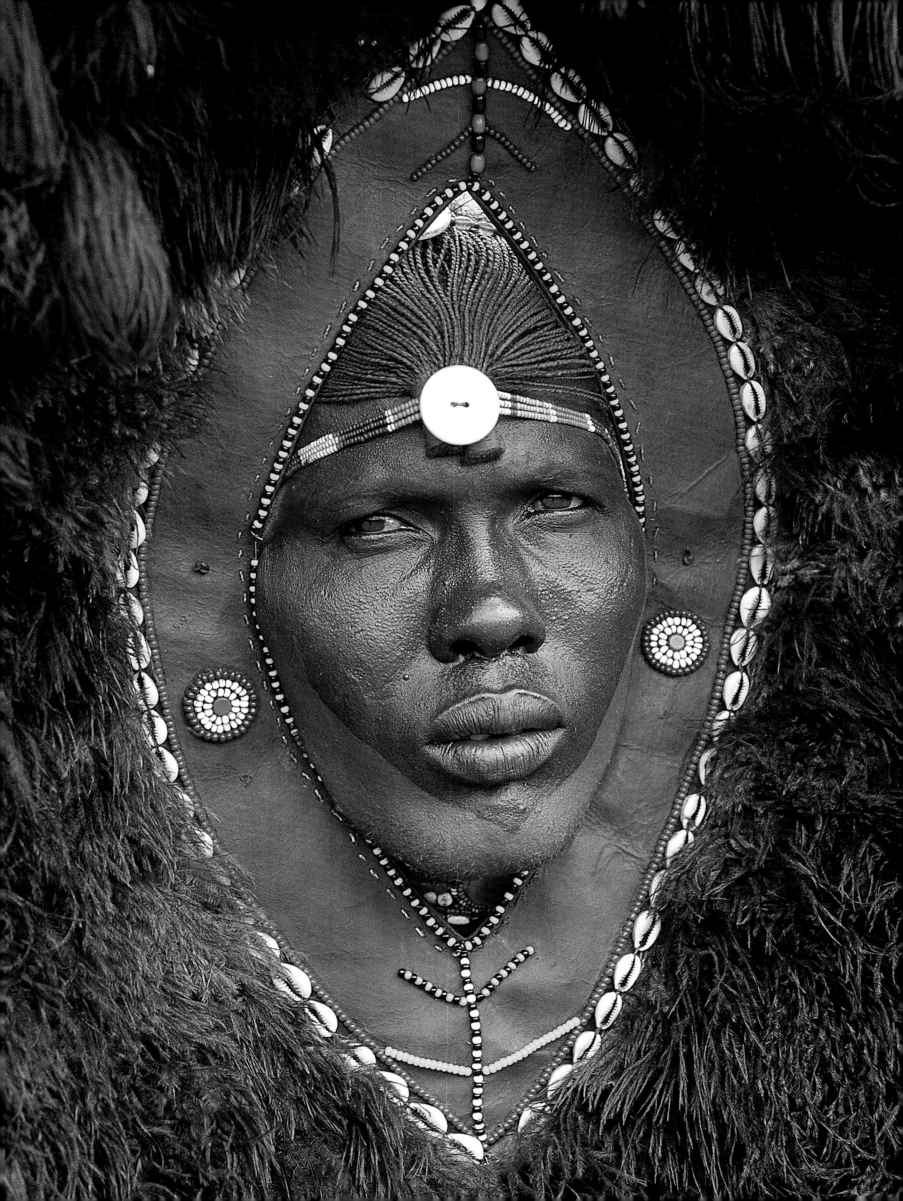

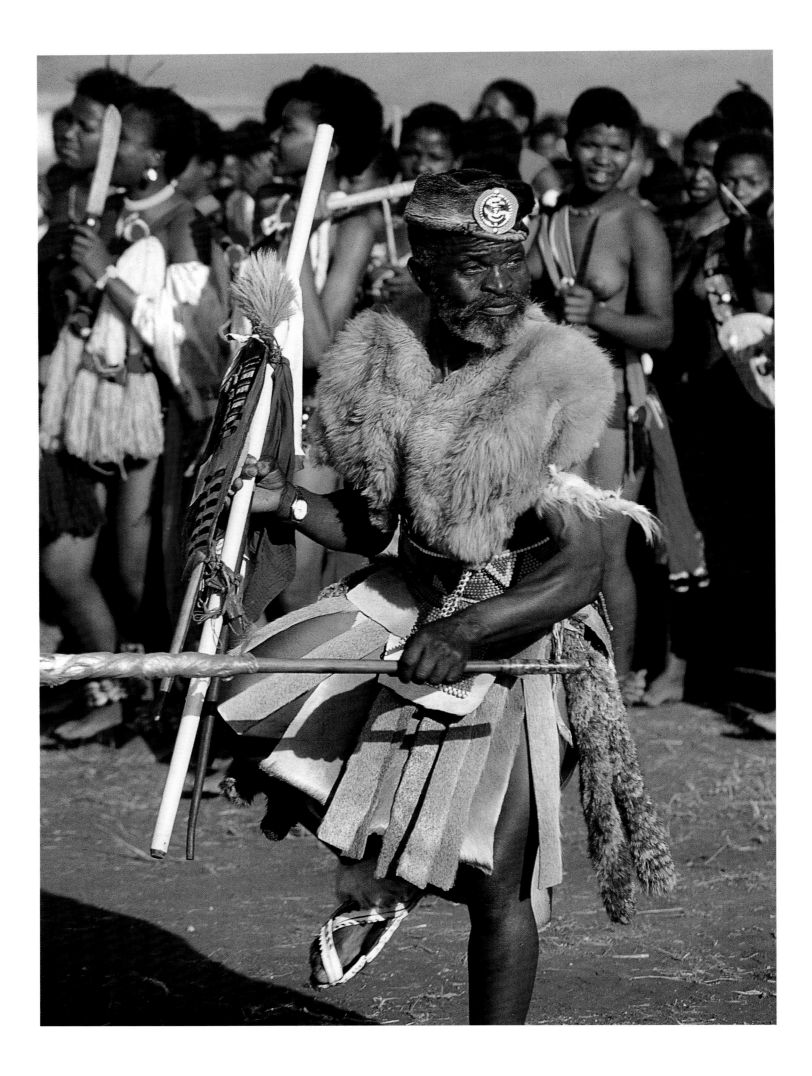

Another aspect of hunting among African cultures is the use of spotted animal skins, such as cheetah and leopard, which usually denotes royalty. Spotted fur ornaments, including headbands and capes, are worn by Zulu chiefs as well as by members of the royal family of Swaziland. Former Zairean president Mobutu Sese Seko was invariably seen wearing a spotted fur cap, an effort to show his connection with his cultural traditions. However, these are symbols of the past, of a time when wild cats could still be hunted. Today, hunting is banned in most African countries that still have considerable reserves of game.

The use of leather for clothing, shields, and other traditional items continues to diminish as more and more cultures lose their close contact with livestock herds and with a semi-nomadic lifestyle. Today's African is more likely to carry a leather briefcase or a wallet than a shield.

OPPOSITE: *A Swazi elder, wearing traditional fur and leather garments, dances at a harvest ceremony.*

EPILOGUE

Many of the traditional items seen in these pages are rarely used today. Others have been adapted to take advantage of new materials. A boy who has undergone a circumcision ceremony may no longer spend months in the bush, learning the ways of his people. He may, instead, return to a mission-run school to continue his Western education. His generation offers a snapshot view of the cultural changes his people are undergoing: traditions exert powerful forces, attaching a boy to his age set and to his culture, but education pulls strongly too, with its promises of an easier life in the city.

It is too soon to write 'the end' to the story of traditional African life. When I was in Kenya in 1974, a circumcision ceremony and age-set creation of the Maasai was taking place, and it was widely believed that it would be the last ceremony of its kind. Yet, in 1990, I was fortunate enough to be able to attend a circumcision ceremony of the Samburu. For nearly a week I witnessed the preparations, dances and rituals surrounding the creation of a new age set; all over northern Kenya, boys were going through the same rituals, which I observed in the Lorroki Forest, about an hour's drive from Maralal.

Yet the end is surely in sight. Increasing urbanization, the pressure of insufficient land resources to support large herds of cattle and high population growth rates are all combining to make traditional practices look more like a luxury than the coherent, stable way of life they truly represent. Ironically, this comes at a time of awakening interest in traditional cultures on the part of outsiders. In South Africa, for instance, cultural villages – many of them imaginatively and sensitively conceived – go some way toward keeping traditional ways alive. The process of cultural change can hardly be reversed, yet we can celebrate the ingenuity and artistry of African peoples, and the myriad ways in which they have turned locally available materials into objects of both beauty and utility.

BELOW: *Clad in fur and feathers, King Mswati II of Swaziland takes part in a national celebration.*

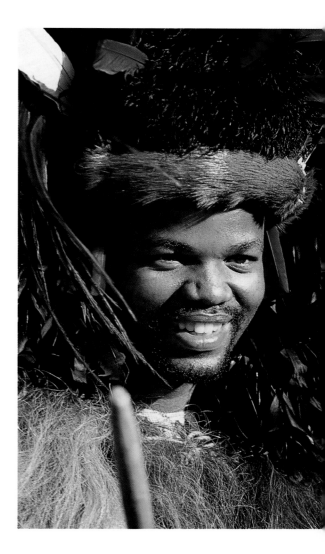

INDEX

ACKNOWLEDGMENTS

I am grateful to all the craftspeople whose work has inspired this book, and whose traditions continue to flourish in Africa. I thank all those who made the study of Africa's material cultures their life work. I am especially grateful to Alan Donovan for his insightful comments on the text while this book was in production. Great thanks go to Richard Meyer for his help in deciding which of the many cultures of Africa to include and for his expert comments on the photographs. My thanks to Rhodia Mann for introducing me to her Samburu friends and for affording me an intimate look at a Samburu rite of passage. Thanks also to Donna Klumpp Pido for her insights regarding the Maasai use of colour. At Struik Publishers in Cape Town, my thanks go to managing editor Annlerie van Rooyen, designer Janice Evans and editors Alfred LeMaitre and Lesley Hay-Whitton for shepherding this book through its development. The publishers would like to thank all the photographers who have contributed their talents to this publication, and to the many individuals who have lent their time and expertise. Special thanks go to Carol Kaufmann of the South African National Gallery, Cape Town, and to James Masautso, of the Chapungu Sculpture Park, Harare.

Finally, this book is dedicated to Jason Lauré, who first showed me the way to African cultures, and who has continued to encourage my writing about the crafts of Africa for more than 20 years.

ETTAGALE BLAUER, NEW YORK, 1998

PHOTO CREDITS

First published in 1999
by New Holland Publishers (UK) Ltd
London • Cape Town • Sydney • Auckland

24 Nutford Place
London W1H 6DQ
United Kingdom

14 Aquatic Drive
Frenchs Forest
NSW 2086, Australia

80 McKenzie Street
Cape Town 8001
South Africa

218 Lake Road
Northcote, Auckland
New Zealand

2 4 6 8 10 9 7 5 3 1

ISBN 1 85368 970 X

Managing editor: Annlerie van Rooyen
Editors: Alfred LeMaitre and Lesley Hay-Whitton
Designer: Janice Evans
Design assistant: Lellyn Creamer
Picture researcher: Carmen Watts
Consultant: Alan Donovan
Map illustrator: Annette Busse
Proofreader: Lesley Hay-Whitton
Indexer: Claudia Dos Santos

Reproduction by Hirt & Carter Cape (Pty) Ltd
Printed and bound in Singapore by Tien Wah Press (Pte) Ltd